GETTING OFF

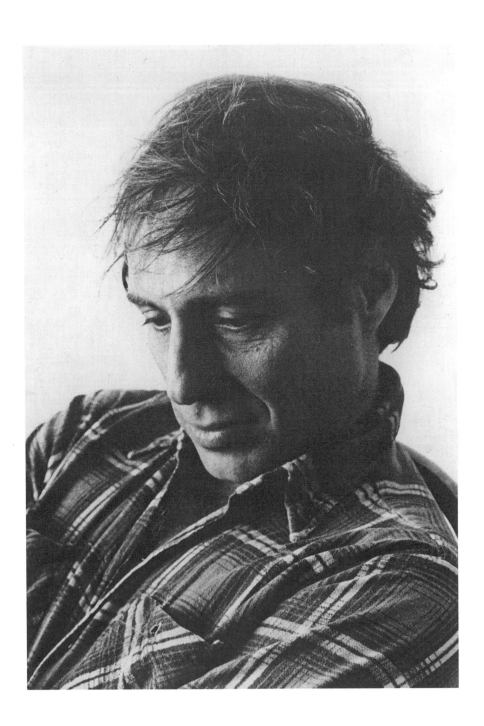

GETTING OFF

LEE BREUER
ON PERFORMANCE

WITH STEPHEN NUNNS

Foreword by Sharon Levy

THEATRE COMMUNICATIONS GROUP NEW YORK 2019

Getting Off: Lee Breuer on Performance is published by
Theatre Communications Group, Inc., 520 Eighth Avenue, 24th Floor,
New York, NY 10018-4156

This publication is made possible in part by the New York State Council on the Arts
with the support of Governor Andrew Cuomo and the New York State Legislature.

TCG books are exclusively distributed to the book trade by Consortium Book Sales
and Distribution.

A catalogue record for this book is available from the Library of Congress.

ISBN 978-1-55936-533-8 (paper)

ISBN 978-1-55936-862-9 (ebook)

Frontis photograph of Lee Breuer, Milan, Italy, 1980 by Ilaria Freccia

Front cover photograph by Tom LeGoff

Back cover photograph: *Un Tramway Nommé Désir*, Salle Richelieu,
La Comédie-Française, Paris, France, 2011, Éric Ruf and Françoise Gillard
(Stanley and Stella); photo by Micro Magliocca

Cover, text design and composition by Lisa Govan

First TCG Edition, June 2019

FOR SHARON: A DEDICATION

What is the difference between an acknowledgement and a dedication? Is it the difference between a "thank you" from the conscience and a "thank you" from the heart? If so, this then is a dedication, a thank you from my heart to Sharon Levy, who inspired, initiated, and edited this book. Without Sharon it simply would not exist.

—LEE BREUER

For Karen and Zack.

—STEPHEN NUNNS

CONTENTS

FOREWORD

by Sharon Levy

One night in 2007, after an audience talkback in Toronto for *Mabou Mines DollHouse*—one of many such nights on the road listening to Lee Breuer speak about his work—I was amazed, yet again, at the sheer brilliance of his approach to performance. I asked Lee if any of it had been documented. When he said no, I knew that I had to do something about it.

Lee Breuer is a rare artist who is not just influenced by the work of master artists worldwide. He studies and works with them on their home turf: Bunraku puppeteers, Chinese opera performers, gospel and jazz musicians, Trinidadian pan bands, Grotowski's Theatre Lab, the Berliner Ensemble, French Lecoq artists. The breadth and depth of his knowledge and understanding of what seems like the entire spectrum of theatrical genres and techniques from the beginning of time is staggering. As a theatre student in Australia in the '70s, had I heard Lee speak about his synthesis of the ideas and methods of Stanislavski, Brecht, and Meyerhold, I might have saved myself a lot of time and angst groping in the dark, seeking the one style, drama-

tist, director, genre that encompassed all that interested and excited me. It's not just what he says, but also the way he speaks about his work that is as fascinating and illuminating as the work itself. You can actually wrap your head around it to the point where, after the fact, it seems obvious: retelling a Greek tragedy as a black Pentecostal church service; examining the misplaced power of the patriarchy by casting little people in the male roles; examining a woman's pain through the eyes of a dog in love with her master. Of course!

Lee has spent a lifetime examining issues with which he has grappled personally and which have frequently been at the core of his work, especially gender and power. I was drawn into that vortex when I saw a production of *The Shaggy Dog Animation* in Minneapolis in 1987. I had met Lee a year earlier in Atlanta, when *The Gospel at Colonus* was playing there, and *Shaggy Dog* was one of six projects he pitched to me over lunch. When I produced it—with RuPaul and Bernardine Mitchell, among others, in the cast—I knew I'd touched a nerve when the response was in equal parts bravos and hate mail. Lee's work goes straight to the gut, messing with the mind along the way. It takes no prisoners.

Despite the clarity and coherence of Lee's conceptual thinking, the way all his ideas come together for the stage is by no means simple or straightforward. As his producer on many shows since the early 1990s, I can attest that none of it ever happens without a lot of trial and error, angst, and unexpected expense. His ideas are copious and come in a free flow from a mind that, if tamed (if that were even possible), wouldn't happen. And not every idea is a great one. Figuring out which ideas to give time and resources to is a real challenge, because, of course, he wants to try them all to see how or if they work. In the real world that's just not possible. Like others who've worked with Lee, there was a time I swore I was never going to work with him again. For all the brilliant worldwide successes that will go down in theatre history, there are some that are just chaotic and confusing, leaving bruised egos, wounded pride, and people heading for the exits. After one such experience in the late '90s, I didn't speak with Lee for years. Then, unexpectedly,

I bumped into him at a concert and we fell into each other's arms like long-lost family: my brother from another mother. A few weeks later Lee called to ask if I would come to a rehearsal of a new piece he was working on at St. Ann's Warehouse in Brooklyn (*Mabou Mines DollHouse*). "One of the best things I've ever done, I think," he said to me, "but I need some help." So, battle scars by now all healed and skepticism curbed, I showed up. If he was right that it was one of his best (and it was), who in their right mind would not want to be part of it? Ten minutes in I saw one of those miraculous moments onstage that takes your breath away, not because of any spectacular stagecraft, but because an actress (Maude Mitchell), in rehearsal clothes without sets or lights, crawled across the stage in a way and for a reason that no woman could fail to recognize and not want to weep over. When Lee gets it right, he gets it so right that you'll follow him, as many have, to the ends of the earth.

Lee Breuer is really hard to say no to, not just because his enthusiasm in all its forms is infectious, but because for anyone who recognizes a truly great idea when they see it, turning your back on it would mean questioning your entire life's work. So when he asked if I could help him—which, among other things, I knew meant raising some finishing funds—I made a deal with him. If I came on board, I promised I would never outright dismiss any new idea he had, but he had to agree to always discuss it with me so I could evaluate it in terms of time and money. Then we could determine together whether it was worth pursuing. Over the course of several decades, we did pretty well with that system.

This book, with commentary by Stephen Nunns, who is able to contextualize Lee's work better than any writer I know, was designed to give you an inside look into one of the most exceptional creative minds I've ever encountered. Historically speaking, his lifetime of work as a director, writer, and adaptor should be examined and studied by anyone interested in performance. At eighty years old, Lee Breuer is still at it.

I couldn't be more grateful for the opportunity to have played a part in making some of his groundbreaking work manifest.

EXPLANATORY NOTE

Getting Off is a pastiche. It consists of interviews with Lee Breuer done over a twenty-year period, bits and pieces of Lee's own writing, and critical evaluations and biographical snapshots of Lee and his work at various points in his career.

The narrative is splintered, composed of different tracks that play consecutively, cut back and forth—or even simultaneously—and treat Lee, his work, and his thoughts as fragmentary texts.

It's a way of meeting the man on his own turf.

—*Stephen Nunns*

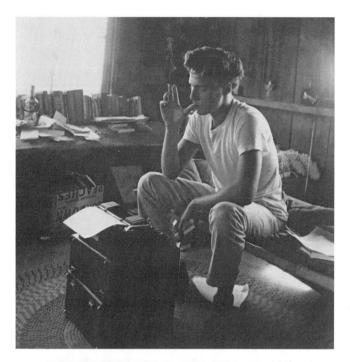

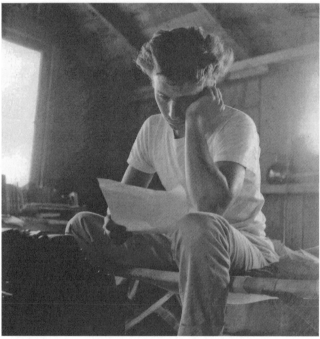

Lee Breuer, the Goat House, Big Sur, California, 1959. Working on The Run.

INTRODUCTION

ANIMAL MAGNETISM: LEE BREUER AND THE SEARCH FOR AN AMERICAN CLASSICISM

by Stephen Nunns

I feel like it's a game and there is a constant effort to out-guess the system. I cannot get past the fact that I'm fascinated by the game itself. And that the game is: Can a maverick, can an outsider, can a bee buzzing outside the window of the system, make enough of a whack on the window to get the system to notice? Just for fun. And what techniques does that bee use? How long can he do it? How can that bee out there make enough noise bashing his head against the windowpane without *dying*? But still disturb something that's going on inside the system house, you know?

—*Lee Breuer in an interview, March 2004*

Since he first arrived on the New York art/theatre/performance scene in 1970 with *The Red Horse Animation*, Lee Breuer has been at the forefront of the American theatrical avant-garde, creating challenging works both independently and with Mabou Mines, the company he cofounded that year with JoAnne Akalaitis, Philip Glass, Ruth Maleczech, Bill Raymond, and David Warrilow. Breuer's

work as a director has included celebrated stagings of Samuel Beckett (the Obie Award–winning productions of *Play*, *Come and Go*, and *The Lost Ones*), radical readings of classics, including *The Gospel at Colonus* (an adaptation of Sophocles featuring Clarence Fountain and the Five Blind Boys of Alabama that was produced on Broadway in 1988), *Mabou Mines Lear* (Breuer's controversial gender-bending adaptation of *King Lear* in 1990), and his revolutionary reinterpretation of Ibsen with *Mabou Mines DollHouse*.

Breuer has also been a prolific writer, redefining the concept of character and the usage of biography in such works as *The Shaggy Dog Animation*, *A Prelude to a Death in Venice*, *Hajj*, *Ecco Porco*, *La Divina Caricatura*, and *Porco Morto*. Breuer's writing exhibits a truly American voice, one that has managed at various times—and often simultaneously—to evoke Charlie Parker solos, beat poetry, Fillmore West rock-and-roll, Melvillian expansiveness, Saturday morning cartoons, Mark Twain, 1950s doo-wop, Keseyian acid tests, and Emersonian transcendentalism. And that's just a partial list.

Meanwhile, his directorial work has dabbled in a vast array of European performance techniques—at any one Lee Breuer piece, be it a restaging of a classic or a performance of one of his own texts, an audience might encounter the realism of Stanislavski, the estrangement of Brecht, the physicality of Meyerhold, and the ritualism of Grotowski, at times almost simultaneously. Breuer has also displayed a keen interest in the theatrical traditions of other cultures, including Balinese shadow puppetry, Caribbean carnival, and Japanese Bunraku.

This salad-bar approach to both his writing and directing has, at times, infuriated critics, with some of them perceiving Breuer as being a scattered, pomo-dilettante-art-huckster—a kind of late-twentieth-century Professor Harold Hill with an attention deficit disorder. Certainly, there have been moments when critics and audiences have had good reason to be confused. Rather than simply engaging in Western imperialist appropriation, Breuer has attempted—with varying degrees of success—to utilize intercultural techniques as inroads into exploring a new American cultural

identity, something that throws equal amounts of African, Caribbean, and Asian aesthetics into the melting pot, along with European classicism. Rather than being a site of aesthetic inconsistency, Breuer's mix-and-match techniques are an attempt to engage in typically American anti-formalism with a European high-art style. It's not only an attempt to discover his own artistic voice. It's also a very public struggle to define just what American art is—or perhaps could be—in the second half of the twentieth century.

TRACK ONE: BUILDING A CHARACTER, OR BIOGRAPHY AS CULTURAL HISTORY

Both Breuer's writing and directing have brought into play the "sociobiological" question of character—as he puts it, "What is the real animal, society or the individual?"[1] Particularly in his writing, where he often utilizes metaphor to its (occasionally il)logical extreme—and engages in his own peculiar brand of animal husbandry—Breuer has explored the nature of free will, bringing into question where the individual leaves off and society begins. In a Breuerian worldview, the individual stands as a mirror (sometimes a funhouse one) of society. Therefore, the concepts of history and biography are both intrinsically bound up with one another: After all, *my* personal narrative may actually be intertwined and utilized as part of *your* biography, and both our histories can become immersed in and elements of—to borrow Breuer's metaphor—the larger anthill of culture.

Since the utilization of the individual as a metaphor for a larger discourse is a big part of Breuer's modus operandi, it seems only fair to use a similar tactic when approaching him as a subject. Indeed, I would argue that the personal and professional histories of Lee Breuer mirror the narratives of the American avant-garde in the sec-

1. David Savran, *In Their Own Words: Contemporary American Playwrights* (New York: Theatre Communications Group, 1988), 12.

ond half of the twentieth century. By investigating Breuer's trials and tribulations, his artistic successes and failures, his personal and professional crises (as critic Ross Wetzsteon once wrote, "[Breuer] has crises, turning points, pivotal moments the way other people have colds"[2]), one can also follow a trajectory of, the metamorphoses of, and ultimately (borrowing Breuer's animal imagery again), the *domestication* of American experimental performance during the same period. Once upon a time, Breuer was dubbed "The Wild Man of the American Theatre" and was actively shunned by the mainstream and critical establishment. That dynamic has changed, and today Breuer is the recipient of a MacArthur "genius award" and a French Chevalier Ordre des Arts et des Lettres, and is celebrated in mainstream publications such as *The New York Times*. (See, for example, Margo Jefferson's description of Breuer as "a wizard-director, an alchemist who blends ideas, genres, styles, texts and technologies to make new kinds of theater.")[3]

All of this would seem to suggest that either the world has finally caught up with Lee Breuer, or he has simply become savvier at playing what he calls "the system." In either case, questions inevitably arise: Is this newfound general acceptance a result of Breuer being a more radicalized byproduct of the American Century? Does the American avant-garde truly take as *oppositional* a stance as its European counterpart, or is it really bound up with majoritarian interests? Or has Breuer, over his fifty-year career as both insider (white male intellectual) and outsider (antiestablishment experimental Jewish bohemian), managed to play both ends of the field, playing the late capitalist game while simultaneously sticking a shiv into it? Has Breuer actually had a hand in shaping the aesthetics and expectations of artists, critics, and audiences of his era, and therefore brought the term avant-garde back to its literal meaning? Or is he simply an unwitting pawn in—and a cultural byproduct

2. Ross Wetzsteon, "Wild Man of the American Theatre: Lee Breuer Turns His Life and Off-Broadway Upside Down," *The Village Voice* (May 19, 1987), 20.

3. Margo Jefferson, "Fun-House Proportions Turn Dominance Upside Down," *The New York Times* (November 24, 2003), E3.

of—a society dominated by commodity fetishism? These are pre-
cisely the kind of chicken-or-egg quandaries that Breuer constantly
attempts to address in his work.

TRACK TWO: MERITOCRACY,
OR THE EDUCATION OF LEE BREUER

As I noted above, Breuer can be viewed as the personification of
a larger narrative of the American avant-garde art during the sec-
ond half of the last century. For example, Breuer's background is
decidedly middle-class; his grandfather lost all of his savings and
investments and his father struggled—unsuccessfully—to keep his
family afloat. By the time Breuer entered UCLA at the age of six-
teen, his father had died, leaving the family saddled with debt, and
his mother was incapacitated by mental illness. The only reason
that Breuer was able to attend college in the first place was because
of the then-recent burst of federal subsidy into higher education,
and the shift toward more meritocratic admissions processes, both
of which were byproducts of the burgeoning Cold War.[4]

It was in his first year at UCLA that Breuer discovered art—up
until then his mother had planned that he become a lawyer—and
began to embrace a bohemian existence. In this way, Breuer repre-
sented a new kind of experimental artist, at least from an American
socioeconomic standpoint. After all, if we were to compare the Breuer
family's downwardly mobile status to the economically privileged
standing of many earlier American experimental artists (the Yale-
educated Thornton Wilder, whose father was U.S. consul general to
Hong Kong; fellow Yale graduate Charles Ives, whose grandfather
was a railroad and utilities magnate; Radcliffe alum Gertrude Stein,
whose father attained financial success via real estate and railroad

4. On the changes in higher education during the postwar period and after, see
Louis Menand, "The Marketplace of Ideas," American Council of Learned Societies
Occasional Paper No. 49, 2001, http://archives.acls.org/op/49_Marketplace_of_
Ideas.htm.

investments), it seems likely that in an earlier era financial neces-
sity would have made Breuer's life take a markedly different path.[5]

TRACK THREE: FOLLOW THE MONEY, OR THE CASH VALUE OF THE AVANT-GARDE

Historically, American art has been tied up with politics. Perhaps
relating to de Tocqueville's claim that U.S. citizens "will habitu-
ally prefer the useful to the beautiful, and they will require that the
beautiful should be useful,"[6] art has often embraced political utili-
tarianism. In particular, the early American avant-garde was linked
with radical politics.[7] By the advent of the Cold War, a new apoliti-
cal American aesthetic had appeared, though there is some question
as to just *how* depoliticized art was during this period, particularly
considering the discovery of clandestine funding by the federal gov-
ernment (often through the CIA). By the late 1960s, the federal gov-
ernment accepted experimental art—what Nelson Rockefeller once
called "free enterprise" art—and had given up being covert about
funding it.

With all of this in mind, the decision by Breuer and Maleczech
to return from Paris in 1970 to start an experimental American the-
atre company was a keenly practical one. From 1965 to 1970, the
American founders of the company, Akalaitis and Glass (who would
later marry) and Breuer and Maleczech, had been living in Paris. (It

5. It's worth noting that most of Breuer's contemporaries in Mabou Mines came
from working-class backgrounds, including Frederick Neumann, Ruth Maleczech,
JoAnne Akalaitis, and Bill Raymond. Both Maleczech and Akalaitis's parents were
first-generation European immigrants. Indeed, of this group, Breuer's background is
the most middle-class.

6. Alexis de Tocqueville, *Democracy in America, Vol. 2* (New York: Vintage Classics,
1990), 48.

7. See, for example, Martin Green, *New York: 1913: The Armory Show and the
Paterson Strike Pageant* (New York: Collier Books, 1988) and Dickran Tashjian, *A
Boatload of Madmen: Surrealism and the American Avant-Garde 1920–1950* (New
York: Thames & Hudson, 2001), esp. 110–75.

was there that they encountered the fifth founding member, Anglo-Irishman David Warrilow.) They scraped together a living by doing translations and dubbing films, performed small experimental theatre pieces, and traveled around Europe, having encounters with, among others, Jerzy Grotowski and the Berliner Ensemble. However, by 1970, the romance of Parisian bohemianism had worn off: Both couples now had children, and the prospect of creating an English theatre company in France, performing for tiny audiences, seemed less and less appealing. Akalaitis and Glass had returned to the U.S.—Glass had initially been in Paris on a Fulbright scholarship—while Maleczech and Breuer temporarily relocated to London. As Breuer tells it, it was a transatlantic phone call from Akalaitis that persuaded Maleczech and him to pack up and return to New York:

> I was trying to figure out if there was a deal where I could teach some place and start a company. We were thinking, "We don't want to go back to the States." But nothing materialized. And then JoAnne called up and said, "There's *money* here, it's LBJ's Great Society, you can get an apartment quickly, you can get some furniture"
>
> The fact of the matter is, we rehearsed on welfare. We went on welfare for six months I couldn't get unemployment—I hadn't had a job . . . but I could get welfare. Imagine me, a healthy person, just because I had a one-year-old baby, could qualify for welfare? I mean, I'm white, college-educated, healthy—and still, I can get *welfare*? Of course the conservatives are ready to bump us all off! I mean, I could go pick up a welfare check and go to rehearsal!
>
> I still have my welfare card. I've got long hair . . . I mean, it's completely unbelievable. It was like giving the Merry Pranksters welfare!

Thanks to the welfare state, Mabou Mines's first piece, *The Red Horse Animation*, was born.

Soon, these pranksters discovered that considerably more arts funding was available in the U.S. than in Europe at that time (at

least for non-nativist work). Indeed, that year Richard Nixon was asking for an increase in the annual budget for the National Endowment for the Arts, from $8.2 million to $16.3 million. (The next year he doubled it again.)[8] And, as we see, support was not only available through such official means: It was standard Mabou Mines policy through the 1970s and 1980s to pay the company members a base annual salary—$200 a week for 26 weeks—so that they could collect unemployment during the remainder of the year.[9]

It would appear that the relationship between a scrappy, bohemian theatre company like Mabou Mines and the American government is considerably more complicated than a simple *épater le bourgeois* scenario. Ironically, the company is, in some ways, a *product* of the state.

TRACK FOUR: BREUER'S PLURIVERSE, OR THE INTERCULTURAL IMPULSE

Breuer's persistent interest in engaging in formalism on his own terms can be discovered in the artist's eagerness to explore—some have suggested to exploit—intercultural staging techniques. But the question of exploitation is a complicated one, since this is not simply a question of a Western intellectual's privilege of choosing his culture "the way many of us now choose food to eat,"[10] or as Disraeli once suggested, seeing the East as a "career,"[11] or engaging in some kind of antimodernist nostalgia trip through non-Western cultural artifacts unsullied by the plague of the Enlightenment.

8. See Bruce J. Schulman, *The Seventies: The Great Shift in American Culture, Society, and Politics* (New York: The Free Press, 2001), 27.

9. See Don Shewey, "The Many Voices of Mabou Mines," *American Theatre*, June 1984, 5.

10. Richard Schechner, *Performative Circumstances: from the Avant-Garde to Ramlila* (Calcutta: Seagull Books, 1983), 323.

11. See Edward W. Said, *Orientalism* (New York: Vintage Books, 1978), 5.

Breuer instead sees the appropriation of other performance techniques as just another step in discovering an American aesthetic, one that acknowledges the demographic changes that have taken place in this country in the second half of the last century. And although he has taken flack from critics for creating the theatrical version of imperialism—critic Jonathan Kalb, reviewing *The MahabarANTa* in *The Village Voice*, criticized Breuer for engaging what he termed "neocolonial opportunism"[12]—a look at modern America today bears Breuer's perspective out.

According to U.S. census statistics, the percentage of the population that identifies itself as "white" has dropped from 83.1 percent in 1980 to 72.4 percent in 2010. And if Hispanic population is taken out of the white equation, that number drops to 63.7 percent. Meanwhile, every other group has increased (with the exception of African Americans, whose numbers have held steady). Breuer's work is trying to reflect these demographic shifts. As he puts it, "American culture today is becoming triangular. The influx of African, Caribbean, and Asian cultural ideas, along with European ideas, are creating a new culture—no longer a strictly European one. This is the ultimate melting pot."[13] To Breuer, "choice" is not the issue. To him, this clashing and/or synthesizing of culture *is* the modern national experience during the twilight of the modern nation state. It's just one more step toward what he calls an "American classicism."

TRACK FIVE: I LOST IT AT MOVIES, OR THE REVOLT AGAINST FORMALISM

This track begins with Breuer's post-university life. Ironically, it is in Europe—specifically the post-university period when Breuer and Maleczech lived in France—that he begins to try to find a specifi-

12. Jonathan Kalb, "Big Bug Stories," *The Village Voice*, November 10, 1992, 102.

13. Gabrielle Cody, "Lee Breuer on Interculturalism," *Performing Arts Journal* Vol. 11, No. 3/Vol. 12, No. 1 (1989): 62.

cally American voice and style, turning away from formal European models. Breuer did not completely abandon formalism after the creation of Mabou Mines—witness the early conceptual works such as *Arc Welding Piece* and *Music for Voices*—but he soon veered onto a decidedly anti-formalist track, or at least one that viewed formalist principles with a calculated and jaundiced eye. (An early example was *The Saint and the Football Player*—Breuer's Dantean take on America's pastime—with music in the form of football play calls by Philip Glass.) I would suggest that this marks a critical difference between Breuer and his contemporaries, many of whom discovered the location of their formal aesthetic and then rarely deviated from that path.

It's important to note that Breuer's attempt to discover an American classicism doesn't constitute a complete abandonment of formalist techniques. From his earliest directing experiment (an attempt to do a Stanislavski-based performance of Brecht's *Caucasian Chalk Circle*) to his more recent (for example, a production of Ibsen's *A Doll's House*, that, through melodramatic performance techniques, highlighted the playwright's debt to Sardou, Scribe, and other propagators of the well-made play), Breuer has been keenly interested in mixing high formalism with populist aesthetics—mixing and matching materials that can be alternatively (and sometimes simultaneously) incredibly illuminating and absolutely frustrating for the viewer.

It is in this formalistic looseness that one might discover Breuer's difference from his contemporaries. Breuer eschews the cool, technological distance of Elizabeth LeCompte and the Wooster Group. He only embraces Charles Ludlum–style camp and irony when it suits him, and abandons it when he feels that sincerity and naturalistic acting techniques have more cash value in a performance. Trying to compare his work to Robert Wilson and Richard Foreman's formalist approaches is pretty much a waste of time. (That is why critic Bonnie Marranca's attempt to house all three under the moniker of "theatre of images" doesn't hold water today, though the fact that she was dealing specifically with an early conceptual work—*The*

Red Horse Animation—means she was right at the time.)[14] Finally, Breuer and his collaborators in Mabou Mines have no preoccupation with a specific performance technique (as in the work of Anne Bogart and the SITI Company); they are notorious for stealing from a myriad of styles or performance aesthetics, often switching from one to another in the same piece. The same holds true for Breuer's writing. Acknowledging his tendency toward purloining the prose of dead poets, he writes, "Fortunately, should they misunderstand my panegyric, most are unable, at their level of decomposition, to sue for libel."[15] Still, it was in popular culture that Breuer saw the *real* future: pop music, paperback literature, television, and movies.

Especially movies.

"DO I OWE A DEBT TO THE CINEMA," Breuer wrote in his first Mabou Mines piece, *The Red Horse Animation*.[16] Clearly, he, like most of his generation, owed their aesthetic as much to popular culture as to Camus and Kafka (two of Breuer's college-era influences). While this might be bemoaned by some as an example of the barbarians at the gate, what it represented to Breuer and his ilk was a freeing up from the constraints of highbrow European formalism— an attempt to discover a true American voice.

For Breuer, that voice was to be discovered in a new Cold War America that finally embraced its position as a global player. As a result of shifting cultural tides, Breuer believed that a real American classicism couldn't simply be located in a concert hall or a Broadway house (though he eventually found himself in both of these arenas); it was to be found in such diverse places as 1950s doo-wop groups (*Sister Suzie Cinema*), African American Pentecostal Church services (*The Gospel at Colonus*), pedestrian dance (*The Red Horse Animation*), the independent film world (*A Prelude to a Death in Venice*), even Alcoholics Anonymous meetings (*Ecco Porco*). "A country's

14. See Bonnie Marranca, *The Theatre of Images* (New York: Drama Book Specialists, 1977).

15. Lee Breuer, *La Divina Caricatura* (New York: Green Integer, 2002), 210.

16. Lee Breuer, *Animations* (New York: Performing Arts Journal Publications, 1979), 40.

classicism is its statement," Breuer once said. "Molière, Corneille, and Racine say it for France. Shakespeare says it for England, but nobody was saying it for America or they were saying it in such a minimal way, a neo-European way, that I didn't think it was really an American statement. Is O'Neill really an American statement? No, he is just another Irish playwright writing another Irish play."[17]

Of course, messing with an anti-formalist aesthetic is a highly provocative move—a point that Breuer is keenly aware of. This is exemplified in *La Divina Caricatura* when Rose—the dog who is the main character of this "fiction" (which is a collection and rearrangement of a number of Breuer's performance texts)—bursts onto the art world scene:

> I was faced with a crisis. Being a Minority Species in the art world I'd Max'd out. Now I had to make art or I'd be indicted. So I made my move. I moved out of politics. Then I moved down West Broadway. I was deep in the heart of Curb Your Dog country when I pissed on an Oldenburg. It was a big Fire Hydrant they were loading into Max Weber's
>
> It is not particularly difficult for an animal to understand the Art Market. Which like any other market is about Who's Top Dog. Status is achieved through the Creation of Value . . . a salient feature of late capitalism[18]

As with any portion of Breuer's work, there is more than a little autobiography going on in this passage. The main critical response to Mabou Mines's early work could be best described as suspicious, due, in large part, to the company's tendency to slip between the disciplinary cracks. "Cultureburg," Tom Wolfe's term for the gallery world of the 1960s and '70s, where the group's initial, highly conceptual pieces were first performed, often looked at the company somewhat warily. Meanwhile, the "straight" theatre world generally threw its collective hands up in exasperation. Clive Barnes, review-

17. Cody, 62.

18. Breuer, *La Divina Caricatura*, 68–9.

ing a version of *The Red Horse* performed at the Guggenheim for *The New York Times* in November 1970, mentioned the fact that Mabou Mines took its name from a mining town in Nova Scotia near where the group rehearsed the piece. "They were certainly very well rehearsed," Barnes observed, "yet a wayward thought crossed the mind that they might have been more gainfully employed in mining."[19]

Times, once again, have changed—Breuer's anti-formalist version of the avant-garde has actually become a form of classicism. This is not all that surprising, since an *épater le bourgeois* approach hardly makes much sense considering, among other things, the proliferation of the punk aesthetic (with an inherent anarchy and violence that makes the endurance art of Chris Burden look tepid) and the advent of realty television (which merges the Marina Abramovich–style high concept of art-as-everyday-life with Andy Warhol's prediction that everyone will be famous for fifteen minutes).

Witness Breuer's revisionist take on Ibsen, which was the surprise hit of the 2003–04 New York theatre season. Breuer's basic directorial concept—that the male roles would be played by dwarfs—didn't seem particularly divorced from the director's Southern-fried approach to 1990's *Lear*. However, instead of garnering scorn and critical pans like *Lear* did, *DollHouse* was celebrated by the critical establishment. The show was a hit, its initial run extended by St. Ann's Warehouse by three weeks, and a steady stream of celebrities and New York's cultural elite trucked nightly into Brooklyn to see Maude Mitchell and the three-foot-eight Mark Povinelli do their melodramatic takes on Ibsen's text. By the evening when the curtain was held so that celebrity sex therapist Dr. Ruth Westheimer could arrive to take her seat, it was clear that fifty-some-odd-years down the line, Lee Breuer's version of the avant-garde could no longer be considered outré, antagonistic, or disconnected from American culture. In many ways, it *is* American culture.

19. Clive Barnes, "Stage: Trio of 'Red Horse Animation,'" *The New York Times* (November 20, 1970), 32.

GETTING OFF

THE THEATRE AND ITS TROUBLE (EXCERPT 1)

A version of this list of pseudo-philosophic riffs on theatre and art—inspired in part by Alfred Jarry's 'pataphysics and Brecht's "A Short Organum for the Theatre" (which in and of itself was a pseudo-philosophic riff on Marx and Hegel)—was included in Breuer's 1987 TCG collection, Sister Suzie Cinema. *Whereas Brecht's writing was a "description of a theatre of the scientific age," "The Theatre and Its Trouble" is more of a description of a theatre of the facetious age. Breuer has since critiqued the essay for its overt romanticism and floweriness, but it stands as a good indicator of his interests/obsessions at this point in his career.*

1. If a fact falls in the forest and you hear it not—is it a fact at all? Might it not have been your fancy? Theatre, *de facto*, did originate. I'm sure there was a time and a place. But I didn't have a ticket. And no one sent me the reviews. I'll content myself with truth according to the fanciful. Fancy, which is the soul of fact, makes fact ring true. And the truth is, theatre started with the wolves.

2. Moon . . . mountain . . . snow blanket, snow pillow, snow sheet; the bed is coldly made, the table savagely laid, for a howling. Look! It is the moment of the turning around. *The turning around* was initiated in the theatre of the wolves.

3. Sing, O wolves, of wolfish mysteries. Why does one wolf turn around? Is one chosen? Does one sing better than the rest? Is one inspired by the wolf ghosts of wolf ancestors? Does

one preach the wolfish word? We hear. We echo. We howl. We harmonize—we wolves.

4. Sing. Dance. Paint your faces. Don't ask an actor why. Ask a singing bird, a prancing peacock. Ask any fish who changes colors. Applaud the *mie* of Tomasaburo! Applaud the postures of lions.

5. Read your program. It is a genetic program.

6. Performance is the method of natural selection adopted by culture. Culture is society's DNA. Performance is fashion. Survival of the fashionable. That's what it's all about.

7. What is acting? Acting is the moment when, after the *performance* turns around to the front, it turns back to the side.

8. And half of you is half assing you. And that's the theatre and its trouble.

CHAPTER ONE:
HAPPY JUST TO KEEP MY EDGE

In which Breuer contemplates the yin of Peter and Wendy, *'pataphysics, and redders and blackers*

EXCERPTS FROM A LECTURE AT TOWSON UNIVERSITY, MARCH 2007

What I want to do today is . . . well, to tell you the truth, I can do whatever you want. But it seems that the gist is that we should have a conversation. And we should have a conversation on a couple of subjects that are very important to you: process and how to get it together to actually do something in the world—in this mess.

The first thing I wanted to do was show you some videos, by way of diversion. You see, I think my writing has changed, and I want to stop directing for a while and concentrate on writing, because I think I've moved into another area that I'm very, very happy about. Steve [Nunns] spoke about *Ecco Porco*.[20] Well, there was a small sequence in it that I wrote for Ruth [Maleczech] that we turned into

20. *Ecco Porco* was performed as a workshop at Mabou Mines's ToRoNaDa Space, New York, in 2001. It premiered at Performance Space 122 in January 2002.

a one-act called *Summa Dramatica*.[21] It's a spin on Alfred Jarry's 'pataphysics. 'Pataphysics is defined as "the philosophy of magical solutions." It's a send-up of metaphysics and it's absolutely hilarious. Jarry, as I guess you all already know, was the writer of *Ubu Roi* and initiated the so-called avant-garde in the world. And died a penniless drunk—an ether junkie asking for a toothpick.

'Pataphysics is an amazing spin. It's the spin that never stops spinning. And it's an awful lot of fun. So, I'm trying to do a series of pataphysical works, one of which I'm going to show you today.

Summa is a lecture that is to be delivered—we're picking it up where William James dropped it about 100 years ago with his lectures on *The Varieties of Religious Experience*. So, this takes place in Edinburgh, and it's a lecture by a cow on the art of acting as a religion. And I want to do it at the Actors Studio because half the jokes are about them. Maude [Mitchell] read it a while ago and she said, "This is impossible. You can't act it. It's unactable." And then she saw Ruth tackle this thing and she said, "Well, except for Ruth." So, I'm pretty pleased, because it's a new form. It's commedia, but it's like a new take on commedia.

I'm interested in comedy. And consistently interested in how comedy works, and this is just another branch that I'd really like to evolve.

Looking at my work philosophically, it's a lot like what Brecht did. He did something, and then he put a lot of philosophical and political bullshit together to try to give some rationale for it. He had this kind of great idea about alienation and distancing, and then he spent 15 years trying to tie it to Marxism. A complete failure. But he figured he had to, and he was very smart. It was a *political move*, because ultimately he got a fucking fortune from East Berlin.

21. *Summa Dramatica* was eventually performed in a double bill with *Porco Morto* under the title *Pataphysics Penyeach* at Mabou Mines's ToRoNaDa Space, New York, in January 2009, as part of the Public Theater's Under the Radar Festival.

So, it was just a political move. Most theatre philosophy is a political move. To tie it to something, or get it published, or kiss the ass of some class that's going to support you. Just look at it politically and I think you'll start to figure it out.

I think if you look at *my* philosophical takes, they change from piece to piece. But there are a few consistent ideas in it. One of them is the idea—stolen from Brecht (which Brecht stole from Meyerhold)—that you can basically work dialectically in the theatre. That was his big trip about why it was Marxist. But it's really the *Hegelian* Dialectic, not necessarily the *Marxist* one. And the idea is really simple: Basically, you are always saying *two things at once.* And those two things are *usually different.*

Now, if the audio, if the voice and lines, are saying the same thing as the movement, it *can* become tragic—but it's usually redundant. You are actually saying the same thing twice where you *could* have said it once and simultaneously said something completely opposite. You'll find that one of the classic dialectical moments used by Brecht is the small scene in *Mother Courage* where everybody is dying and bleeding, and they are playing a toy march over it.

This, of course, has been taken over by Hollywood. The classic Hollywood irony is to set up a counterpoint musically. The trick is you understand that music always tells you what to *feel*, and acting and dialogue for the most part tells you what to *think*. So, if you're told to feel one thing and told to think another, then at least you make a choice about what is *really* going down. You have to decide whether your mind is telling you the truth or whether your emotions are. Usually, it's neither. Usually, it's some synthesis of the two.

Theatre does not exist on the stage. Theatre exists in your head. And what you see on the stage—and this is my *favorite* number, here, but I *really* believe it—is about fifty percent of what you perceive as the theatrical experience. The other fifty percent is a predilection in your mind to see things a certain way.

You see someone on the stage that is handsome, and you want to *believe* that he is a good person, because he is handsome. So,

your mind says, "If that guy is cool-looking, he must be a real good guy." Or, if she's beautiful, then she must have a big heart. It's the fairy-tale view of life. That viewpoint is embedded in your mind in a Kantian way. So, when you see theatre, when you are presented with an image, it is then counterpointed by what your mind says *should* be taking place on the stage.

In other words, half of you is seeing what you *want* to see—your programmatic idea of the stage—and the other is what the stage is feeding you. These things go like this. *(Joins hands together.)* And so if your mind is going to change, the powerful image of the stage is going to adjust what that program is in your mind. But the theatre takes place here. *(Taps his head.)* That's the theatre experience. It's not here. *(Points to the stage.)* This is only half of it.

But going into this half *(indicates the stage again)*, *that* splits also. The music might tell you, "This is very sentimental"—we do this all the time in *DollHouse*, we use Edvard Grieg, you know, underneath Ibsen. (It's actually an in-joke because after *Peer Gynt*, Grieg vowed that he'd never work with Ibsen again as long as he lived. So we have to *smash* them together later, after death.) But in any case, the idea here is that in Grieg's sentimental, romantic view, we have *one* look at things; and then we have the visual image, where all the men in this production are no more than three-foot-five, three-foot-six inches tall. So, you see these little actors, and then you hear this romantic music that sounds like a Valentino movie, you get this wonderful balance of irony.

There are *tremendous* options for humor here, and there are also tremendous options for being moved in a way that you wouldn't really expect. One of the comments that always gets me off is when someone in the audience says, "I didn't know whether to laugh or cry at that particular moment."

So, what you have is a synthesis of this dialectical approach in which you are choosing what the *statement* is, what the *message* is, after the balancing of the *thesis* and *antithesis*, in order to make your *synthesis*. And then the entire stage image works as a thesis, your mind is an antithesis—or vice versa—and the synthesis is the new

you: the "post-viewing-of-this-production *you*," as opposed to the "previewing-of-this-production *you*." This is when you say a piece of art changes your life. People have told me that *The Gospel at Colonus* did this for them. That they looked at theatre differently after that show. That's what happened to their head: It got adjusted just a little bit.

So, that's what I'm looking for. I'm looking for it all the time. Less of that happens in *Peter and Wendy* than in any one of my other productions, because it's less political. It's more yin. I wanted to see how yin a production I could do. It's written and designed by two very talented women, Liza Lorwin and Julie Archer. So it really represents Julie and Liza's minds and work and philosophy.

So, we did that. And I thought, the way I can sign off on it is if it is euphonious, beautiful, and all of a piece. If I feel like I've done a beautiful bit of staging, then I can live with the fact that there's little or no politics in it.

I suppose if you wanted to stretch it, the political issue at work could be that it is a classist work of the English upper class, in which you have a nostalgic upper-middle-class woman who wishes that she didn't capitulate to join the system, but kept her fantasies alive that she had at five of being an "other," a "different," a lover of Peter Pan. The point here is that she can be a hippie, she can become a Lost Boy, she can go to Neverland, so long as she never gets to be over five. But as soon as sexuality enters into it, the system dominates, she's taken over, and everything locks her down. And it's very sad, but it's a very, very, very upper-class sadness.

I guess I *am* proud of it, because I think it *is* beautiful, I think it *is* well directed. I didn't write it, though. And neither did Liza, really. *J.M. Barrie* wrote it. He was a tour de force of the theatrical world. He was like a Truman Capote figure—bouncing along on top of British society. And this was really his only work of genius. His other plays are not anything close. This happens to draw from really deep down.

The story goes that J.M. Barrie grew up in Edinburgh—which is why we have the Scottish twist to it and the Scottish music—and his older brother died when he was about eight years old. And his mother went insane. She wouldn't believe that his brother was dead. In order to get his mother to talk to him, Barrie had to imitate his brother's voice. Which he did. So, when he was twenty years old, he was imitating his six-year-old brother. So, to have a mother, he could never grow up.

Peter Pan had a lot of sexual pathology. Barrie was supposedly impotent and had this actress wife, who got kind of frustrated and split. He became a kind of an upper-class barroom joke, because he was seen as the little man who couldn't *get it up*, not couldn't *grow up*. He was about four-foot-eleven He was part of the ilk of the British sophisticates—brilliant, very funny, wonderful comedian that had a serious sexual trauma earlier in life that inferred itself all the way through his life. But it probably made him commit himself to a deeper love of motherhood than anyone else who has ever written a story. I mean, the icon of motherhood is there—that's it. You know, Mrs. Darling . . . that's it.

He had this terribly tragic life. All the kids who were models for the Lost Boys and for Peter all died these terrible deaths. They were either gassed during the First World War, or committed suicide at Cambridge. His life came to a very tragic end in which all his dreams and all his fantasies just collapsed into dirt, death, disillusion, and blackness. He died depressed. It's an interesting story that was of course never dealt with in the Johnny Depp movie.

Anyway, this is what I did: Luckily, I had a grant to study the Bunraku in Osaka. The two Bunraku puppets in the production are Peter (lead puppeteer Basil Twist) and Hook (lead puppeteer Cathy Shaw). Bunraku is a classical form, in which there are three puppeteers—the master puppeteer doing the head, eyebrows, and left arm; the second puppeteer doing the right arm; the third puppeteer doing the legs. But they move as a dance team. It's considered a dance form. I think it is considered the most sophisticated puppetry

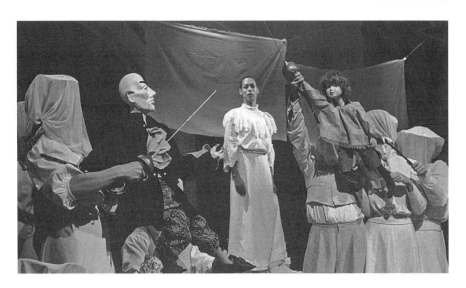

Peter and Wendy *at the New Victory Theater in New York City, 1996. From left, Jane Catherine Shaw (Hook animation and design), Karen Kandel as Wendy, and Basil Twist (Peter Pan animation). Peter Pan puppet designed by Julie Archer.*

in the world. They are rod puppets, but as rod puppets go, they're just unbelievably sophisticated.

There's also a religious overtone to Bunraku because the classic puppet has no body. It just has a wooden head and two wooden hands. It has an apparatus and it has cloth. The entire form of the body, including the feet—which are supposed to be made by wrapping your fingers in the cloth—is an *entire* illusion. So, it's very Zen in the fact that lying on the table it is a wooden head, and two wooden hands, and a piece of cloth, and the master puts his hand inside and creates life. But he creates life because he creates the *illusion* of life. This is the whole Buddhist take on existence—and the teaching is embodied in the art of Bunraku in that you can breathe life into something through formality and manipulation. This life is precisely illusion itself, and it can be withdrawn. And when it is withdrawn, all that's left is a void.

So, that's one half. The second part of it is another classical puppetry form called *wayang kulit*, which is shadow puppetry. It

originated in South India, but now it's centered in Java and Bali. In shadow puppetry, the *dalang*, the master puppeteer—who is, in a way, a priest—uses up to thirty voices. He takes every voice of every shadow that you see. This is the key to the idea of what [actor] Karen Kandel was doing. And it was phenomenal the way she did it because normally the *dalang* is behind a screen. He doesn't have to worry about acting a character, doing movement at the same time, turning upstage when the puppet talks, and then turning downstage when she's talking—manifesting cinema cuts in a way, so you'll follow who's talking.

We used some shadow puppetry, too. We used a little shadow of Jane, we used the shadow of the battle—that was stolen directly from *wayang kulit*. But for the most part, the visuality was Bunraku, and the audio was *wayang kulit*. Then I added my own twist, in that Karen played a character—the narrator—and she was visual—there was a visual impact of actually seeing her. She takes more the form of the master storyteller in Bunraku, who is a singer. And so she is more the storyteller, but a storyteller *within* the action, rather than the classical tradition of sitting outside the action and looking at it.

Julie Archer's wonderful design came from a previous work that she did five or six years before with Ruth in which she utilized this idea that a set could be made from book pop-ups. So, there were these various enormous numbers of books in which different parts of the set would pop up out of these books. The bed was a pop-up, the whole house was a pop-up. You know, that kind of deal.

So, given all of that, I think it fit together in a pretty wonderful way. But you see, it's adapted from the novel, *not* the play. I just had a strange fight with the dramaturg and the artistic director of Arena Stage. They thought there were three endings to our production. And I said, "Sure, there are three endings. It's a novel. It's not a play. It ends like a novel, and it's more sophisticated for having those three endings, and that's the way it's going to stay." And I said, "I know what you want. You want it to end with the duel and the death of Hook, and that would be great if it was headed for Broadway." Because, remember the applause we got for that? It'd be really easy

that if, when the lights came up after that, everybody was standing there for a curtain call, and the audience would stand up, they'd walk out, they'd have a ball. Okay. And thinking that way, it should also *start* with the flight to Neverland. So, anything that has any depth or information in it should be just cut out.

I said, "Yes, that's a great suggestion if it were going to Broadway. Unfortunately—or *fortunately*—it's not." And the dramaturg at Arena—who's an ex-Yalie—I embarrassed him a little bit by saying, "You know, that's a *Broadway* idea. It's not a *real* idea—it's a *Broadway* idea." And he finally understood what I was talking about.

But we just bumped flat out into this LORT consciousness, which is imitating the Broadway consciousness, which is basically the media consciousness, and on and on and on

Anyway, it is what it is. I'm proud of it. It isn't in any way really representative of my work. It's just what I can do if I want to make something beautiful. And I'm proud that I could do it. But it isn't really *my* work. But I am very proud of it. And it is one of the three plays I've done that I think in some way . . . oh, shit . . . how do I say this . . . ? In some way, this production, along with *The Gospel at Colonus* and *DollHouse*, has become part of the American theatrical canon. What does that mean? It means it's taught in about one hundred universities. It means it lasts in repertory for at least ten to fifteen years.

My model for this is Meyerhold. You create productions that actually become more iconic than the work they are based on. It's like *The Inspector General*. It's pretty hard to think of "*The Inspector General* from Gogol." If you are a theatre person, you think of it via Meyerhold's production, where you had thirty-five people stretched across the proscenium eating dinner, and throwing food at the audience, and stuff like that—these genius ideas. There are other examples of iconic productions: There was Peter Brook's *A Midsummer Night's Dream*. In a way, *A Chorus Line* was one. These things are iconic, they redefine theatre at the time, and they become more important than the literary event, even though the literary event is possibly a masterpiece—like *The Inspector General*.

That's what I'm pointing toward, and that's what I got closest to in these three productions. But I haven't been able to achieve that with original work because in order to get that acceptance, you have to rely on the muscle of a classic. And so, you are forced into this ballgame of being an interpretive artist. It can be *wildly* interpretive, *radically* interpretive, but it's still *interpretive*. It's not a wholly original work.

And therein lives the dilemma.

I think young artists have some very deep decisions to make. Sabrina Hamilton and I were talking in the car last night and, you know, Sabrina is another avant-garde artist.[22] Many of our instincts are similar, but one of them is not.

Sabrina has a festival that's very, very important, very, very specific, and she's never gone into the red with that festival. I have never been out of debt since I was sixteen years old. That's years of debt. Those are two different paths. I can't ever envision not being in debt. I got a MacArthur, okay? And I was in debt the year after I got it because I threw all the money into an enormous $100,000 piece. Lost all the money. It's either I'm a terrible gambler, a terrible businessman, or else there's something about taking that kind of a chance that produces the emotional edge that I need to work.

So, you gotta figure out whether you're a blacker or a redder. You gotta think about how you're going to proceed, because there's two different ways. I say I'm a redder because I want to work bigger, wider, more flamboyantly than I ever could do as a blacker. And I don't want to wait. People say, "Yeah, but look at all the stress you're under. Look at all the crap you're dealing with. You got the IRS down your neck, and this, and that." And it's absolutely true. It's a toss-up. And it's probably the core decision you will make all your life. Are you going to go into academia? Okay, but if you teach, are you really going to have enough time to really be an artist too?

22. Sabrina Hamilton is artistic director of the Ko Festival of Performance in Amherst, Mass. For many years she worked with Mabou Mines as lighting designer, production manager, stage manager, performer, and assistant director.

These are the big decisions. But the question is, what is the most effective artistic stimulus you can find? Sometimes it's desperation. Sometimes it's debt. We've seen that by looking at this European model that it's usually *not* security. Security can be the end of it all.

People have asked me recently if I would have made any different decisions. I'm seventy and I've been in the theatre for fifty years. And if I lived it all over again, I think there are very, very few decisions I would have made differently. I've seen too many of my other friends who made the other decision—you know, I'm going to take, like, two years and do an HBO series, or this, or that. Or try to hustle a film. Or direct at Lincoln Center. Or any pile of other idiot things. And they never come out of it. It's like you go underwater and you never come up again. And when they do come up, they're scared. I've seen this over and over again—you do two or three TV scripts and you come back and then you try to hit a big avant-garde thing again, and you've lost your edge.

It's curious, but I really feel that I'll be happy as long as I can keep my edge. And it's pretty much in the hands of God how long you're going to get to keep your edge. I'm seventy. Next year I could lose it. Five years from now.

There are certain artists who have the tremendous luck to continue to grow until they die. Kind of like dying in the saddle. Dante was a classic example. He wrote the last four stanzas of the *Divine Comedy* in the last two months of his life. They found them in his drawer after he died. On the other side, you get the burnouts like Fitzgerald who are finished at thirty-six. Great artists who crash early and then fall apart. I hope to God I'm more the first than the second. It keeps making life a very exciting thing to be part of.

Other than that—it ain't.

CHAPTER TWO: THE ANIMATION OF ASHER LEOPOLD

BY STEPHEN NUNNS, 2004

WITH INTERRUPTIONS FROM BREUER'S *THE RED HORSE ANIMATION*, 1970

OUTLINE	**LIFELINE**	**STORYLINE**
WHY PRETEND I CAN DESCRIBE MYSELF . I CAN SEE MYSELF IN EVERYTHING THAT WALKS AND TALKS AND CRAWLS ON ITS BELLY . OR JUST LIES THERE .	WHY PRETEND MY ACTS MEAN ONE THING RATHER THAN ANOTHER . WHY PRETEND IT'S ALL LAID OUT LIKE THE LINE ON MY HAND .	WHY PRETEND TO BE ORIGINAL . IT'S SO MUCH WORK .[23]

Lee Breuer has often been referred to as the consummate Californian artist.[24] He's also often thought of as a member of an elite New York avant-garde. But actually, Breuer's early biography is considerably more complicated and less bicoastal.

23. Breuer, *Animations*, 29–53. All capitalized text in this section is from *The Red Horse Animation*.

24. See Richard J. Stayton, "An Interview with Lee Breuer," unpublished manuscript, 1980, and Bonnie Marranca, introduction, *Animations*.

"Why's everyone think I was born in California?" he asked *The Village Voice* arts editor Ross Wetzsteon in an interview back in 1987. "I was born in *Philadelphia*." But then Breuer points out in the same interview, "I consider myself a Southerner, a Southern Jew as a matter of fact."[25]

A look at Breuer's biography demonstrates that trying to pigeonhole him regionally is a fraught and ultimately pointless exercise—not only because of his family's transience, but also because Breuer's life changed—and he pretty much reinvented himself—at the age of sixteen.

HOW I USE MY IMAGINATION .

I REMEMBER NOTHING . WHERE I CAME FROM . HOW I GOT HERE . NOTHING .

OUR FIELD . GOOD . THE FENCE . THE WATER . HOW I MAKE IT ALL UP FROM THE BEGINNING . MY BIRTH . MY OLD SIRE . THE NIGHT . HOW I HOLD ME IN MY ARMS AND TELL ME A STORY .

Asher Leopold Breuer was born on February 6, 1937, the only child of Joseph, an architect, and Sara. Joe Breuer was not very much of a presence during Breuer's formative years. "I never saw my father more than one day a week right up until I was five years old," he says. "He was always working in New York and traveling a lot during World War II."

As a young man, Joe Breuer demonstrated a lot of promise. He'd had aspirations to be a visual artist, but ultimately decided it would be far more practical to study architecture at the University of Pennsylvania. While a student at Penn, Joe lived the life of a typical, young, 1920s petit bourgeois socialite. "He had a fucking *Stutz Bearcat*," says Breuer. "He even had a *raccoon coat*. He was sitting on the top of the world when he was a student—eighteen or nineteen years old That was when my parents got married."

Sara Leopold (Lee's name derives from his mother's maiden name) was considered a bit of a catch—though a complicated catch.

25. Wetzsteon, "Wild Man of the American Theatre," 23.

"I saw a picture of her when she was a child," says Breuer. "She was an astonishing child—no question about it. She had little curls; she had these little Mary Janes; a frilly little dress . . . she was a perfect little doll." Sara was an only child, and her father owned a clothing store. As Breuer puts it: "It was typical Jewish garment industry shit. Married his first cousin. Typical deal."

And yet there was something not-so-typical going on. At age fourteen, Sara announced that she needed to leave the family, and, oddly, the Leopolds offered up little resistance. They sent her to the Goucher School, a private girls school in Pacolet, South Carolina. Despite health problems—she developed diabetes insipidus while at the boarding school—she finished with top grades, earning herself a place initially at Vassar College and then, eventually, the University of Pennsylvania. While in college, Sara—who had aspirations to be a writer in the Fitzgeraldian style—got a job as a columnist for a local newspaper. But she soon tossed all of it away, quitting the job, leaving school before graduation, and marrying her college sweetheart, Joe Breuer. From that time and for the rest of her life, Sara had little contact with her father. She did not speak to him again until he was on his deathbed.

It was not until fifty years later, at age eighty-nine, spurred on by watching Anita Hill's testimony during Clarence Thomas's confirmation hearings for the Supreme Court, that Sara acknowledged to her son that something insidious had happened to prompt her disengagement from her family.

"She told me that her father had a business associate that used to come over and make her sit on his lap," says Breuer. "He would feel her up. And she was too horrified to tell her father. She said she never told anyone about that.

"Well, putting two and two and six together, my fantasy is that it was *her father* and not a business associate. I feel like there was covert intent there. But there was something between her and her father, because she *demanded* to leave home at age fourteen.

"There had to be some kind of weird bullshit going on," he continues. "A good, middle-class Jewish girl, first-generation Ameri-

can, running off from the home, not finishing college I mean, she had a *career* . . . she had a column in the local newspaper with her picture on it when she was eighteen. And to run off and get married and then be a housewife?"

I GET MOVING AGAIN .

AND STAY ON THE TRACK . I ENTER A GORGE . THE PATH RUNS ALONG A STREAM . I CAN SEE MYSELF . IN THE STREAM . MOVING ALONG WITH ME . SAY . IT IS MY IMAGINATION . SAY IT . MY REFLECTION IS MY IMAGINATION .

Meanwhile, Joe Breuer's upwardly mobile trajectory at the University of Pennsylvania was about to be derailed when he received an emergency missive regarding his own father. Max Breuer, Lee's paternal grandfather, was a tiny dynamo of a man who had originally worked as a woodcutter in Hungary. Breuer family folklore claims that Max, who had a temper of legendary proportions, got into a nasty fight in his native country with another woodcutter that culminated in him hitting the man in the head with an axe. Figuring he had killed the other worker, Max's family got him out of the country as quickly as possible (family legend says twelve hours), and Max Breuer hopped a steamer for the U.S. When Max had finally made it through immigration at Ellis Island, he looked up a cousin who was already entrenched in the Lower East Side of Manhattan. Upon arriving at the apartment, the cousin informed Max that the other woodcutter had actually recovered from his injuries, and was doing fine.

Max Breuer eventually settled in Wilmington, Delaware, raising a family, opening a successful candy and tobacco store, and dabbling in real estate. The Breuer family was upwardly mobile at that point, but during his son Joe's tenure at the University of Pennsylvania, Max got wind of the fact that the DuPont Company—Wilmington's cottage industry—was going to expand its operations and was planning on buying real estate around its current factory. "Max bet they were going to expand to the west," says Lee. "He borrowed every dime he could from relatives and from his cronies at the synagogue and bought up all these old buildings and lots west of the fac-

tory. When he had mortgaged himself into the grave, he found out that the DuPont Company had decided to expand east.

"He died of apoplexy a few months later. It's a very middle-European joke."

Joe Breuer, who had been living the life of an upper-middle-class Ivy League college boy at Penn, headed back to Wilmington to deal with his father's bankrupt candy store. According to Lee, Joe spent the rest of his healthy adult life paying off his father's debts, working nights while running back and forth between Penn and Wilmington, trying to finish school.

Upon his graduation, Joe got work in New York as an architect for Macy's department store during the company's expansion into other markets. "My parents went to Broadway shows, art openings," says Breuer. "They played their part." But as the Depression took hold and finances became scarce, Sara, now pregnant, moved to her mother's house in Wilmington while Joe stayed in a room in New York to work. Lee was born in Philadelphia in 1937. "I was an only

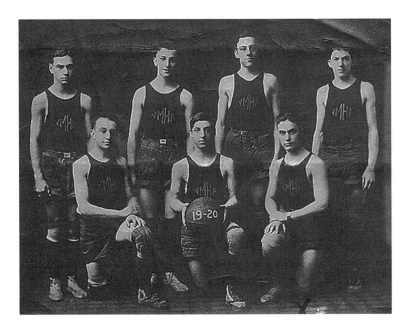

Joseph Bloomingthale Breuer, bottom right, with the YMHA basketball team, Wilmington, Delaware, 1926.

child because she wasn't supposed to have children because of her diabetes," says Breuer. "But they cheated and had one. I always wanted a brother or sister. I was always lonely."

The Breuers moved constantly during Lee's preschool years, though most of his childhood was spent south of the Mason Dixon Line. Joe Breuer joined the Marine Corps as a military architect, and Sara and Lee followed him to a variety of bases in North Carolina and Virginia.

"I was very secure when I was about five, because I was living in a beach community in North Carolina on the Cherry Point marine base," Breuer recalls. "I remember a lot of images from World War II: We had blackouts; there were subs that were torpedoed; bodies used to wash up on the beach. There was a big U-boat scare But I loved it. I was a little beach tyke."

ARABIC NUMERAL ONE .
HOW I GET A LITTLE
DRAMA INTO MY LIFE .

Breuer's beatific beach-boy lifestyle ended in 1942. His father was deployed to a base in Oklahoma, and Breuer's mother balked at the idea of relocating there. Instead, Sara packed up Lee and his grandmother and headed to Chicago, where the family lived in a hotel for six months while Breuer attended the elementary school at the University of Chicago Laboratory Schools. The American philosopher John Dewey founded the Lab School in 1896 and saw it as a petri dish for experiments in progressive education. Dewey saw education—along with everything else, as pragmatist philosophers are wont to do—as an intensely social experience, inexorably connected to real-world problems rather than obscure nonpractical theories. School was seen as a practical extension of the child's life—math skills were taught via recipes; history and geography were taught through field trips and explorations of the city; science and biology were taught through visits to local farms. Knowledge, in other words, was connected to real life.

The five-year-old Lee thrived in this new environment. "It was probably the hottest education I ever got," says Breuer. "We went to

farms and learned about how eggs developed We learned about the whole city We went to department stores, the library, the fire department."

The downside to the Lab School was that it was *too* good. Breuer excelled in Chicago and was actually reading by the end of his time there—most kids were lucky to be recognizing letters at age five. When Joe Breuer was relocated once again the next year—this time to Baldwin, New York, on Long Island—the family was reunited, but Lee's educational abilities placed him out of first grade, and he was moved into second.

"In a way, my bullshit started because of the Chicago experience. In Baldwin, I went into the second grade. So, I was already a year younger than everyone else in my grade. That was kind of deal-able. But, at that point, the New York school system was considered hot. So, the next year, when we moved back down to Virginia, they moved me up to the fourth grade. And then, the year after that, when we went to California, the school system was even *worse*, so they skipped me out of the *fifth grade*."

By the time the Breuer's finally settled in California—after a brief period in Portland, Oregon, where the elder Breuer briefly held a job as the main architect for Meier & Frank department stores— Lee Breuer was three years younger than everyone else in his class.

"I was in junior high when I was nine years old," Breuer says. "I had a hell of a time keeping up socially and athletically. I found out later that I was actually a reasonable athlete when I was in my regular age and weight group. But there I was playing J.V. basketball as a senior, when I was the same age as a *freshman*.

"I ended up having to bullshit my way socially with a peer group that was three years ahead of me. So, my motivation was to look cool—to fake it that I was older than I was—that I was hipper than I was—to be creative."

Today, Breuer sees the Chicago Lab School as being the reason for the creation of the "Lee Breuer persona." "Eighty percent of the articles that are written about me describe me as being half full of genius and half full of bullshit. You know: I'm a con man. Well, it

was the con man persona that *started* at that particular point. How does a fifteen-year-old look *eighteen*? How does a fifteen-year-old deal with *eighteen-year-old girls*? I became a con man—but also I was pretty bright and pretty creative, so my con was very elaborate and baroque. I was good at it.

"So, this persona, which is a huge part of my creative life, can be traced directly back to my kindergarten years in Chicago, where they taught me to read a year or two too-fucking-well early, bounced me a year ahead, and off I went into having to learn how to con to keep my nerve."

> THE MANNER IN WHICH I TROTTED BY MY
> SIRE'S SIDE . IN A CIRCLE . INSIDE HIS
> CIRCLE . ON THE THRESHING FLOOR .
> LEARNING ABOUT BREAD . MY SIRE'S NAME
> WAS DAILY BREAD .

Meanwhile, Joe Breuer's health had been on a slow but steady decline. His problems had started soon after his graduation from university—brought on in part from the stress of dealing with the remains of his father's debts. "By the time he finished paying it all off ten years later, he had hypertension," Breuer says. "He was addicted to rauwolfia"—a popular antihypertensive at the time— "which had this intense affect on him. It would make him very emotional and he would cry a lot.

"I basically never knew him when he was healthy," Breuer adds. "He was always a bit sick. And then just kept getting sicker."

> FIELD . FENCE . AND SO ON . MY BIRTH . FIRST
> SAW THE LIGHT . AT NIGHT . WEANED FROM
> TIT . TO GRASS . MY DAM . ONE OF THE HERD .
> YEAH . MEMORIES OF CHILDHOOD . YEAH .
> HAD IT FAT . PLAYED GAMES . PLAYED
> STUPID . THE BULL THAT USED TO JUMP THE
> FENCE INTO OUR FIELD TO DROP HIS LOAD .
> MY SIRE . HE ALWAYS ADVISED ME TO
> LEAVE WELL ENOUGH ALONE . BECAUSE IT
> MADE THE GRASS GROW . MY SIRE LIKED TO
> FEEL THE GRASS GROW . UNDER HIS FEET .
> MY SIRE'S NAME WAS DAILY BREAD .

Joe Breuer's professional life was not much healthier. The Portland department store job had been the family's chance to achieve real upper-middle-class status, but it didn't turn out as planned.

"For the first time he was the boss," says Breuer, "but he was never cut out for that—he couldn't handle the politics. He got canned within a year, because he refused to sign off on escalators that he didn't think were quite safe. They wanted to get a better deal, and he wouldn't sign off on it. So, they fired him."[26] The chain of events devastated Breuer's mother. "We'd bought the house," says Breuer. "My mother had bought the china. She thought she was going to finally live like the little Boston aristocrat she'd always wanted to be. But it was over."

> I GO THROUGH MY CHANGES . FORWARDS .
> AND BACKWARDS . SOONER . OR LATER . I'LL
> COME TO WHERE I AM . I THINK . I'LL COME
> TO MYSELF .

When the family relocated in 1947, Lee Breuer suddenly found himself thrust into a new, totally alien environment: Southern California.

"This was *California*," he remembers. "This was *the Valley*. This was *Hicksville*. If you've seen the film *American Graffiti*, that was it. That was what North Hollywood, California, was like in those days." Even his Chicago Lab School progressive education did not prepare him for Southern California, or, for that matter, 1950s America.

"What's interesting," says Breuer, "is that as a child of the 1950s, I realized that America was so *straight* and so *ridiculous*— this was the Eisenhower period. People didn't smoke pot yet, there wasn't the pill There was only one way out and that was to be an artist. That was the only way to get into your imagination, to *create* yourself in a certain way. It wasn't going to be hippie radical poli-

26. In an interview with Ross Wetzsteon in 1987 ("Wild Man of the American Theatre"), Breuer told a different version of this story—that it was an elevator that malfunctioned, and that a child died when the doors did not close properly. "My father, even though it's not his fault, he feels responsible—he just cracks up."

tics, you weren't going to do drugs, you weren't going to become an alcoholic. You just became an artist."

That being said, Breuer wasn't thinking much about art during his adolescence. He was more interested in other pursuits, more in line with a Southern Jewish kid coming up in the Valley in the early '50s. "I decided that the only way out was to be an anti-intellectual, to be a hood, to be a redneck like everybody else," Breuer says. "I detested the idea of culture. I couldn't let anybody know I was intelligent. Of course, my mother wanted me to get As in school, and I hedged—I got a few. But, you know, I didn't want to get the image of being a brain, and I also didn't want to be identified with a certain kind of Jewish persona, because there was a lot of anti-Semitism at that time.

"There were a couple Jewish kids around in high school who were brainy, and I became pretty close friends with them. But when I was in junior high—nine, ten, eleven, and twelve years old—and trying to make it in the Okie world, I didn't want to be identified as that kind of kid."

The Jewish/Christian split was intense, and Breuer, despite being three years younger than his peers, managed to maneuver his way through it—ending up on the Christian side. "There was also this Jewish/Protestant split in California at this particular point," he says. "The Jewish clubs were the AZAs [Aleph Zadik Aleph], and the Protestant clubs were the Ys [YMCAs]. Only a couple of Jews got into Ys, and I *happened* to be on the lowest level of a Y." Breuer just squeaked in. "I never could drink enough beer."

He eventually managed to talk his way into joining a local gang. "They were all Okies," he says. "They were rednecks. I was the lowest member of the totem pole, but I *was* a member.

"One guy's name was Snuffy. Snuffy's dad was a garbage man. The father of John Picard was a mailman. The father of Bill Waite was a fireman. My friend Chuck's father was a Baptist preacher. Chuck eventually joined the army. Bill became a fireman like his dad. Snuffy was a truck driver and eventually became a drunk. But the thing was, they accepted me as the lowest of the ladder of the gang. This was a very important moment in my life."

TWO .
IN WHICH I GET
INVOLVED .

> HOW I MAKE BELIEVE I'M NOT ALONE
> . THAT MY SIRE'S WITH ME . ALWAYS . I
> BELIEVE IT .
> I CAN CONTACT HIM .
>
> GOOD EVENING SIRE . CAN YOU HEAR ME .
> **YES** . CAN YOU SEE ME . **NO** .
>
> I FORGOT ABOUT THE BLINDERS . HE WORE
> BLINDERS .

OH YEAH . WORKING
BACK .

> MOVING ON . THINGS GO BY . I MUST BE
> MAKING HEADWAY . WHERE WAS I .

OH YEAH . GETTING
INVOLVED .

> DAILY BREAD COULD ALWAYS HEAR ME . I
> WAS NEVER IN STEP WITH HIM . BUT DAILY
> BREAD COULD NEVER SEE ME . OFF TO THE
> SIDE . HE WORE BLINDERS .
>
> HE COULDN'T SEE ME UNLESS I STOOD IN
> FRONT OF HIM . WHICH WAS IMPOSSIBLE . HE
> NEVER STOPPED . HE WOULD HAVE RUN ME
> OVER . HE COULDN'T SEE ME UNLESS I WERE
> TO BACK UP . IN HIS LINE OF VISION . RIGHT
> AROUND THE THRESHING FLOOR .
>
> I THOUGHT OF DOING IT . BUT IT WOULD HAVE
> BEEN INSULTING . AS MUCH AS DAILY BREAD
> WAS INTO BREAD . HE WAS MORE INTO CIRCLES .

After moving to California, Breuer thought that he was finally going to get to spend quality time with his dad. "That was the big thrill of moving to California—my dad was actually going to be around," says Breuer. "But it was that moment when he also started to seriously fade."

Joe Breuer's health had been getting worse and worse. Being fired from Meier & Frank had demoralized him and had taken a toll on both his physical and psychological wellbeing. By the time the family was in North Hollywood, the elder Breuer was in such sorry

shape that his new employer refused to put him on the company's health insurance plan. Breuer got sicker and sicker—mostly related to heart and blood pressure issues, but he was also experiencing vision problems—which demanded extended stays in the hospital, all paid for out of pocket.

"He was basically a good Jewish man," Breuer says. "And he was *horrified* that he couldn't make a living. He was *horrified* that his eyes were going and he couldn't draw anymore."

CONCLUSION . HOW I CONCLUDE .	THAT DAILY BREAD WAS OF THAT SPECIAL BREED . A HORSE'S ASS .
ITEM . HIS DILEMMA .	THAT HE COULD NOT SPEAK WHILE MOVING . THAT HE COULD NOT MOVE WHILE SPEAKING . AND SO EVERYTIME HE STOPPED TO START .
ITEM . HE GOT HIS ASS WHIPPED .	
	HE WOULD WORK A NIGHT SHIFT IN THE THRESHER ALL ALONE .
ITEM . HIS BRIGHT IDEA .	
	NOT ONLY COULD HE SPEAK HIS PIECE . HE'D MAKE MORE BREAD .
ITEM . HIS PRACTICALITY .	
ITEM . HOW MY OLD SIRE PROCEEDED FORTHWITH TO THE THRESHER .	
ITEM . THE ZEAL THAT HE DISPLAYED .	
ITEM . THAT HE GALLOPED .	THAT IT WAS A LEAP OF THE IMAGINATION . THAT HE IMAGINED . DAILY BREAD . WHAT COULD YOU HAVE IMAGINED . THE ROPE
ITEM . THAT HE LEAPED THE FENCE AROUND OUR FIELD .	AROUND HIS NECK TIED TO A STAKE STUCK IN THE GROUND . ITS LENGTH . THE LENGTH OF HIS LEAPING .
THE CRACK .	HOW IN MIDAIR IT CRACKED HIS WINDPIPE .

HOW HE SPOKE . THEN . FREELY .

WHO HE WAS SPEAKING ME .
TO .

 THERE WERE NO OTHERS IN THE FIELD .

 HOW I COULDN'T UNDERSTAND A WORD HE
 WAS SAYING . WITH HIS WINDPIPE CRACKED
 HE COULDN'T MAKE A SOUND .

THE WAY HE AND WAITED . ON ONE KNEE . DAILY BREAD .
CONCLUDED . WHAT COULD YOU HAVE BEEN WAITING FOR .
 APPLAUSE I'LL BET . HE WAS FULL OF THAT
 HORSE SHIT .

In 1954, when Lee Breuer was sixteen years old, his father died of an aneurysm in the brain.

"When he died, his last buck and his last breath were just about simultaneous. We sold the house We sold everything. It put us down to zero. I didn't get a dime of inheritance. I got Social Security until I was eighteen.

"And then I was on my own."

Sara Etta Leopold Breuer, Wilmington, Delaware, 1923.

A YELLOW STAR APPEARED . TIP OF HIS
TONGUE . WHERE THE WISE WORDS WERE .
THAT SHOULD HAVE BEEN MINE .
TRADITIONALLY . THEY WERE STILL IN HIS
MOUTH . I COULD TELL HIS TONUGE WAS
GOLDEN . I . BIT . IT . . OUT . . . AND . HAVING .
LEARNED . . NOTHING . . ABOUT . . . CIRCLES . . .

FADE .　　　　　　　　I . . STARTED . . . RUNNING

I LOOK DOWN . I CAN　　LIKE A REFLECTION . PULLING EVEN WITH
SEE MY STORY .　　　　ME ON THE SURFACE OF THE STREAM . I CAN
　　　　　　　　　　　FEEL MY LIFE AND MY IMAGINATION COMING
　　　　　　　　　　　TOGETHER .

ROMAN NUMERAL
THREE . I COME TO　　　AND HAVING LEARNED NOTHING ABOUT
WHERE I AM .　　　　　CIRCLES I STARTED RUNNING IN A LINE .

This was not the life Sara Breuer had anticipated. She had always had cultural and artistic pretensions—she had fancied herself a writer—but other than the newspaper column she had written when she was eighteen, she had never really been able to make these dreams a reality.

"She was a great romantic," Breuer says. "She wanted to be a writer. But she never had the guts to commit to being an artist." As a result, Sara Breuer focused on her son—he was to be her great work of art.

"She wanted to live vicariously through me," says Breuer. "My mother projected all of her desires for a creative life into me. But at the same time she was giving me double signals, because she also said she wanted me to be a nice Jewish lawyer—she had me convinced that I should be a lawyer. But meanwhile I think her image of what kind of a writer I was supposed to be was that I should look like Gregory Peck and I should be very Fitzgeraldian. It was all very WASP-y. Very 1920s. I was supposed to be a 1920s-style writer living in the West Village."

Inevitably, tensions were high between the mother and son, especially as Joe Breuer—who had never been much of a presence to begin with—retreated due to his health. "My family was gender-reversed a little bit," Breuer admits. "My mother wore the pants.

My dad was just a really sweet guy who really loved my mother and would really do whatever she wanted. It was simple. He tried to be a good husband and a good man, and he just got beaten down. He just didn't have the edge."

One perfect example of the boyhood tension stemmed from Breuer's involvement with his gang. On the first day of junior high, the boys had decided that they would arrive en masse at the school on bicycles—projecting themselves à la Marlon Brando and his cronies in *The Wild One*. "So, we all went on our bikes," remembers Breuer. "We took the fenders off; we put motorcycle handlebars on the bikes; we had long ducktails, Levis, white shirts We're all set to go . . . and my mother wouldn't let me." Her reason: Because the kids had to cross a set of railroad tracks on their way to school.

Breuer made a stink. He really wanted to show up to school with his rat pack. "So, what does she decide?" he asks. "She decides to try to *drive* the whole gang to school. I was just mortified. I thought it was the end of my social credibility."

The anecdote offers insight into the tension that had been slowly developing between Breuer and his mom. The tension was based on Sara Breuer's own dichotomies. While she regretted not becoming an artist—according to Breuer she had an image of herself as "a 1920s hot-shit motorcycle girl-poet kinda deal"—she also wanted to play it safe—longing for a cozy middle-class existence that precluded any radicalism. "She didn't have the guts," says Breuer. "She stayed a little Jewish frau.

"She was classic middlebrow. She always wished she had been from New England—from Boston. She wished she had a house in Cambridge. If not that, then she wished she could have been a Southern belle. Behind all this was the fact that she was an Anglophile."

I WAS NEVER WEALTHY .
NOT PARTICULARLY
STRONG . HAD LEANINGS .
ONE DAY I WAS LEANING
EIGHT DEGREES .
THOUGHT I WAS FALLING
ON MY FACE . BUT NO .
IT WAS EVERYTHING
AROUND ME LEANING
EIGHT DEGREES THE
OTHER WAY . THEN ALL AT
ONCE MY LIFE WENT FLAT .
ALL ALONG THERE'D BEEN
A SLOW LEAK . IN MY
SPACE .

Breuer had begun chafing at his mother's bourgeois sentiments even before the family had moved to California. "I really wanted to be poor when I was six, seven, eight years old," says Breuer.

"Kids still wore knickers back then," he continues. "I remember this kid—Tommy—I remember him shivering at school, because his socks were too short for his knickers, and he didn't have a jacket with a hood. Meanwhile, my mother had me wearing leggings; and she had me wearing a scarf; and had me wearing a hat under my jacket with a hood. I was all bundled up, sitting there, and wishing to God that I was poor, and cold, like Tommy, who reminded me of images right out of Buster Brown. I wanted to look like that kind of character. But really, I looked like a little putz."

Despite his attempts at rebellion, Lee found himself dependent upon Sara. "I think what became the issue with my mother was the enormity of the romanticism of her life at the time," he says, "and the same time her *tremendous* strength, which made me at times infantilized and emasculated. All the way up until UCLA she was correcting my essays before I'd turn them in. She was obsessive about punctuation. I would go into these crises where I'd be like, 'I don't know what the next sentence is!' I was *totally* codependent on her. I just couldn't get an original thought going unless she had signed off on it somehow."

ROMAN NUMERAL SIX .

> AS OPPOSED TO MOVING IT'S AT A
> STANDSTILL . IT'S LIKE A FEVER AS OPPOSED
> TO A CHILL . THERE ARE VOICES THAT
> I HEAR WHEN I'M NOT SPEAKING . I SEE
> THINGS . I'M NOT MYSELF .

HOW IN MY ILLNESS I MY LIFE SOMEWHERE . AND HOW IT COMES
SEE SOMETHING . TO ME THAT I AM A REPRESENTATION .
 THE WAY I SUSPECT THAT I'M NOT WELL
 REPRESENTED . THAT I'M NOT WELL .

ROMAN NUMERAL SEVEN .
SHOWING THE ILLNESS .

HOW THE RED HORSE . TEARS ITSELF APART . AND TRIES TO HOLD
 ITSELF TOGETHER .

> YOU'VE BEEN HERE BEFORE . HERE'S
> WHERE YOU STOP . THIS IS THE PLACE .

As Joe Breuer's health declined, Sara's idiosyncrasies were becoming more and more pronounced. She retreated—spending more and more time disconnected and alone, exhibiting signs of what eventually would be diagnosed as manic depression. "I think my father's illness kept her together," he says.

After Joe Breuer died, Sara went into a deep, downward spiral. "She's gone into this long depression. She hasn't gotten out of bed for three months. She knows it's too late to start another life without my father. And this doctor—I'm fifteen years old, my father's died practically yesterday—shoves a piece of paper and asks me to sign it. It's to commit my own mother.

"Fifteen years old, man. I've had two lives—before fifteen and after fifteen. Sometimes I think I'm so hooked into fifteen I'll never get past it."[27]

27. Wetzsteon, 24. Breuer is misremembering his age here. Joe Breuer died in January of 1954, when Lee was nearly seventeen.

LOSS OF CONNECTION .

NOW YOU JUST GO
THROUGH YOUR
MOTIONS .
NUMBER SEVEN .
DO YOUR SHOW .

HERE'S WHERE YOU CUT OFF . NO MISTAKE .
LOOK AT THE TIME . YOU STOP TRUSTING .
YOU CAN'T FEEL A THING .

WIPE YOURSELF OUT . OUT OF THE GORGE . GO
ON . INTO THE LIGHT . YOU CAN SEE YOUR
WAY . YOUR DUST . YOUR METHODS .

YOU CAN SEE THROUGH YOURSELF .

LOSS . OF CREDIBILITY .

NAME . THE RED HORSE . **BORN .** ELEVEN SEVEN .
NOW RESIDING . IN THE MIDDLE . **COLOR .** SEE
ABOVE . **BRIEF DESCRIPTION .** A ROMANCE .
NAME THE RED HORSE—

LOSS . OF IMAGINATION

I CAN'T HELP YOU . I CAN'T FIND YOU .

ITEM . LOSS . OF MIND .

YOU . LOSE . IT .

THE THEATRE AND ITS TROUBLE (EXCERPT 2)

58. Theatre's language comes up from the street and down from
 the church and meets. Noh comes down from Buddhist
 chanting, the Bunraku of Chikamatsu Monzaemon up from
 the Osaka tea houses; Shakespeareanisms come down from
 Anglican sermon and up from the "stews" on the Thames. In
 Latin Europe it is down from the Mass and up from Comme-
 dia dell'arte. A new vernacular language like Dante's is the
 beginning of the cultural nation. There is a language like this
 in America—as different in spirit from King James's English
 as Dante's Italian from the Latin of the Church. It comes
 down from Baptist and Pentecostal preaching and up from
 the ghettos. Black oratory, like music, is a four-hundred-
 year-old Afro-European synthesis. Is it Elizabethan English
 for the new world? At the moment it's drafting its history
 plays with the speeches of Jacksons and Kings.

CHAPTER THREE:
THE AVANT-GARDE KID

In which Breuer lays out an adolescent plan

FROM AN INTERVIEW WITH STEPHEN NUNNS IN NEW YORK CITY, 2001

When I was eighteen, I moved out of the fraternity I'd been living in when I started UCLA. I dropped the idea of pre-law. I moved in with my girlfriend—her name was Leah. She had quit school. She went to work and I went to school. And my life really changed. I wanted to write. I started taking a playwriting class at UCLA. I got a production done of my first play and it won an award. I was living with my girlfriend . . . was penniless . . . hanging out a lot . . . I was starting a pattern. But it was a complete break from the life I led before. I didn't want to be a bourgeois kid anymore. I wanted to be an *avant-garde* kid.

There's no question that I had one course at UCLA that changed my life. It was taught by a guy named Oreste F. Pucciani. The thing that was so hot about him was that he looked like Camus and wore Italian suits. And the first thing he said was: *(thick Italian accent)* "Theatre in Los Angeles does not exist." And I thought, "Ohhh, this is my man!"

In one semester I was introduced to the plays of Beckett, Genet, Giraudoux, Artaud, Sartre, and Camus. That was in *one* semester. I was so fucking excited. I couldn't get an A in that class, because I'd be taking a test, and I'd be still answering the first question and the test would be over. Pucciani said, "Well, you take this very seriously, but you're not very well organized."

That course changed my life. And then being able to work in this tiny little theatre on campus I was at UCLA in 1953, and there happened to be a little bungalow—'cause they hadn't built a theatre department—and that tiny little bungalow had a little theatre called 3K7. It had fifty seats in it. Complete rotgut. But they gave it to the kids. There wasn't a single professor that looked into a project there until its so-called opening night. We cast it, we lit it, we designed it, we performed it, we chose the plays—they were all original plays. I had three plays done there. And I was hooked for life. One of them got very well known, and it was a big . . . you know . . . it turned people on. And I was hooked for life. That was it.

So, it was a combination of the Oreste Pucciani course and being able to work in this tiny little theatre, being left *totally* alone, and doing anything I wanted, and that's how I was hooked.

Eventually I went to San Francisco, and one of the most important things in my life was the drug scene. I started looking at art differently after doing peyote and LSD. I started seeing composition differently. A mildly keyed-in psychedelic experience changed my way of looking at things.

It changed my confidence. When I first looked at abstract expressionism, I would *secretly* say to myself, "I don't understand that painting." But after drugs, I would go back and I would say, "I understand that painting, and I know I like that, and I don't like that, and I like that, and I don't like that" A little drop of acid changed my life? Well, it might have. I don't know. Actually, this was all pre-LSD. In those days, an Indian guy named Cowboy, the same Cowboy as in Jack Gelber's *The Connection*, would arrive from New Mexico with a burlap sack full of peyote buttons.

Being in San Francisco in the '60s was critical. It was like being in Paris in 1915. Just as many people died of drink in Paris as died of drugs in San Francisco. They were about the same. So, it was a very similar society. I had the luck of being in an interesting place at an interesting time. And that was the way my life got changed.

I was pretty much an autodidact. I did it myself. I was sixteen the year *Godot* was published. I read Camus's *The Stranger* that year too. When I was seventeen, I went all the way up to San Francisco just to steal a copy of *Howl* from the City Lights Bookstore. That went along with my image of wanting to be a beatnik.

I wanted to be an existentialist. I wanted to be a beatnik.

And this was all basically laying out a plan to get out of the United States. But that took some time.

CHAPTER FOUR: DOWN AND OUT IN PARIS AND LONDON (AND THE NETHERLANDS AND BERLIN . . .)

In which Breuer remembers Europe—with a poetic interruption

FROM AN INTERVIEW WITH STEPHEN NUNNS IN NEW YORK CITY, 2004

Ever since I was at UCLA and started reading existentialism, I wanted to check Paris all out. I wanted to see the Paris of Camus and Sartre—and of course it was all gone by that point. But it was certainly less gone than it is now. This was Paris in the mid-sixties. There was still a lot going on. We were there in '68.

What happened was that Ruth Maleczech and I eventually saved up enough money to go to Europe. We spent months going all over the place—and by the time we got to Greece, we were down to our last dime. We knew Philip Glass and JoAnne Akalaitis by that point, and after a hitchhiking trip along the Turkish coast, they came and took us back to Paris. Phil was on a Fulbright.

Ruth was going bananas because she hadn't acted in a year. And within a week of being in Paris, she got an acting job. They were producing LeRoi Jones's *Dutchman* in France for the first time. They were calling it *Le Métro Fantôme*. Ruth was cast in an English version that only played on Tuesday nights. All the black Parisian community would come down to see the English production, and

Ruth became quite a celebrity—she was great. People were scream-ing in the theatre when she pulled out a knife and killed this black guy on the subway.

Anyway, all the English film dubbers in Paris would come down to see the show and soon she landed the job of the voice of Catherine Deneuve in *La Chamade*. She did a great job, and finally we had a way to make a living. That was the way we could stay in Europe for four more years. We actually weren't in Paris that long—we just made enough money to go traveling again. We went to Morocco for three months, we were in Ireland for a month, we went to Scotland for a month, we went to Poland, Amsterdam We went every-where. And whenever we went broke, we would come back to Paris and Ruth would do a film. They loved her—they always had work waiting for her the second she got back.

On one of those trips, we went to Germany to see the Berliner Ensemble. It was amazing. David Warrilow and Ruth and I took the train and hitchhiked up to Berlin. We stayed in a little hotel near Checkpoint Charlie and we would walk across into East Berlin. After a while, we got away with just staying over at the Berliner Ensemble. We would sneak Beatles records to them It was great. And they were wonderful, we met all the Berliners. Helene Weigel was still alive and she did the whole mother thing with us. She welcomed us with open arms and said we could sit in on any rehearsal we wanted. We saw rehearsals of *Man Is Man*. And for the first time I saw mul-tiple directors working at the same time. There were five directors and then there was a kind of collective discussion about what should happen, and then they'd decide. A lot of the Mabou Mines method came from watching this collective work at the Berliner Ensemble.

Another image that we had to start the company with was Grotowski. Two of the founding members went to Aix-en-Provence in 1967 to study with him. They came back with a lot of wonderful ideas and then later went to Poland to talk to him.

You know, you gotta put that Grotowski training stuff in quotes. Ruth and JoAnne took a three-week workshop with Grotowski and never had another moment of acting training in their lives. I never

had one theatre course in my life. I was an English major. I think this game is self-taught.

Anyway, Grotowski said something really fantastic. At that time there were a lot of imitators—all these kids running around standing on their heads doing all sorts of weird movements and exercises. Then they started figuring that wasn't Polish enough so they all picked up Polish accents—all these little Grotowski monkeys running around. It was really pretty laughable because Grotowski had said, "If you really want to understand what I do, your work will look nothing like mine—absolutely not—because if you work from yourself, from your psyche, your heart, your imagination, your subconscious—it can't be me. If you start mimicking me, you're making a horrible mistake." I truly took that to heart. And I thought that the theatre I was helping to found at that point in time had to be a collaboration. It had to be all five of us.

Eventually, Ruth and I ended up in London. I was trying to figure out if there was a deal where I could start a company. We were thinking, "We don't want to go back to the States." But nothing had materialized in Europe. And then JoAnne called up and said, "There's *money* here"

The fact of the matter is, we rehearsed on welfare. We went on welfare for six months I couldn't get unemployment—I hadn't had a job . . . but I could get welfare. Imagine me, a healthy person, just because I had a one-year-old baby, could qualify for welfare? I mean, I'm white, college-educated, healthy—and still, I can get *welfare*? Of course the conservatives are ready to bump us all off! I mean, I could go pick up a welfare check and go to rehearsal!

One of the first things we did was the Beckett series at La MaMa. Ellen Stewart gave us a $50 a week stipend. We were all living on $50 a week. She got the funding for us from the Rockefeller Foundation. This is the way funding worked in those days: The guy who was running the Rockefeller fund at that time and Ellen would meet at the same séance. They had some mischievous woman who ran these

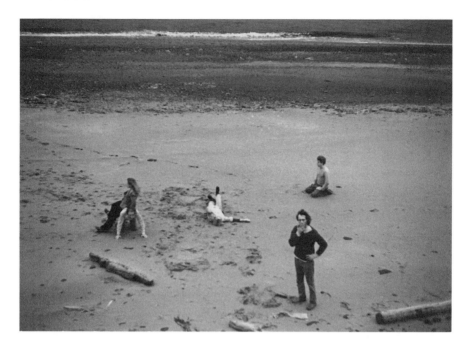

Mabou Mines, working on The Red Horse Animation, *Cape Breton, Nova Scotia, 1970. Clockwise from top right, Philip Glass, Lee Breuer, David Warrilow, Ruth Maleczech, and JoAnne Akalaitis.*

séances and they would meet there. All the big funding deals happened at séances. So, they'd meet at this séance, and this guy knew Philip Glass because he was involved in the music world. So, he and Ellen came up with the cash so that we could become a resident La MaMa troupe.

Ellen wanted another La MaMa troupe. She had a kind of Manifest Destiny. She was going to populate the world with La MaMa companies. And basically, that's what she did. She wanted to be the entrepreneur. She was an amazing producer.

CHAPTER FIVE:
MABOU MINES: HOW WE WORK

BY LEE BREUER, 1976

This essay, originally published in the first issue of Performing Arts Journal *in spring 1976, was supposedly a description of the working methods of the company in the 1970s. Breuer has recently disavowed it, claiming that it was written to capitalize on the romantic notion of collectivity and collaborative creation that was prevalent in the 1970s. "It was a fiction created with the sole purpose of making certain funders happy," Breuer now says. (He initially did not even want it included in this collection.) He has since acknowledged that Mabou Mines was less collectively organized than many people assumed at the time.*

Fiction or not, it's an interesting piece of writing, one that catches the zeitgeist of that specific period, coming out of such (supposed) collectives as the Living Theatre, the Open Theatre, and the Performance Group.

RECENTLY SOME PEOPLE HAVE ASKED US HOW WE WORK. WELL. HERE'S HOW WE DO IT. USUALLY TWO OR THREE PEOPLE ARRIVE AROUND ELEVEN THIRTY. THOSE. USU-

ALLY. WHOSE KEYS DON'T WORK IN THE STUDIO LOCK. OR IF THEY WORK IN THE STUDIO LOCK THEY DON'T WORK IN THE FRONT DOOR. THESE ARE BAD DUPLICATE PEOPLE AND THEY GET PISSED OFF AND GO HAVE COFFEE AT THE BINI BON.

THE WORK HAS BEGUN.

CHOOSING THE BINI BON WHICH DOESN'T HAVE A TELE-PHONE OFFERS THE REHEARSAL EFFECTIVELY INTO THE HANDS OF GOD. WHEREAS. HAD THEY CHOSEN THE HEBREW NATIONAL ACROSS THE STREET. AND. SPIGOT-ING DIMES INTO SLOTS. TRIED TO FORCE THE ISSUE. THE ENTRY. THE MOMENT. WHICHEVER WAS MOST FORCIBLE. ALL WOULD BE BLOWN.

THAT TACK WOULD HAVE CONDEMNED FUTURE INTER-COURSE TO THE COOLER OF REMORSE RECRIMINATION AND THE GENERALLY SNOTTY REMARK.

ACCESS IS GAINED. AS A RULE. NOW. EVENTUALLY. BUT BACK WHEN WE WERE AT 22 READE. BEFORE THE IDEA WAREHOUSE BURNED DOWN. SOME OF US WOULD GET IN. AND THEN SOME MORE OF US WOULD GET LOCKED IN THE FREIGHT ELEVATOR. IN THOSE DAYS WE'D WORK TOWARD EACH OTHER FROM BOTH SIDES OF THE ELEVATOR DOOR.

AND FOR COUNTERPOINT. CALL OUT THE WINDOW TO THE LAST OF US STILL ON THE STREET. WHO. THEMSELVES. WOULD SHOUT INTO THE SUB BASEMENT FOR GENE THE SUPER. WHO. HIMSELF. WAS PLAYING HIS FENDER BASE WITH THE VOLUME UP.

THAT WAS NICE. THAT WAS SHOW BIZ. A KITE CORD OF INTERACTION UP ELEVATOR SHAFTS. DOWN DRAINPIPES. INTO THE SUB BASEMENT. THAT WAS WORK.

ENOUGH NOSTALGIA. BACK. NOW. IN THE STUDIO WE SEE
TO OUR PERSONAL COMFORTS. DAVID DRINKS THE FIRST
OF TWO COFFEES HE HAS IN A PAPER BAG. AND DOESN'T
TAKE OFF HIS COAT. BILL READS THE ENQUIRER. I STAND
BY THE RADIATOR. IF THERE'S NO STEAM I MOVE OVER
TO THE HEATER. I STAND THERE TILL IT BURNS MY PANT
LEG. THEN I SQUAT DOWN TILL IT BURNS MY BUTT.

THIS IS TENSE. THIS IS ABOUT FINDING IT. "IT" BEING
ALMOST THE SAME "IT" AS THE "IT" IN "LOSING IT."
THOUGH NOT IDENTICAL DUE TO "ITS" EVOLUTION IN THE
TIME OF "HAVING IT."

JOANNE RUTH AND TERRY DRIFT INTO THE BABYSITTING
BUDGET. ONCE RESOLVED. CASH FLOW IS EXPEDITED BY
SIGNING OVER TERRY'S WELFARE TO FRED WHO PAYS HIS
UNEMPLOYMENT TO THE ORDER OF JOANNE. (WE ARE A
STATE SUPPORTED THEATRE). WHO THEREUPON DISTRIB-
UTES BY PERSONAL CHECK. APPROPRIATIONS. WHICH. IF
BEFORE FIVE O'CLOCK AND AFTER THREE. CAN BE FUN-
NELED THROUGH JOE'S CHECK CASHING ACROSS FROM
THE 14TH PRECINCT. AND WILL BE EVEN MONEY NOT TO
BOUNCE WHILE THE DOLE CHECKS CLEAR. IT IS UNDER-
STOOD THAT THIS ENTIRE TRANSACTION HINGES UPON
JOANNE REMEMBERING HER CHECKBOOK. FAILING THAT.
RUTH USUALLY TRIES TO BORROW FIVE BUCKS FROM
LINDA TO COOL OUT LESLIE.

THOM SITS VERY STILL FOR UPWARDS OF THIRTY MINUTES
STARING AT THE WALL. NO. STARING. ACTUALLY. AT THE
LIGHT SWITCH ON THE WALL. THEN WITH NO CHANGE OF
EXPRESSION HE GETS UP AND TURNS THE LIGHTS ON.

WE LOOK AT EACH OTHER. VERY BRIEFLY. THEN FRED
PUTS ON HIS HAT AND LEAVES. IT'S ABOUT THE PARKING

METER. FRED USUALLY PARKS TEN OR ELEVEN BLOCKS AWAY WHERE THERE'S AN INCLINE. IN CASE OF A DEAD BATTERY. WHEN HE BRINGS IN HIS CAR. AND EVEN WHEN HE DOESN'T HE STILL SEEMS TO ENJOY THE WALK TO THE PARKING METER. AND BACK. AND TAKES IT OFTEN.

THIS IS HOW WE WORK. WE WORK WITH A LOT OF DOUBT. AND SOME FEAR. BECAUSE REPEATING OURSELVES IS NOT REALLY ACCEPTABLE ANYMORE. AND KIDDING OURSELVES IS NOT. AS IT USED TO BE. SO EASY. FEARS THAT ANY PRESENTATION OF OURSELVES. THIS PRESENTATION OF OURSELVES. FALSIFIES. HYPES. MILKS. PURPLES. FAILS. AND THE THOUGHT OF JUST NOT BEING ABLE TO CUT IT HANGS PALPABLY DAMOCLEAN.

WE ASK OF OURSELVES SOMETHING PASSABLY ORIGINAL. PASSABLE. LESS. TO THE OTHERS OF US SITTING THERE PASSING ON IT. THAN TO OURSELVES. PASSABLE IN THE SENSE THEN THAT PASSING ON BE PERMITTED. AND ANY. REALLY ANY. ABSOLUTELY ANY WAY WE CAN GET TO IT IS HOW WE WORK.

AND THE QUAINT EFFECTS. RITUALS. AND PROCEDURES DESCRIBED ABOVE. COUNT THE TIME DOWN EFFECTIVELY AND WITH MINIMAL PRETENSE AND COMMOTION UNTIL SOMETHING HAPPENS. SHOULD IT EVER. EVER AGAIN.

WHICH IS TO SAY TO OUR STUDENTS. OUR COHORTS AND FRIENDS. AND OTHER INTERESTED PARTIES. THAT WE DON'T REALLY PRACTICE WHAT WE TEACH. WE TEACH THE SMORGASBORD. BECAUSE THAT'S WHAT ACADEM- ICS PAY FOR. AND WE NEED THE BUCKS. THE SMORGAS- BORD IS A FAMILIAR BUFFET. SAY PLATTER BY PLATTER LEFT TO RIGHT TO FRONT ROW. GROTOWSKI PLASTIQUES AND CORPORELLES. BRECHT DISTANCING THEORY. SOME-

THINGS LIKE BIOMECHANICS. MASKING. MOTION-TIME VARIABLES SLOW FAST AND CADRED. KATHAKALI AND BUNRAKU STAGING IDEAS. NEW DANCE. MINIMAL ART. SPORTS. NOTABLY BOXING AND FOOTBALL. FILM TECHNIQUE AS THEATRE METAPHOR. THE VISUAL PUN. REAR LEFT TO RIGHT. PSYCHOLOGY AS PERFORMANCE LOGIC. FORMALISM AS A PERFORMANCE LOGIC. ROCK AND ROLL. NOTABLY LITTLE RICHARD. NEW MUSIC. NOTABLY PHIL GLASS. PERSONALIZATION AS STANISLAVSKI EXPLORED IT. DEPERSONALIZATION. PROCESS ART. SOUND AND RECORDING TECHNOLOGY. POP. MIXED MEDIA. UNMIXED MULTIMEDIA. THE LANGUAGE OF SAMUEL BECKETT. ARC WELDING. (THAT DIDN'T QUITE WORK). COLLABORATION. VIRTUAL ISOLATION. EVEN GOOD OLD TIMING AND CHARACTERIZATION IN OTHER WORDS. THE STUFF WE'VE PLAYED WITH. THE THINGS THAT HAVE WORKED FOR US.

WE DON'T KNOW WHAT WILL WORK. CHANCES ARE. WHAT HAS. WON'T.

WHICH IS TO SAY. WE DON'T KNOW HOW WE WORK.

FOR A GIVEN BODY OF MATERIAL. ON A GIVEN DAY. FROM A GIVEN POINT OF VIEW EMERGING FROM A GIVEN COLLECTIVE CONSCIOUSNESS. THE HOW OF HOW WE WORK MUST. TOO. BE A GIVEN. AND FOR EACH WORK AND WORK DAY. GIVEN ANEW.

THE THEATRE AND ITS TROUBLE (EXCERPT 3)

60. Theatre is fighting a Hundred Years' War with art. The motivational tradition versus the formalist! What's *good* in one is *bad* in the other. *Good* performance is *bad* acting. *Good* acting is *bad* performance. *Dramatic* time is cornball art. Abstract imagery is *arty* theatre. *Psychology* is too personal for art. *Conceptual art* is too intellectual for the theatre. This is an unholy war. Where theatre is still holy it is still necessary. Aesthetics shrivel in the pure light of necessity.

CHAPTER SIX:
BETWEEN ART AND PERFORMANCE

In which Breuer speaks of Mabou Mines and the art world

FROM AN INTERVIEW WITH STEPHEN NUNNS IN NEW YORK CITY, 1998

I've had about fifty jobs in my life, starting out as a janitor. I moved furniture. Phil Glass and I even had a plumbing company—I was the world's lousiest plumber's assistant. I was a dishwasher at Food, the SoHo restaurant where all the artists came. I was a coffee boy at Enrico's in San Francisco.

I basically was out supporting myself, but it was tremendous freedom for a kid that age. I could do what I wanted to do and go where I wanted to go. So what happened was I always had this fantasy that I'd make a living as an artist so I tried all sorts of places. I tried L.A. and then San Francisco then Europe. Europe was the easiest. But I came back to New York.

When I came to New York thirty-five years ago I was working in the art world. Not as an artist, I was moving art. Bill Raymond, the actor, had a moving company moving art from gallery to gallery in all these SoHo lofts. So, we were hauling all this art up about six flights. And I got to hang out with some really big guys like Oldenburg, Rauschenberg, and Serra. This was the heyday of the transition from

abstract expressionism to objective art where you go over to Jasper Johns, when art became postmodern.

So, you're moving from an ecstatic crazy emotionalism to a really objective cynicism that's almost Zen. A lot of this happened when it was the end of the real European post-Freudian influence and the beginning of meditative, let's be Tibetan about all of this, let's be Zen about all of this. This enormous cultural transition happened, and it produced a different kind of art with the idea that the *politics*, the *art*, the *play*, and the *concept* were the same thing that you look at from different angles. It was one organic *unity*, where the concept is the art. It's the *idea* that's the *art*. And along with that, many of these people began to represent this idea as simply as possible—make the idea pure without a lot of garbage about it. Like you write the idea on a sheet and frame it and *that's* the piece of art.

In the conceptual art world there were a lot of wonderful little tricks that artists used in the '70s. One of the tricks was to take everything *super* literally—the way they used language, which was totally different from the way the surrealists used to use language as a design element and how it fit into the composition. What the conceptualists did was they made ironic jokes about the titles of their pictures. I remember going to one guy's studio and he said, "Hey, come over, I'm doing flower arrangements." I went over expecting to see flowers and he was standing in the middle of the room with flour you bake bread with and he was arranging it all about—a real conceptual joke.

We came from the other side. We were basically theatre people who were interested in art and interested in the concept of performance, interested in the conceptual switch to the art world—the turnover from the '60s to the '70s. So instead of having abstract expressionism you have a conceptual, cooled-out, minimalist take on things. This was the art world aesthetic for at least ten years.

It was all minimalism and conceptualism—artists who felt that the main thing to be avoided at all cost was emotion. They were so rigidly intellectual—people like Carl Andre—all those bearded, corduroyed tough guys who never cracked a smile. They were very

bright and some of them were very good artists. But they were rigidly anti-emotional. The basis of their aesthetic was that you DO NOT theatricalize.

The art people just couldn't understand the value of theatre itself. They thought of theatre itself as corn. Once a work was acted, once it was emotionalized, they really couldn't tell the difference between that and soap opera. Theatre was all the same, and it just wasn't art. It was "folk art." I actually heard Richard Serra once refer to theatre as a "folk art."

Despite all this, in the 1970s Mabou Mines was part of the art world. We performed in galleries and museums, at the MoMA, the Walker Art Center, at the Whitney, at the San Francisco Museum of Modern Art, and a number of galleries like the Grey Gallery and the Castelli Gallery in New York. We did not actually enter a theatre for the first six years of our existence.

Now, we found that when we performed in a gallery, we had a different performance than when we performed in a theatre. We did the *B. Beaver* at the Paula Cooper Gallery and all the art world turned out, and it was the *coolest* performance. The humor was much more intellectual. Then we got into a theatre, and Fred's characterization became larger Things became far more emotional and theatrical. And you could just see that the art people did not want to go to the theatre and the theatre people did not want to go to the art galleries. And we had a foot in both worlds.

Joseph Papp at the Public Theater, perhaps the most famous producer of his day, the producer of *A Chorus Line*, came to see one of our productions and brought us to the Public Theater. He became our patron for the next six years. This allowed us to exist and develop our work on our own. At that time, we worked with a number of painters and sculptors who have become famous since, like Gordon Matta-Clark, Nancy Graves, Richard Serra, Tina Girouard.

Also composers: Philip Glass was mentioned; we worked with Keith Sonnier.

Once Joseph Papp brought us into the theatre, we started to change. We weren't just artists who decide they want to do some performance. We were theatre people who were interested in art as opposed to artists who wanted to get involved with theatre.

In the art gallery we found that the people interested in art were more intellectual, more astute in terms of the formalistic aspect, but they didn't want to feel. They were afraid of emotion, and so our productions became more formalistic and more intellectual. When we moved to the theatre we became more and more actor-oriented and started dealing much more with feeling, and hopefully we've skimmed the best of both audiences at this particular point. But it was very interesting how we had to change from one to another when we changed from the theatre world to the art world.

CHAPTER SEVEN:
AN ACTOR EVOLVES

BY LEE BREUER, 1977

This 1977 article from SoHo Weekly News *is one of the first critical analyses of performance art that was published in a popular publication. Breuer was reacting to a shift he was noting in most contemporary performance—a move best exemplified by the Wooster Group's production of* Rumstick Road. *Breuer was acknowledging that performers such as Spalding Gray were taking Stanislavskian character work and Grotowskian experimental performance to its logical end— that is, breaking down all of the distinctions between the character and the actor. As Breuer notes, in* Rumstick Road *(as with all of Gray's performance work), "Spalding is the text."*

Breuer's article captures the moment when performance art truly came into existence, and his analysis lays the groundwork for his own hybrid approach to the art of acting.

When I saw it a few weeks ago I realized that I wanted to say something about *Rumstick Road*, and in its context, something about the actor and the art of acting in experimental theatre.

Over the past decade the orbits of the theatre world and the art world have often caused the two to be perceived in states of partial or total eclipse. In art, the shadow of the theatre has produced "performance art." In theatre, art has formed the conceptualizing actor.

This is as big and important a current in the art of acting as was the development of motivational technique, and the notion of the Brechtian or "epic" performance. In other words, this is the third new idea about acting in this century.

Motivational acting is based on the idea that an actor feels something during performance analogous to the character's emotional stream and not simply performance hysteria. And Brecht's idea is that the actor "say something" in performance over and above the simple elaboration of character.

There are two schools of motivational acting, both based on the link between felt emotions and muscular responses which produce "expressions" in face and body, and tones and qualities in the voice. One, Stanislavski, is simply "emotion produces expression." The other, "expression produces emotion," is not directly attributable to the work of one person but often related to the work of Meyerhold, with roots going back to Delsarte. Oversimplified, they can be viewed as the "Be Angry and Look That Way" school and the "Look Angry and Be That Way" school. Techniques evolved toward subtlety, specificity, range, and sophistication. But no matter how proficient acting became, it never questioned its "role" as a technique to interpret given material.

Brecht didn't question it either. He just gave more material to interpret. Along with character and psychology, the actor was asked to comment on moral and political issues. But he *was* asked to have a point of view on his role, and in this task, the actor as *self* took a first step onstage.

The idea of the actor as creative artist began with Grotowski a little over a decade ago. Along with his highly publicized physical technique (an elaboration of biomechanics utilizing hatha yoga) came a few wonderful ideas.

1) The idea that motivational technique was not limited to the style of realism, that Brecht's solution to "style"—objectivity—was not the only one; that beneath emotions visible in terms of social psychology, i.e. "realism," lay others that became visible in subjectively abstract images akin to dreams. The implicit statement was: Actor, your life is your material.

Grotowski himself stopped short of taking the statement literally. The notion was revealed through superimposed texts. With *Rumstick Road* it's finally all out of the bag. The statement reads: "I'm my own material on all fronts—visually, vocally, historically, spiritually, psychologically, intellectually, and emotionally. I am myself and I create myself before you." Now the advent of the conceptualizing actor makes acting no longer an interpretative but creative art.

There is something Clean about the artist as individual practitioner. You have an idea—you write a book. You have an image—you make sculpture. In the collective arts, it's really messy. Not quite so bad in music where composing and performing capabilities often reside in the same individual.

But in the theatre it's crazy. Conceptualists and performers collect into two camps: the "here's what's to be said but I can't say it, you say it for me" camp and the "I can say anything about anything except something about myself, give me the lines, shut up, and consider yourself lucky" camp.

Elizabeth LeCompte and Spalding Gray in the medium of theatre follow that passage made in dance by Meredith Monk in *Education of the Girlchild* and by Yvonne Rainer in *This Is the Story of a Woman Who . . .* , works perceived by some as theatre too. But I see them as dance, in the sense that the acting is danced because the mind of the performer is coming from there, just as the dancing in *Rumstick Road* is acted, because it's coming from there, just as some theatre directors "paint" their productions while others "write" them.

Rumstick Road is based on material resident in the life, thoughts, and feelings of Spalding Gray and is centered around the performance of Spalding Gray. Use of documentary material—verbal and

visual and emotional—creates a conduit of impulse "unramified" by "creative" writing. Spalding is the text. And through this text are perceived the subtexts of Elizabeth LeCompte, Ron Vawter, Libby Howes, and Bruce Porter.

Rumstick Road is not only superlative work, but a manifesto of a kind of actor's liberation in a performance art too often linked with prostitution as the oldest profession in the world: the subprofession specializing in foreplay. Perhaps it is natural and fitting that acting evolves, with feminism, into a new phase. The piece is an image of the acting mind as distinct from the dance mind (Monk), the architectural mind (Wilson), the painting mind (Foreman), or the writing mind (Ludlam).

THE THEATRE AND ITS TROUBLE (EXCERPT 4)

37. There is no such thing as a director. There is only this thing of a *t'ing*. When you leave out the *h* you leave out one hemisphere, two worlds, and six continents because da Caribbean *t'ing*—in fact, any *t'ing* any place you find it—is really the *African t'ing* on a world cruise.

38. Have you ever met a director with anything to say? I doubt it. Have you ever met a typist with something to write about? There is no such thing as a director because directing, like typing, is a skill. Who you probably have met, in the theatre or on the set, is some creative individual, say, a poet (Brecht) or an actor (Stanislavski) or a painter (Wilson) with a tangential skill. You may have even met a producer. The art of producing is to work with certain materials called *realities*—real money, real people, real estate. It is a curious, difficult, and limited medium that cannot rest with truth and beauty. It can only succeed with success.

39. But your *t'ing* is not your skill. It is not even your art. Is it your song? Yes and no. Your sex? Is that the little *t'ing* itself? Your style, your totem, your phenomenological fingerprint? (If it is, you better figure out another way to say it or it gets to be another thing.) *T'ing* is your piece of the big picture puzzle given to you alone to lay with for a lifetime. *T'ing* is soul.

40. Poets of the oral tradition are pulled by the tongue's music away from the printed page. A writer with a directing flair is pulled into a love affair with *image*. In Japanese, *writing* and *painting* are the same word. Illustrated scrolls and

Egyptian tombs and Gothic windows, like comics and the movies, tell stories. We word pictographers live in a dream. We dream we are Fellinis training clouds of *lire*. In cruel reality we are cutters and splicers on an imaginary dole; we are the mixers who've never mixed their rock-and-roll.

CHAPTER EIGHT:
A SENSE OF DIRECTION

In which Breuer considers directorial vision and company tensions

FROM AN INTERVIEW WITH STEPHEN NUNNS IN NEW YORK CITY, 2001

Stanislavski was and probably is the big root for me. When I was twenty-one I had written three plays at UCLA and Ruth was in one of them. We then moved to San Francisco and within the first year Ruth had joined the R.G. Davis Mime Troupe, which eventually became the San Francisco Mime Troupe. And I was working at Enrico's coffee house where I got injured and got workman's comp. I got a tooth smacked out by an espresso machine.

So, I got a little vacation and I sat at home trying to write. But I got really lonely because Ruth was in rehearsal all the time. So, I started hanging around the Mime Troupe, connecting up with all the second-string Mime Troupers, which at that time was Bill Raymond, and Ruth, and a couple of other people. The Mime Troupe was situated in a peripheral way to the Actor's Workshop. Ruth and Bill wanted to audition for the workshop, and I decided that maybe I would try directing their audition. Well, in order to prime myself for this, because I'd never directed before, Ruth got me *An Actor Prepares* and *Building a Character*. I read them through

and through and I was totally fascinated by the idea of motivational acting.

Now here comes the hilarious part—the play I chose to work on was *The Caucasian Chalk Circle*. So there I was—trying to figure out how to direct Brecht by using Stanislavski.

What I put together was a really interesting union between external and internal work that I continue to work with. I had a lot of formal imagery from hanging around the Mime Troupe, but the acting was straight out of Stanislavski.

It was through the audition that I got an assistant directing job at the Actor's Workshop. Alan Schneider was there as a guest director and he saw the audition, and he went absolutely crazy for it. He loved it, and he talked Herbert Blau and Jules Irving into hiring me.

In the end, I got into directing through my Stanislavski/Brechtian version of *The Caucasian Chalk Circle*. And that was the start of my signature that eventually became a mix of Stanislavski and Meyer-

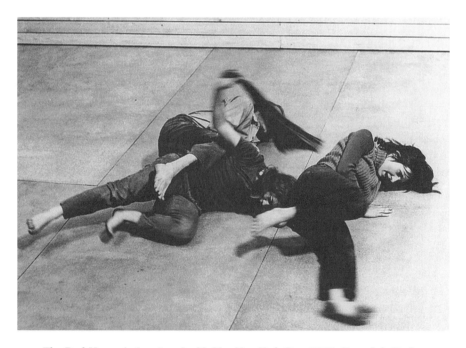

The Red Horse Animation, *La MaMa, New York City, 1970. From left, Ruth Maleczech, David Warrilow, and JoAnne Akalaitis.*

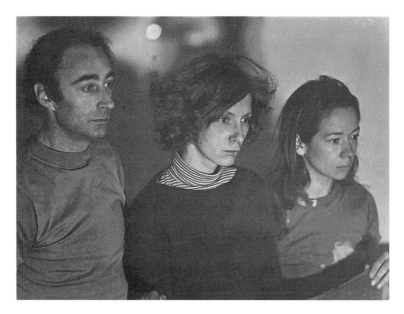

The Red Horse Animation, *La MaMa, New York City, 1970. From left, David Warrilow, JoAnne Akalaitis, and Ruth Maleczech.*

hold. I mean, years later I realized that Brecht had stolen everything from Meyerhold. So I wasn't really copying Brecht—I was copying Meyerhold and getting into the whole Meyerhold/Stanislavsi dichotomy. I was straddling these two guys, with the visual stuff coming from Meyerhold but still managing to have a motivational core and a truth—the sort of thing that Meyerhold didn't really care about.

It's a combination that Ruth was the best at. Maude was really good at it when she was doing *DollHouse*, where she had a high formal presentation and a lot of truthful internal work going on at the same time. Ultimately, it's a really sophisticated approach to comedy.

We're looking for a higher synthesis, a philosophical height where you can watch Maude weeping while you're giggling to death. I talked to many people who sat through the opera in *DollHouse* in Act 3, and they understood what was happening formally, but they were thrown off because the acting was still truthful and internal. A lot of these people said to me, "I didn't know whether to laugh or

cry." The thing is, if your mind is in a place where you don't know whether to feel sad or happy, then you are in a much better space to understand what is going on. Laughing *is* crying—it's the same physical response. It comes from the same places in the nerves. You stimulate a certain nerve, and you don't know if you are going to get a laugh or a sob. Either way, it's going to be a form of depressurization.

Anyway, when I think of my style, I realize that it started right there at the very first gig.

Though it might sound weird for me to say it, I've accepted that the Actors Studio is important to me, because I don't want to forget the fact that I owe everything that's different about my work from the rest of the avant-garde to my connection to the motivational tradition. Because the other people in the avant-garde, they don't know anything about motivational theatre. They don't give a fuck about motivational theatre. That's all Broadway crap, or, you know, Brando and the movies.

I learned a great deal from the conceptionalists that I was supposed to be a part of—Wilson and Foreman and people like that. Bonnie Marranca put us together in *The Theatre of Images*. But I realize that I'm fundamentally different from them in that I know something about acting. It's not just all about images. You know, ultimately Bob [Wilson] is a great designer and Richard [Foreman] is actually a really good painter. But they are just animating paintings and putting them into time. Their pieces are just temporal installations of paintings. And though I have a fair sense of how to deal with visualities, I am not a painter. And don't direct like a painter.

There's a classic American anti-intellectual aspect to the whole Method thing too, which is worth thinking about. What came out of it was that classic statement that actors don't need to think. But of course, that's purely political; because if actors don't have any brains, then directors are able to exert control. You establish this master/slave situation where a wonderful, exotic, emotional tool is put at the disposal of a Svengali.

The B. Beaver Animation, *the Public Theater, New York City,
1974. From left, JoAnne Akalaitis, Bill Raymond, Fred Neu-
mann, and David Warrilow.*

Mabou Mines was the opposite of that whole scene. We believed
that actors needed to be able to think. Even now, I really find it a
hard row to hoe with an actor who doesn't know how to think very
well, because no matter how emotionally available they appear, the
choices are often an issue. I certainly can't control every single act-
ing choice, and if an actor isn't very smart, then all that emotional
energy is going to lead them to start making bad choices. But when

you get an actor like Bill Raymond in *A Prelude to a Death in Venice*, or Ruth in *Hajj*, things like that, then it's a real kick.

But it can also get away from you.

That's what happened with Mabou Mines.

Throughout *The Red Horse Animation* and *The B. Beaver Animation*, we really had a truly democratic collaborative aesthetic.

Being the director, I found that I didn't actually have much more directorial control than the actors in the piece. And when that actor was really, really bright—like for instance, JoAnne Akalaitis—and had a different aesthetic than me, then we would get into conflict.

For fifteen years the word was out that *Red Horse* and *B. Beaver* were written collaboratively, because people thought everything that came out of Mabou Mines was collaborative. People were literally telling me that I didn't write the stuff. They were saying it was collaborative writing, collaborative directing, and so on. As a result of this, I wasn't trashed as a director—I was trashed as a writer.

There were people who called *The B. Beaver Animation* gibberish. But it wasn't—it was just because the play was so embellished with complicated staging, complicated movements, in-jokes, and art-jokes. I mean, this was the five superpowers—JoAnne, David Warrilow, Ruth Maleczech, Bill Raymond, Fred Neumann—and they were so good and so funny that we had a visual-paradise-*Goon Show* kinda deal. But there wasn't much left of the writing—it was in shreds.

So, when I started doing *Shaggy Dog Animation*, I talked to everyone about how I wanted to have more control. I wanted to be able to tell a story. I wanted it to hold up in a narrative way. But the thing is, when I said that to them . . . well, David left. And that was the last time JoAnne and I worked together.

There was always a little bit of a power struggle between JoAnne and me once she started to direct, because JoAnne represented a very different aesthetic. She really embraced the gallery scene, and

The Shaggy Dog Animation, *the Public Theater, New York City, 1978. From left, JoAnne Akalaitis, Rose (designed by Linda Hartinian), Bill Raymond, Terry O'Reilly, and Linda Hartinian.*

Philip Glass had a lot to do with that. He had a lot of influence on all of our '70s stuff—he brought new music into the bargain. I mean, we did *Music for Voices*—I *loved* that piece, but Philip was upset because he didn't think the performers sang it well. That's part of the reason why he left—he got exasperated that we couldn't sing his music right. He wanted trained musicians, and we couldn't really do it. We were riding on Philip's coattails, but there was no question that we were holding him back. I think he really just came to the conclusion, "Hey, it's easier over in Bob Wilson country."

He did *Einstein on the Beach* and that was that. He would do the occasional thing for us when we needed music, but he wasn't really associated with us anymore. There was much more credibility working with Bob Wilson, and you know, aesthetically, it was a much better fit. Bob's a formalist; he really doesn't care about acting

or characterization. I mean, if an actor wants to act something, that's fine, but it's not really his concern—his concern is how long it takes that actor to cross the stage. I suppose that's great for a composer. I mean, I'm not capable of understanding emotionally the importance of whether something is a half a second longer or shorter. Bob is. He can really go crazy over whether someone crosses the stage in twenty-seven seconds or in twenty-seven-and-a-half seconds. Me, I really don't give a fuck.

I think there was an aesthetic connection that Philip had with Bob that he didn't have with us. As far as Mabou Mines was considered, it became a much more theatricalized situation after he left. But we still had his influence through JoAnne. And as long as she had that sort of Glass aesthetic going on, she had the Glassites following her.

So, there was this tension between two aesthetics; between my kind of thing and JoAnne's aesthetic. Don't get me wrong—JoAnne contributed a lot to what made Mabou Mines great. She was ironic and wry and anti-emotional and funny and all of that kind of stuff. She was great. She was intellectual in a totally raunchy way.

Little by little, the other company members started to believe that the power lay with the director/writer. And out of that came the idea that everybody could do everything. I thought that was kind of bullshit. But the company embraced that illusion for a while. I mean, I'm the first one to admit that I am not good enough to act in a Mabou Mines piece. I don't have the chops to do it. It was purely political that everyone started directing, because they thought that was where the power lay. And they were right in a way.

Anyway, JoAnne, Ruth, Fred, and then Terry [O'Reilly] all eventually came to the conclusion that the key to their legitimacy lay in the director/writer combination. Curiously enough, it hasn't worked out that way with Ruth, because she has incredible credibility as a performer. And that has as much value as directing.

So, Mabou Mines was full of tensions. Everyone wanted to direct. Bill Raymond was directing. Greg Mehrten, too. And since

we basically produced one show a year, it was possible I could sit there for seven years until my turn came around. And so the next step that happened was that people worked outside the company because they didn't want to wait around like that. Also, some of us had bigger ideas than the company could afford to produce.

I still had the inside track because I had started out as the director/writer. And I had a track record for a few years being the only one. And so when I had to get in line behind JoAnne and Ruth and Bill, I found that other options came. *The Gospel at Colonus* came up, *Lulu* And when these other options came up and I did them, then we got into a big mess.

You see, after *Gospel* was such a big hit at BAM in 1983, some of the Mabou Mines funders thought I had left the company, and the money was withdrawn horribly. So, when we had a major crisis when JoAnne and Bill and everybody left, the company almost went bankrupt because people thought there was no real center anymore. I mean, JoAnne had left to do the Public Theater, I had left What was Mabou Mines?

CHAPTER NINE:
THE AVANT-GARDE IS ALIVE AND WELL AND LIVING IN WOMEN

BY LEE BREUER, 1982

In this 1982 SoHo Weekly News *article, Breuer acknowledges how the feminist movement of the '70s and '80s influenced and radically changed the American avant-garde. Indeed, from Breuer's perspective, avant-garde aesthetics not only owe a great deal to feminism; in many ways, feminist ideology was the avant-garde at this moment in time. He also notes the avant-garde's influence having an effect on a lot of different kinds of theatre (including commercial uptown work). And he seems to imply that the inviting of female artists to the table is in some ways responsible for the aesthetic shifts of that period.*

These are auspicious times for avant-garde theatre—now, today, next week, too. Because right now two plays are playing in New York: the Wooster Group's *Route 1 & 9* and Squat Theatre's *Mr. Dead & Mrs. Free*. And though both groups use a collaborative process (and in the case of Squat, present a defensively collaborative stance), try to distinguish the veins of the women—Elizabeth LeCompte, Anna Koós, and Evá Büchmuller—in the wall of the col-

lective mine shaft. (LeCompte directed *Route 1 & 9*; Koós edited
the film presentation of *Mr. Dead & Mrs. Free*; these dynamics and
associative choices set the tone of each production. Büchmuller per-
forms brilliant comedy and designed some of the decor and imagery
in *Dead/Free*.)

Try to distinguish the separate strains of these women's contri-
butions to their respective collaborations, and put them all together
in their own context. Try, because seen together they may mean
something important in charting the direction of the avant-garde in
the '80s. Anyway, *I'll* try. I have their permission to do so. (You need
some gimmick to talk about your friends.)

Koós, LeCompte, and Büchmuller are women in their middle
thirties. Look right behind them to two women in their early forties,
Ruth Maleczech and JoAnne Akalaitis, and to their productions,
Wrong Guys and *Dead End Kids*. Take Liz, Anna, Evá, Ruth, and
JoAnne out of their collaborative companies and see them as part of
another collaboration called: "The Thought and Art of Women in the
Theatrical Avant-Garde." Here are the stepping-stones in the avant-
garde stream for the year 1982. Here is a way to walk from one left
bank to the other. Here is perhaps the idea of the new idea of the
'80s: in deference to laziness, let's call this the "ripe times" decade.

And how'd we get here?

The '60s. *The Energy:* political. *The Form:* collective creation.
Examples: the Living Theatre, San Francisco Mime Troupe, Open
Theater, the Manhattan Project, and the roots of the Performance
Group and Mabou Mines. *The Model:* the Polish Laboratory Theatre.
The Idea: From out of the romance of the countercultural left comes
a masked man and a Polish Indian (Jerzy Grotowski in his dark-
glasses period and Ryszard Cieslak doing hatha yoga) saying, in a
few hundred thousand words or less, "A small, 'poor,' talented group
of unknowns—mutually protective and fanatically committed—can
beat the game and change the nature of the art." Overt aesthetics
and covert politics with the intent to subvert bourgeois art. Their
message is: A collective will win in the economic decadence of the
individual ego.

The '70s. *The Energy:* religious. A new paint job of Buddhism on the house of Christ in the garden of Moses with the toolshed of Marx and the outhouse of Freud. *The Form:* the ashram—in showbizese, Guru and Groupies, Inc., a not-for-profit organization. *Examples:* Robert Wilson's Byrd Hoffman, Richard Foreman's Onto-logical-Hysteric Theater, Meredith Monk's the House. *The Model:* the performance artist. Pick a card, any card—a [John] Cage, [Bob] Rauschenberg, [Anna] Halprin, even [Ken] Jacobs—any personal-ity in a given field motivated toward a public forum. Call it per-formance music, performance art, performance dance, performance film. Or don't call it performance. Call it opera, like Bob Wilson.

The label doesn't matter. The point is the form of the energy manifest in the assemblage: the relation of the creator to his "insti-tution." A Monk to a House, a Wilson to a Byrd, a Foreman to an Ontological-Hysteric is not the same beast as an [Andre] Gregory to a Manhattan Project and a [Joseph] Chaikin to an Open Theater. The latter were leaders in a collective process. The former were/are artists who "install" their visions in theatres with the help of help-ers. Not to say that some helpers aren't incredibly helpful. What I want to distinguish is the different balance of power in the making of the oeuvre.

The Idea: a meditative consciousness can be a dramatic con-sciousness. Images can be a language (see Marranca, *The Theatre of Images*). Anti-theatricality is theatrical. Amateurism is super-professional. The subconscious, the abstract, the associative, the secrets, the myths, that which in theatre is termed the "subtext," is the *real storyline*. This is classicism upside down. If you analyze all this overt subtext carefully, you can find the little well-made play.

The '80s. A guess. *The Energy:* psychological. Not that it's not both religious and political, but that I think the new avant-garde energy is now living in women in the realm of the individual psyche. And I think this is permitted by a shift in stance of the Women's Movement. Maybe women have just enough room now to put down the big guns for a K-ration break and be major artists in their fox-holes. Maybe a decade of "Fuck you, Pig" has gained just enough

turf—enough Erika Munks at Drama Desks, producers like Ellen Stewart, Lynne Meadow, Zelda Fichandler, and Julia Miles, Rockefeller Foundation–backed women's projects, Laurie Andersons in *Life* magazine, Elizabeth Swadoses produced by Papp, and Meredith Monks with major record contracts—just enough victory power (as opposed to sop power) to work without sexist subterfuge and the wave of a manifesto.

What is so joyful about these works I cite is that they are examples of women artists doing art in theatre, not women doing women's art in theatre. The energy of the '80s is in the pockets of calm where women can risk and feel and say the important things they have to say in the true and subtle vulnerability of their consciousnesses and not behind the howitzers of their assault. Not "All Power to the Women" but "Enough Power" so they can work. Look at the results—a rebirth of the avant-garde.

Finally, what's important about *1 & 9* and *Dead/Free*—as seen in a context of *Wrong Guys* and *Dead End Kids*, as seen in the context of Monk at the Public Theater, as seen in the context of the '70s (above), as seen in the context of the '60s (above that)? Well, to the *Times* what's important about these works is NOTHING: one bombed and the other can't even get reviewed. To the New York State Arts Council, LESS THAN NOTHING. Both groups alienated the administrative sensibility and got their grants cut. This policy is now part of the public record. To the Bureau of Statistics, SOMETHING CURIOUS. The five women in the theatre arts focal to this writing are mothers or mothers-to-be. The most visible women artists of the '60s were not. (It takes collaboration to make a baby?)

To me? What's important to me is that they document an advance in the art of comedy. Theirs is a triumph of technique in the field of oppositions. New droplets of irony leak out of new seams of associations; acting and imagery achieve a very advanced symbiosis.

I'm not into quibbling here. I don't think these pieces reach any great coherent philosophical heights, because they are busy moralizing. And when you moralize you limit yourself to a critique. What mediates the stance is that each is laced with inadvertent fascina-

tion. Squat, the Hungarians, take on N.Y. New Wavelets; the Wooster Group, the black and white of the WASP sensibility; and Mabou Mines, the creative macho (Maleczech) and power in the Faustian metaphor (Akalaitis) and its transformation from the alchemical to the atomic.

(An aside. Accusations of racism have been leveled at *1 & 9* and I don't want to skirt the question: Is *Route 1 & 9* racist? I would say yes: *Route 1 & 9* is anti-white, anti-WASP, and possibly anti-feminist as well. Of course, the black symbolism is more volatile and of course it bears scrutiny. The irony of the situation is that accusations of racism have come from whites, not blacks. This case has thus far been tried in a white court. We have to trust the black sensibility here and respect the black will and hope that it will make its position clear.)

I do not think that in an area of technique these works are triumphant. And that area of technique is the in-depth synthesis of the idea "theatre" and the idea "performance art." The turf war has gone on for most of this century. It's a typical border war, platoons out scavenging each other's material every night. In theatre, the "apparent" conflict was between the motivation tradition—Stanislavski to Strasberg—and the formalist one—Meyerhold to Brecht. But it was still a nitpicking skirmish over representational modes. The real conflict of aesthetics was being fought with another idea of performance that I guess went something like Jarry to Futurists to Dadists to Bauhaus to Black Mountain to performance art. Here in *1 & 9* and *Dead/Free*, I think we have a form that is absolutely neither Performance Art nor Experimental Theatre, but precisely both. Not alternately one then the other. Not one masquerading as the other. Both.

Question: *Why is this so hard to do?* Answer: Aesthetic traditions of the theatre world and the art world. They peer at each other as over a Gaza Strip. What's "good" in one is "bad" in the other. Good performance is bad acting. Good acting is bad performance. "Dramatic" time is cornball art. Abstract imagery is "arty" theatre. Psychology is too personal for art. The conceptualizing art intellect is too "minimal" for theatre.

In 1970 Mabou Mines began to work within this curious and fascinating dialectic and for five years courted the art world in galleries and museums, trouping along behind New Dance. And then for five years performance artists with progressively more daring have mounted theatre works, not installations. They got hooked. The hook is the "heat" in the public nature of the form. And the other hook, the one for theatre artists, is the freedom to abstract and subjectivize and "intermediate" that is inherent in performance art.

I think the wind is blowing from SoHo uptown. Experimental theatre will not become painting and sculpture. In this decade we will see performance art become integral to the body of theatrical aesthetics. All the nice junkies are shaking hands, and most of them are women.

THE THEATRE AND ITS TROUBLE (EXCERPT 5)

25. From the moment I first saw and fell in love with the Bunraku in Paris I thought that it, not Noh, was the true poem of the stage. For psychology was abstracted. The more prosaic the idea the more poetic it became. To see a Bunraku puppet dance was, frankly, nothing much. But to see one take a piss was an epiphany.

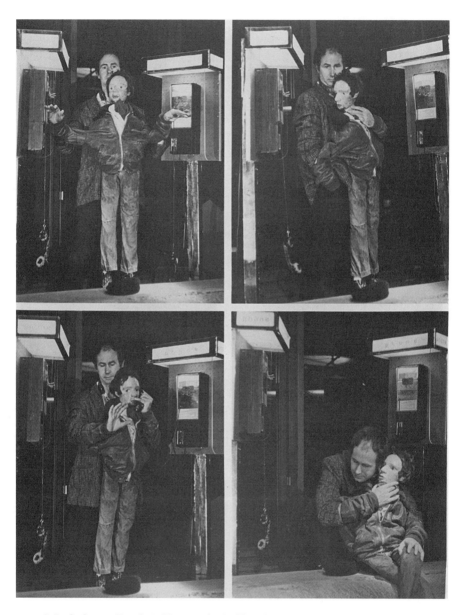

A Prelude to a Death in Venice, *the Public Theater, New York City, 1978.*
Bill Raymond and John (designed by Linda Hartinian).

CHAPTER TEN:
PRELUDE TO PRELUDE

In which Breuer ruminates on a love of puppetry

FROM AN INTERVIEW WITH NICOLETTA CHERUBINI IN PARIS, 1980, AND A TALK AT THE GROTOWSKI INSTITUTE CONFERENCE IN POLAND, 2009

I say there is no fantasy. It's all alive.

What is born of yourself is not under your control. It is under the control of the influences of your life, the stories in your life. I believe firmly in archetypical imagery, in the idea of control by the ancestors, in the idea that you are given a voice, that a character is simply an aspect of the *persona* of yourself, that you are never one thing—that you are constantly giving off energy the way an atom would radiate. All of this energy is characters: They come back to find you. You give up aspects of yourself: Some of them are identical, many others appear to be you, but they are not.

John was born because I walked around New York with a leather jacket and a blue hat. I asked myself: What is my purpose in walking around New York with a leather jacket? I shouldn't be walking with a jacket, I'm forty years old. I loved to wear a leather jacket. Why? Because John is born of a necessity, of the need that found me when I was sixteen. John is born of the problem of my sixteenth year. John is an attempt to supplant loss, to deny the future; it is a character

born of the necessity of my life. The creation of John was a purging of my John. Once I had him as a puppet I could kill him in myself. For me, the act of creating is an act of killing—when I want to kill John, I write John. It is an act of killing—an act of purging, in a sense. It is an attempt to purify, and it's like vomiting, and you throw up characters. This is essentially the drama of creating. It is a way of saving the self, because this something—a character—is making you sick.

Being an artist is a real thing. Loving, being afraid of dying, is a real thing. But I think there are very few real things that I understand. What I understand very well are the clothes that real things hide in, the coats and hats, the illusion and the covers: This is the theatre of the world, this is the illusion of the world, and my part as a craftsman is to *understand* illusion, to be able to *create* illusion. In a way, I feel that in terms of the world my job is to be a magician, in an attempt to perceive the truth.

The way I've chosen, I think, is the *via negative*. I have eliminated as *not true* the Horse, the Beaver, the Dog from other plays, and John, so far. This has taken twelve years. What I now find is that at least the truth is that it is not that.

But why a script? What kind of speech act is a theatre text? Asking for love. That's the precise answer. That is the speech act. In theatre terms, we call it an action. It is the action of a literary text. It is an offering and a hope that there will be a response.

A Prelude to a Death in Venice is a piece I wrote twenty-four years ago for and with Bill Raymond, one of the founding actors from Mabou Mines. Bill was a great puppeteer as well as actor. The way he used the puppet was as a ventriloquist dummy; the mouth didn't necessarily move, but the rest of the puppet acted like a ventriloquist dummy. It was a kind of East Village beatnik presentation, à la 1971, at that particular time. John was a little puppet about three feet tall and very full of himself, and he was calling everybody on the telephone and presenting himself as a presenter and an actor and a producer. You've got, once again, a theatrical image. The idea was

that he was trying to produce himself by using a theatrical metaphor, and he was also representing the presentation of the actor who was really representing the subtext of the puppet. A lot of what I do is a theatrical deconstruction in which different theatrical elements deconstruct different parts of the performance. Here, the puppet represented the character that Bill was presenting, and Bill himself, the actor, was representing the actor who motivated the character, and you interlock between the two.

Brecht often says that in epic acting, the ideal epic actor wears a character like a suit of clothes and moves it around. You see the soul of the character inside of the costumed presentation, but that soul doesn't necessarily agree with what the presentation is doing. So, I might be making very nice out here and presenting myself as a sweet guy talking to you like this, but actually my eyes are looking around to see who's with me and who's against me and all that sort of stuff. So you have this idea of looking out from the social characterization that you have.

I remember the paperback cover of Erving Goffman's *The Presentation of Self in Everyday Life*, where there's a photo of these two elegant ladies in the 1930s. They are wearing mink coats, and they're walking out of a cab to the opera. They could have been in a Kabuki opera—but they were real. It's possible to look around and think of everybody's face as a mask, in which case it's easy to ask, "Are their eyes saying what their lips are saying? Are your lips making nice and your eyes examining? Are your nostrils surprised and your ears listening?"

You don't just have one mask. It is like those Indian masks with two different faces, where you can go from a devil to an angel and back and forth. Think of that when you think of a face.

This was part of the idea of *A Prelude to a Death in Venice*. It was, of course, a send-up of Thomas Mann, because this puppet wants to die in Venice Beach instead of Venice, Italy. He's got a whole plan about how to die on Venice Beach, and he finds out—of course, his name is John—that his sexual problem is that he's in love with himself; it's autoerotic. So that's basically the little fun commentary I did on Thomas Mann.

CHAPTER ELEVEN:
WORKING WITH WOOD

BY LEE BREUER, 2010

This essay, written in 2010 for the French magazine Puck: Le Point
Critique *(Edition de Institute International de la Marionette #17)*
articulates exactly why Breuer is so passionately obsessed with pup-
petry, specifically the classical Bunraku tradition. Since 1973, when
Mabou Mines first workshopped Breuer's Shaggy Dog Animation,
Breuer has utilized a variety of puppetry styles, most of which come
from Asia. But this seventeenth-century form of traditional Japanese
puppetry—in which three puppeteers (or Ningyōtsukai*) operate a sin-*
gle puppet, a musician plays a samisen, and a single performer, the
Tayū, *does the vocalizations for all of the roles—is a style that Breuer*
has repeatedly come back to, from Shaggy Dog, *to* A Prelude *to a*
Death in Venice, *to* Peter and Wendy, *all the way up to his last origi-*
nal work, La Divina Caricatura, *in 2013. As Breuer outlines in this*
article, puppetry—specifically Bunraku—offers a director a method
for actually attaining the distancing quality, the "Verfremdungsef-
fekt," that was the centerpiece for Brecht's Epic Theatre.

This little organum is not talking about marionettes, nor the media-savvy Hensonite cartoons where puppeteers move foam rubber mouths in primitive lip-synch to their own voices, or about their jaw-hinged ancestor, the ventriloquist's dummy. It's talking about the fully evolved rod puppet like those employed by the Bunraku—a piece of wood and cloth, capable of astounding emotional range, lyric, comic, and tragic.

This little organum is talking about directing puppets, which in this case means a chorus of three dancer-manipulators, one *Tayū* or singer/narrator/actor; one musician (in the Japanese form this would be a samisen player); and one designer/sculptor who creates the visual character form.

What traditions of performance apply to six collaborators on one characterization?

There are four acting traditions that, for the last eleven decades, have been available to directors. 1) Ritual: This style has been postmodernized and called "process acting," meaning that one simply does a prescribed task. 2) Tragic: mythologically credited to Thespis in Athens about 550 B.C. 3) Motivational: credited to Stanislavski and Dovzhenko in Moscow about 1895. 4) Epic: The term is Brecht's but the concept really evolved from Meyerhold in the first decade of the twentieth century. It is a comic caricature form steeped in irony.

Concurrent to and integrated with these acting choices are movement and vocal traditions that form dialectics with each other. The point here is that with a collaborative characterization, it is not always a subtle interpretation if the mood of the movement, acting, and oral phrasing is identical. It is simply redundant. And so, ultimately, the choral presentation produces an alienation effect that increases dramatic complexity.

Two of these categories will seem obvious. Ritual acting is simply the performance of the process of manipulating characterization, the movement of feet, hands, head, and other expressive signifiers. Tragic is the style of embellished realism that adheres most closely to the music of drama in the Platonic sense. This classic technique is taught by repetition and example.

But anachronistic as it may appear, motivational acting is the bedrock of great performance. The puppeteer expresses his emotions through his hands, not his face, but it is critical that these emotions be real, the beats phrased, the actions clear. It is just as unfortunate to see "indicated" puppeteering. Whether it is performed by wood or flesh, it is still just bad acting. So the master, the second, and the feet of a puppet team must all be both dancers who can move chorally and actors who understand motivational techniques.

The Epic style becomes involved through the classic dialectic of puppetry. You are always seeing two realities: a character and a piece of wood and cloth manipulated to appear lifelike. You are always conscious of the "mechanism," while being seduced by emotional reality, the lyricism of music, the precision of behavior, and by drama itself. You are classically observing an alienation effect— the dialectic of magic and mechanics.

"Working with wood"—directing puppets—becomes more and more like making a movie than doing a play. In the seventeenth century, what Chikamatsu Monzaemon wrote was more movie scenario and novel than play, in the post-Ibsenite sense of bourgeois realism. The *Tayū* was character and chorus as well as a camera. Introductory scene settings were sung; this was the establishing shot. Scenes were analyzed and commented upon. Morals were drawn. This is the choral function. And, finally, dialogue was acted, but accompanied by music and ornamental phrasing—in other words, a classical acting approach, often with a Brechtian contrapuntal score. This is the author present voice of a novel as well as a chorus. This is the didactic factor. And considering that the visual structure of the characterization—the design—is frozen like a mask into a single expression or a neutrality, the total effect is very nuanced.

Audiences are not accustomed to expect great performances in works of puppetry. Design is often foremost and behavior is consciously simplified so that dramatic personae can be recognized— heroes, villains, ingenues, and the like. But these diminished expectations have done much to relegate puppetry to a minor art in Europe and America, and this state of affairs need not be. We

must take not just the design and manipulation but the acting and directing of puppets seriously. Where are the great stars of the puppet stage? All in Japan. We must rekindle this tradition in the West.

THE THEATRE AND ITS TROUBLE (EXCERPT 6)

45. "A Short Organum for the Theatre" would have us divide theatrical time into "A.B." and "B.B." ("A.B."—After Brecht—characterized by the *verfremdungseffekt*, and "B.B." by *empathy*). When you emotionally identify, when you are moved, yours is the way of catharsis. We have a decorous image of empathy, the "crying at the sad parts and smiling at the glad part"—but there are more potent forms of empathy.

 Response is performed empathy.

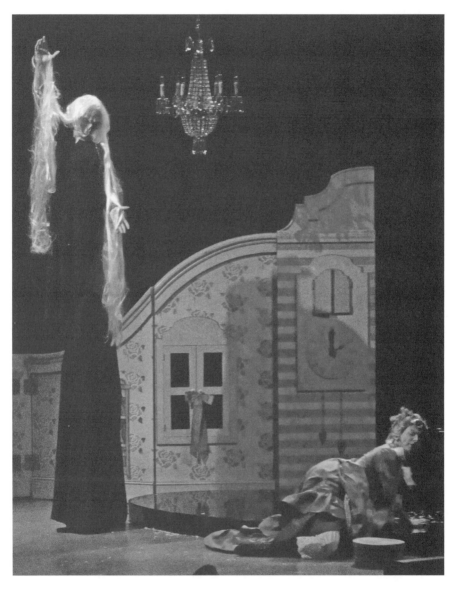

Mabou Mines DollHouse, *Rome, Italy, 2007. Jessica Weinstein, left, and Maude Mitchell.*

CHAPTER TWELVE: SYNTHESIS

In which Breuer considers commedia, Meyerhold, Stanislavski, Brecht, and Africa

FROM A LECTURE IN ROME, 2007

I just arrived from the Kilkenny Festival in Ireland, and all we talked about was Beckett, so I thought that here in Rome maybe we wouldn't talk about Beckett but about the other major influence on Mabou Mines—which was commedia.

We consider ourselves (at least I consider my own work) to be a very modern, technologically oriented commedia troupe. In other words, we're predominantly interested in comedy—comedy with a contemporary American attitude. But the source and the inspiration comes from the improvisational basis of commedia as it originated in Italy.

There is a long discussion now in American criticism about the difference in the avant-garde between experimental theatre and what we call performance art. Close to fifty years ago in San Francisco, when I was just beginning, I had the incredible luck to see the Piccolo Teatro di Milan perform Giorgio Strehler's production of *Servant of Two Masters* with Marcello Moretti. This was an experience I never forgot, because Marcello's performance of Arlecchino embod-

ied the concept of performance art and the avant-garde. The performance artist is talking directly to the audience; there is no other actor; we are not looking in secret at a scene, we are performing directly to an audience as I'm speaking to you. In Shakespeare, we have the aside, but then immediately the actor turns and becomes part of a scene—so, we go from what's called "fourth wall" to what's called "third wall." This is the key to what Mabou Mines does.

I believe that the other contribution to performance art and the avant-garde is very specific and is most clearly represented in the production of *DollHouse* that we're presenting here in Rome. The reason that I mentioned Stanislavski, Meyerhold, and Brecht is the following: I believe that the two roots of the contemporary theatre began at the same time with Meyerhold and Stanislavski.

What we would call the "motivational root" is a performance in which the actor feels what he or she says; the emotion is real, and the actor's response is what's called an empathetic response, in that they attempt to make the audience cry when they cry, to laugh when they laugh, and to become one with them. It's almost a mystical experience. This is the motivational approach originated by Constantin Stanislavski.

The other root, Meyerhold, is the formalistic root, where style, form, movement, and choral work take over and produce the theatrical image. It's not about feeling what the actor feels; it's about a display, an exhibition, and imagery. This is what we call formalism.

Where Mabou Mines is different from more traditional European postmodern theatre is that we try to combine both styles. We go back and forth, cutting back and forth between the motivational and the formalist as if it were a film. It's difficult, and it's very exciting. It takes a certain special technique, which is almost like schizophrenia, to be able to suddenly be weeping and emotional and angry and full of love and the next second to be stepping back and making a joke about it.

The reason I bring Brecht into the discussion is because of his dialectical theatre. This was a theatre in which the audience is given two messages at the same time, and those messages are not the

same. The classic representation of dialectical theatre is in *Mother Courage* in the little battle scene where there's death and blood and violence all over, and the music being played is a toy march. You're getting the music telling us that it's a joke and the action telling us that it's a serious, almost melodramatic, scene. We have to make our own choice as to what we believe the scene is about. It's a dialectic in which there's a thesis and antithesis, and our minds make the synthesis between the two. This is the dialectical approach that we use. The tremendous difference between what we do and the Brechtian model is this: Brecht did not use motivational acting. The actors were not supposed to feel. They were using dialectic of formalism. The music said one thing, the composition said something else, the readings another. But they didn't deal with the feelings: They were left out.

We use as our dialectic these two styles of acting, so we go from Meyerhold to Stanislavski, and Stanislavski to Meyerhold. This is what Brecht did *not* do, and this I think is Mabou Mines's particular métier. This is what we have to offer the theatre world as a new idea—that we can go from the subjective to the objective instantly.

This technique is best represented in *DollHouse*. But we have used the dialectical technique before in a different way, and that is conceptually. For example, in *The Gospel at Colonus,* which appeared here in Italy at the Spoleto Festival in the 1980s starring Morgan Freeman, the two sides of the dialectic are that we use the classic of classics—Sophocles' *Oedipus at Colonus*—and we're casting it with African American gospel singers. The chorus performs gospel music. We show the Caucasian classic, represented by Sophocles, and we see the African American tradition. And we combine them this way.

Basically, what we tried to do in *Gospel at Colonus* was to mix high classicism with popular street culture. Gospel music is the source in the U.S. of rhythm and blues, rock-and-roll, and soul music. At the same time, we used probably one of the most esoteric of all Greek classics, *Oedipus at Colonus*, as a base. Instead of using the type of classical speech that English people are accustomed to,

which is British Shakespearean accents, we used a West African–based accent that you're probably familiar with from all the great African American political leaders in the U.S.—Jesse Jackson, Martin Luther King Jr.—this is the accent. It's a Southern-based African American accent from West Africa and is considered West African classicism. Funeral odes are delivered in this accent.

What we found was that the West African accent worked better for a Greek tragedy than the Shakespearean accent because it still incorporated the chant, that area between singing and speaking which has been lost in Shakespearean English. It still exists in West African classicism and it exists in the African American church, which is the metaphor we used here. So we thought we were able to synthesize these two very widely different approaches—high classicism and popular street culture—into something new.

I want to move the discussion to *DollHouse* now, and I want to say a word about the use of our short-statured male actors, who I think are some of the most talented people I've ever worked with. There are two traditions we wanted to allude to, one very old and one very new. The very old one goes back to Roman comedy, when dwarf actors and comedians were considered the source of the farce. The contemporary one comes from an idea of Brecht's that I saw at the Berliner Ensemble. I saw the production that Brecht directed of *Coriolan* (adapted from Shakespeare's *Coriolanus*) in the late '60s—I hitchhiked up to Berlin, crossed over the Berlin Wall, went to the Berliner Ensemble, and saw this wonderful experiment in which Brecht had turned a tragedy into a comedy. The way he did this was through a visual dialectic. His two stars were Ekkehard Schall and Hilmar Thate, and they were two of the shortest actors in the company, both barely 5'1" or 2" tall. They performed the roles of Coriolan and Aufidius, the two generals, and the whole army, the actors playing the soldiers, were more than six feet tall—6' 3", 6'4". They were enormous.

Along with this, he costumed Coriolan in an enormous red-glove-leather robe that was much, much too big for him, so that every time he would make a classical gesture as in Roman sculp-

ture, the robe would fall over the end of his hand and he would look like one of the dwarfs in *Snow White and the Seven Dwarfs*. So Brecht was able to take a tragic character and in certain poses make him look like a cartoon.

In political terms, Aufidius and Coriolan were to represent the aristocracy, and this was supposed to create an ironic point of view of the aristocracy. We use this idea of short men, but instead of big soldiers put them against very tall women to represent the contemporary patriarchy—the feminist view of the male rulers of the world. Now, *DollHouse* was considered a bourgeois tragedy, the form that Ibsen helped to originate. But what we find in our production is that in the midst of a highly emotional and tragic scene—for example a love scene—if the men and women are to kiss, the woman has to lift the man up. So instantly we go to farce from the tragedy.

Another word about the politics of this production: I want you to know that about twenty years ago the short-statured people of the

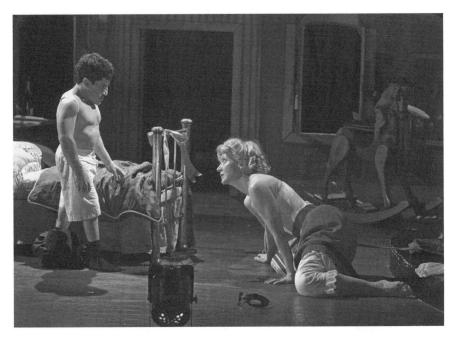

Mabou Mines DollHouse, *St. Ann's Warehouse, Brooklyn, 2003. Mark Povinelli and Maude Mitchell.*

93

U.S. formed a political organization. They now have acting stars like Peter Dinklage; they're moving into businesses. In other words, this is a move toward power for short-statured people of the U.S. The fact that their political movement is so new makes it an exact metaphor for the women's movement at the time of Ibsen in 1870–80. The women's movement was new at that point; there had been one divorce in Norway prior to this play. No woman could have a bank account; no woman could get a job without her husband's permission and on and on and on. So we have a fresh political movement and an older political movement that are riding along together and giving energy to one another.

There were six *DollHouse* productions in Oslo, and every one of the directors was a man. I thought: Why are only men doing *DollHouse*? It was interesting because some of the productions were very sexist, particularly the Schaubühne production.

I shared the adaptation of this text with Maude Mitchell—she was my dramaturg as well as playing Nora. I feel that it is our mutual efforts in this production that have given it neither a male point of view nor a female point of view. I can understand the play through Torvald, and she can understand the play through Nora. Together, it becomes a play about a couple. It's not just about the woman who is revolting, but it's about the two people tied by the sociological strings of society, the pressures of Victorian society, and tragedy ensued because their love was not greater than the pressures of society that was destroying it. We see this as a tragedy of a couple—not just of the woman, not of just the man, but of a couple. This was our political position.

When I was much younger I was absolutely enamored with the great Italian cinema. My favorite director today still is Fellini, but I was also a fan of Antonioni and Rossellini. Fellini was *the man* because I love a serious clown who has a great lyric sensibility.

I feel that Fellini holds the answer to the question here, which is how to construct a great classical work, a part of the canon, and

base it within popular culture. How do you find what is going on in the street in Rome and what is going on in the great classical tradition of Italy, and combine the two? Somehow, you must go down to the street and up to the high echelons of classicism and find where they can connect and combine.

Remember that every great classical idea began as a popular idea. All the great symphonies were using melodies that were folk melodies; the great myths began with stories that were told around fires and sung. And so the fact that high classicism seems to have separated from popular culture is the problem, and the idea is to bring them together, as we did with *The Gospel at Colonus*. That way, some little child who's never heard of Oedipus can understand it through the music, because it's music they've heard every day on the radio. It's a familiar tradition. It's about combining the popular with the classic and finding the synthesis of the two.

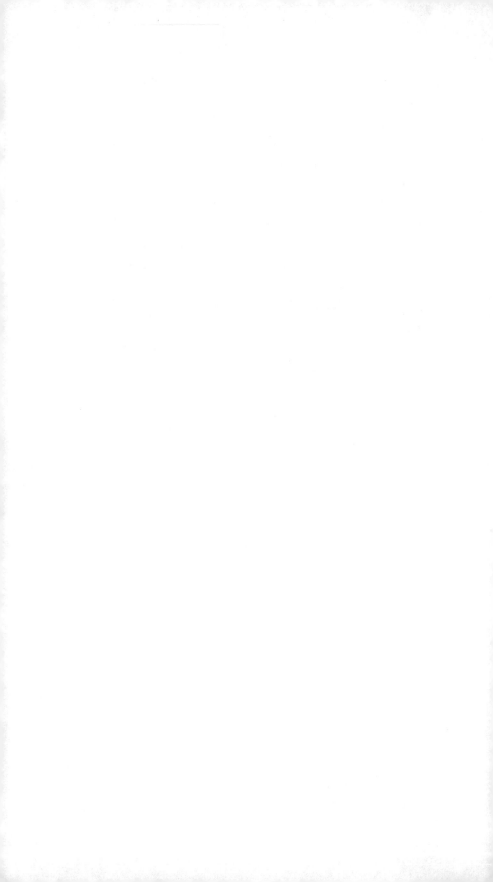

CHAPTER THIRTEEN: *MABOU MINES LEAR,* A CRITICAL DETOUR

BY STEPHEN NUNNS, 2014

Even if I have asshole ideas, I want to get them out there.

—*Lee Breuer*[27]

Mabou Mines Lear was, depending upon your point of view, either a brilliant piece of classical deconstruction way ahead of its time, or Lee Breuer's Waterloo.

Or maybe it was both.

Breuer and Maleczech came up with the idea around 1984 of creating an alternative version of Shakespeare's *King Lear*. Initially, it was Maleczech's project: For a considerable time she had wanted to play the title role—as she put it, she had always wanted "to say the words."[28] Many years before, when she was a young performer apprenticing at the Actor's Workshop in San Francisco, she worked

27. *Lear '87 Archive (Condensed),* disc 1, directed by Jill Godmilow (Chicago: Facets Multimedia, 2001), DVD.

28. William Harris, "Mabou Mines Sets *Lear* on a Hot Tin Roof," *The New York Times,* January 21, 1990, A1.

as a dresser for the actor Michael O'Sullivan in that company's 1961 production of the play. Though one contemporary critic suggested that O'Sullivan was "a shade hysterical,"[29] his acting made a deep impression on Maleczech. (At the *Lear* screening she admitted that she'd "ripped off O'Sullivan's performance.")

A conversation during the initial rehearsals of *Mabou Mines Lear* at Theatrical Outfit in Atlanta in 1987:

> LEE BREUER: I want to keep this Shakespearean. That might seem weird, but Ruth and I went at it for a while, and I think she won. I think she's correct. I tended to want to clutter it up with a lot of realism—kitchen scenes, you know, bathroom scenes, and stuff like that. And she was pushing to keep it simple, and I think she's dead on. I want to keep this kind of contemporary realism, but in very . . . almost Chinese or Japanese touches to keep the space. Because once you keep the space, we are in Shakespeare. Once you start putting fifteen TV sets and a couple of over-stuffed couches and a sink with a bunch of dirty dishes in it, we're into Arthur Miller and we're completely fucked.
>
> So, I think she's dead right on that. *(Laughter)*
>
> No! I mean, when you're right, you're right.
>
> So, I see this opening—
>
> RUTH MALECZECH: It's okay, Lee. I *am* right.[30]

Though Maleczech may have been the impetus for the project, Breuer became enamored with the idea of doing the play, and working with Maleczech's interest in playing the lead role, he came up with the notion of inverting the genders of all of the roles—the only exception being the Fool, who would be transformed into a transvestite.

On top of that, Breuer decided to place the play in an unspecified state in the American South in the 1950s (a reference to the

29. Howard Taubman, "Theatre: Repertory in San Francisco," *The New York Times*, May 15, 1961, 34.

30. *Lear '87 Archive (Condensed)*, disc 1.

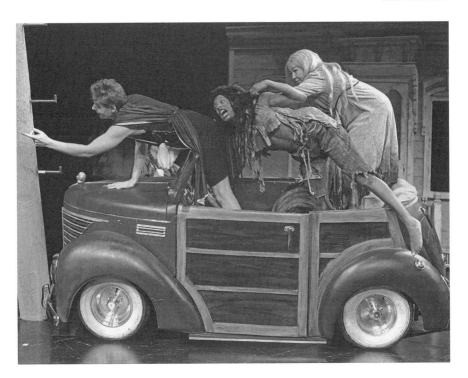

Mabou Mines Lear, *New York City, 1990. From left, Greg Mehrten, Karen Kandel, and Ruth Maleczech.*

suggestion by some historians that Elizabethan English was actually closer to the American Southern dialect than to contemporary British accents).[31]

Finally, he cast multi-racially. This was not, however, the kind of colorblind casting that marked Joseph Papp's Public Theater or Robert Brustein's American Repertory Theatre. By casting, for example, an African American woman (Isabell Monk) as Gloucester and giving her a white bastard daughter (Ellen McElduff, playing "Elva" instead of Edmund), Breuer believed he was taking on "the central issues in America. I might have some valid ideas about restating European

31. See, for example, Mario Pei, *The Story of Language* (Philadelphia: Lippincott, 1965), and J.H. Combs, "Old, Early and Elizabethan English in the Southern Mountains," *Dialect Notes*, vol. 4 (1913): 283–97. Reprinted in *Appalachian Heritage*, vol. 9, no. 3 (1981): 27–37.

classics in an American context," he said during a workshop of the piece at George Street Playhouse in 1988. "I tried it with *Gospel* [*at Colonus*] and hit it; I'm trying again. This is not the kind of superficial meddling you see when a director simply puts Shakespeare in a new period," he added. "This is a deeper meddling."[32]

> *Lear* is about power. That's the subject of the play. Power in its genetic manifestations—what's passed down by blood; political power; economic power. But what we find is that the way power manifests itself in these different groups has an enormous stylistic difference. The way women are powerful is not the way men are powerful. The way black people are powerful is not necessarily the way Japanese people are powerful. Nor the way American Indians are powerful. We [want to] transfer the values that are inherent in the manifestation of power among men, and reverse them.[33]

When the play was finally staged in 1990, it was intended to be the magnum opus of the New York avant-garde and a celebration of the twentieth anniversary of Mabou Mines. Not only did the piece present itself as being aesthetically and politically radical, but the cast was also a veritable Who's Who of New York experimental theatre. Not only were company members Maleczech, Greg Mehrten (who played the Fool), Bill Raymond (Goneril), and McElduff involved, but so were (at various times during the piece's seven-year development period) members or associates of Charles Ludlam's Ridiculous Theatrical Company (Lola Pashalinski and Black-Eyed Susan); the Wooster Group (Ron Vawter) and its predecessor, the Performance Group (Joan MacIntosh); and La MaMa (Karen Kandel).

Also, in keeping with Breuer's reputation as the Cecil B. DeMille of downtown theatre, Breuer added a variety of spectacles—there was a pink mini-convertible (actually a golf cart) that Lear

32. Alvin Klein, "George St.: 'Lear' With Twists," *The New York Times*, January 24, 1988, NJ19.

33. *Lear '87 Archive (Condensed)*, disc 1.

tore around the stage in, a pack of Dobermans (in lieu of Lear's knights and horses), and a cubistic chicken coop onstage (in which Kent was imprisoned). Cordelia (Cordelion) played a drum set in the first scene, which was staged as a backyard barbeque. Gloucester's blind leap took place on a golf course. The storm scene was played on the top of a fifteen-foot telephone pole. Between its long rehearsal and workshop period, its large cast, the complicated handmade sets and props (by Alison Yerxa), and the production's complex sound design, it was an epic undertaking. (All of the actors wore wireless microphones, utilizing technology that was not quite in place in the late 1980s; as a result, in the best-case scenario, actors were sometimes inaudible and/or incomprehensible; in the worst, the receivers picked up the voices of taxi drivers talking on their radios while they drove by the Triplex Theatre in downtown Manhattan.)

The piece, despite Breuer's protestations, was a critical disaster. *USA Today* gave Breuer one of its "Springtime for Hitler" awards for "worst concept"; Frank Rich groused about it in *The New York Times*; even the usually sympathetic *The Village Voice* had to run two side-by-side reviews: one a rave, the other a pan.

Lear went over budget—Yerxa's set pieces were complicated to create; automobiles had to make their ways onstage; dogs had to be wrangled; and the mixing of the actors' voices with Pauline Oliveros's score was a costly technical nightmare. The company initially workshopped the piece at Theatrical Outfit in Atlanta (under the direction of Sharon Levy). It then moved on to "work-in-progress" performances and residencies at venues such as the George Street Playhouse in New Jersey and Storm King in upstate New York in order to buy rehearsal time and find some much-needed cash. Yet by the time the production opened in January of 1990 at Manhattan Community College's Triplex Theatre, the company's finances were spread thin. And so were relationships.

To blame the massive creative exodus from the company that followed on the heels of *Lear* on that production alone would be overly simplistic. Nevertheless, by the end of the experience, the company was in shambles: JoAnne Akalaitis (who kept her distance

Mabou Mines Lear, *New York City. 1990, Ruth Maleczech.*

from the entire project), Mehrten, McElduff, Raymond, and tech-
nician/designer L.B. Dallas all gave notice (B-St. John Schofield
had already quit a few years before). Reasons for the departures
varied: Akalaitis had been handpicked by Papp to be his succes-
sor at the Public Theater, where she lasted, as one writer puts it,
"sixteen disastrous months";[34] McElduff and Raymond decided to
try their hands at more commercial careers in television and film;[35]

34. Jesse Green, "Where Have You Gone, Impresarios?" *The New York Times*,
October 3, 2004, E76.

35. McElduff had already appeared in Lizzie Borden's film *Working Girls* (1986) and
went on to appear in Oliver Stone's *JFK* (1991) and also have recurring roles in the
television series *Homicide: Life on the Street* (1997–99) and *Oz* (2002–03). Raymond
appeared in a variety of films, including John Sayles's films *Baby It's You* (1983),
Eight Men Out (1988), and *City of Hope* (1991). He also had roles in Stephen King's
1991 television series, *Golden Years*, and HBO's *The Wire* (2002–08).

Dallas dropped out of the theatre world altogether, pursuing a career in architecture. Nevertheless, even Breuer acknowledges that the scope, size, and work involved in creating the piece—not to mention the critical reaction, which, contrary to Breuer's revisionist take on history, was almost uniformly terrible—took its toll on Mabou Mines, both on the energy and affairs of the company, and, perhaps more important, on its financial integrity. By 1991, the company was reduced to Breuer, Maleczech, Fred Neumann, and Terry O'Reilly. And a lot of debt.

Lear might have been messy; it may have almost closed down his theatre company; it may have emphasized Breuer's identity as a madman artist. ("The Wild Man persona has kind of haunted me," he once admitted. "I think there were definitely some wild episodes, but all in all, it was tempered a little. But the ghost of this image has followed me for thirty years.") If anything, there was too much conceptualization going on: Gender reversal, setting the play in America in the 1950s, utilizing Southern American accents, using amplified vocal techniques—any *one* of these ideas would have been pushing the envelope at the beginning of the '90s. To throw them *all* into the mix was too much for (at least) the critical establishment.

The Southern accents were particularly galling to the critics. To this day, Lee thinks that the Southern speech patterns' equivalency to Elizabethan English was one of his best ideas—"I *love* the sound of rednecky Shakespeare!" he effuses. And it was also one of his most radical: "It brought out all of their spleen," he now says. "That's why you had John Simon insulting Ruth in such a vicious way. We had the audacity to step into the establishment's territory."

But twenty-five years after the fact, we can see that *Lear* was just a continuation and development of Breuer's experimentation in *American* adaptation—an American "in" to a piece of European classical theatre—an angle that embodied U.S. social concerns, politics, and aesthetics. Breuer had attempted something similar with Wedekind's *Lulu* at ART in Cambridge, Massachusetts, in 1979; Shakespeare's *The Tempest* for Papp's New York Shakespeare Festival in 1981; and *The Gospel at Colonus* on Broadway. And he would

eventually do it again later (and very successfully, from the critics' perspectives) with *Peter and Wendy*, *Mabou Mines DollHouse*, and *Un Tramway Nommé Désir* at the Comédie-Française.

Lear was another stop on what has turned out to be a long, long road.

CHAPTER FOURTEEN: ADAPT OR PERISH

In which Breuer ruminates on adaption and directing

BY LEE BREUER, 1999

There are two developmental lines—one, my original work, and two, my adaptations. The adaptations came into play when the original work really wasn't supportable because it was too far out and couldn't make a living. It was unbookable outside the Lower East Side.

My writing has gotten more credibility lately, but I'm never going to be known as a writer. And that was the split that happened. There are a lot of ways that you kind of kid yourself and say, "Oh, it's all of the same thing." That works for me a little bit, but it's undeniable that my adaptations are a lot more successful—if success means bookability and you can live off it. I don't think I could have ever done the adaptations the way I did them without having done the originals, because all the ideas came from the original work. All the ideas were there, and then they came out in *Peter and Wendy* and *DollHouse.* But they weren't developed there.

The first adaptation was really the Beckett—*The Lost Ones.* It was so much like my stuff—it was so tiny, it was a single actor—

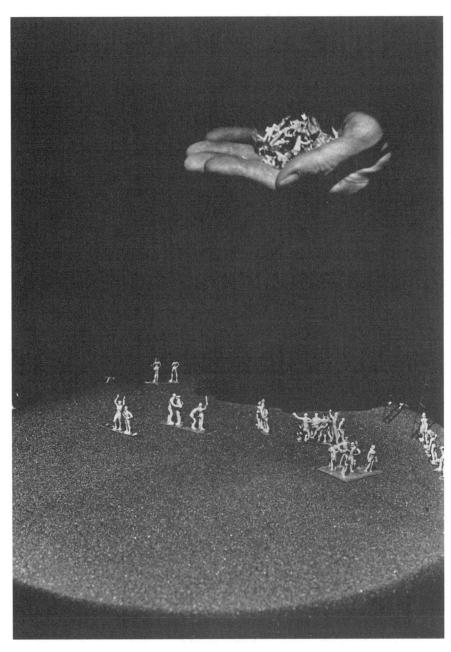

The Lost Ones, *Theater for the New City, New York City, 1975.*

that you'd hardly realize that that was the beginning of the adaptation tradition. But it was, and it was the most successful thing we'd done up to that point. And, in reality, it became clear that me working with great literature was going to go a lot further then working with my own.

Beckett gave a lot of instructions that his work had to be done a certain way. Well, we kind of tore out those pages. We were a little too small for anyone to say anything about it at that time. Beckett got a little feisty later in life because academics were saying they saw all these butchered productions and he got all nervous—"You can't change a comma, you can't change a thing, it has to be done this way." I think Beckett was a genius as a writer, but I don't think he was a genius as a director. It was too bad that later in life he decided he had to become very, very tight and strict.

The first Beckett I worked on was one of the early pieces, *Come and Go*. We did this in Paris. We had three women sitting on a bench behind the audience. They looked like birds—beautiful colored Victorian things. We had it lit so we exposed a curtain and when the curtain lifted it showed a small mirror. What the audience saw was a miniaturized reflection of the women in the mirror at about one third of their normal size. So, the audience was watching the mirror, and then the women spoke from behind the audience so the sound was coming from behind them and they couldn't turn around and look at the performance because it was much more beautiful in the mirror—so they got it from two sides. And the actors were completely in mid-air, floating against black—it was a nice image.

For *The Lost Ones*, we asked for permission to do a reading, but it was difficult. We had done a production of *Play* in Paris and a number of Beckett's friends saw it and word got back to him that we were decent. So Jean Reavey, one of our friends who knew Beckett pretty well, went to him with our request that we be able to do a reading of *The Lost Ones*, because we were really in love with the short story. Beckett grudgingly gave us permission to adapt a narrative work—it's not a play, it's a novelette entitled *Le dépeupleur*. After a lot of waffling back and forth we got a message back: "Okay, straight reading."

Well, we kind of lied a little bit. David Warrilow and I started working on it and after a while it wasn't so straight any more. We said we wanted to do a straight staged reading, but it became a bit more than that. And afterward Beckett wrote a very pithy letter back in which he said, "Sounds like a pretty crooked straight reading to me."

The idea is that it is a story in which the author's voice as a character narrates the story of the cylinder—which is Beckett's *Inferno*. Designer Thom Cathcart used HO gage figures from a model railroad set, and filed all the clothes off of them and painted them nude. So, the audience sees all these tiny little figures. And the audience was limited to sixty in this tiny little environment, but we gave them all opera glasses, so they could watch the tiny figures and listen to David as he manipulated them. So, that's what they're doing: The audience is watching with opera glasses as David is both narrating with the figures, and also himself performing the part of the lost ones trapped in the cylinder.

At a certain point, David joined the audience, and the people watching had the sense of being trapped in the cylinder the same way the tiny little figures were. This was the dramatic concept of it—little by little, the audience understood they were inside the cylinder too.

It's a narrative work of about fifty pages that we were able to edit down—we cut it in half. David's take on it was so subtle—quite a bit different from the clowning in Beckett that everyone's used to from *Godot*, or even *Endgame*. His rhythms were very Thomas Aquinas. It was really an ecclesiastical send-up. And of course, the images were Dante's.

Beckett did see the production later on, and he said he loved it. We happened to be in Berlin doing it there and he came. And he was wonderful. He came over to visit, looked at all the little figures and the stuff, and talked to everybody. He said that he was very glad about the production.

· · ·

I think there's a no-man's-land between adaptation and what you could call "inspired by" or complete transmogrification. For example, with *The Gospel at Colonus*, we began working with the Fitzgerald translation. Robert Fitzgerald was incredible. He let me work on it for three years without charging a dime's royalty; he came to the opening; he said it was the realization of all his dreams; his wife wrote the intro to the publication. Then he died three months later. He was arguably the greatest Greek translator alive at this period. I was thrilled.

He said he thought it was a great idea, even though I changed so much. I rewrote all of the lyrics—I adapted them from his phrases. I even took a passage from his *Antigone* and inserted it. I switched the whole thing around. I cut and chopped like crazy. He really had to trust me. And he really felt it worked.

The way a lot of academically oriented young artists are adapting is that they're putting a patina of image over the work, as in, "Oh, I'll do that in modern dress." And that's supposed to be an adaptation. I think you need to have a much deeper philosophical ground—you have to have a point of view. You have to have something you're pushing.

Maude and I did the Ibsen—we assembled the script together. We found in our research that men have almost exclusively directed Ibsen's *A Doll's House*—it's one of those incredibly intricate things where guys pretend to be feminists, and then once they've gotten a hold of this material, they pull all kinds of shit.

The other mistake is updating it—making the story take place in contemporary times instead of a hundred years ago. The problem with that is that all of Nora's motivation—her reasons for taking the action she does—is tied up with the fact that she lives in the period that she does. There had been one divorce in Norway prior to this play. One. No woman could have a bank account. No woman could

Following pages: The Gospel at Colonus, *Lunt Fontanne Theatre, New York City, 1987.*

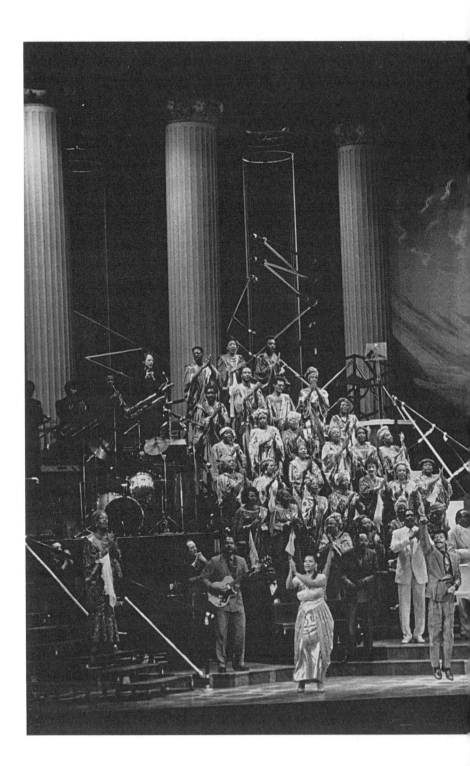

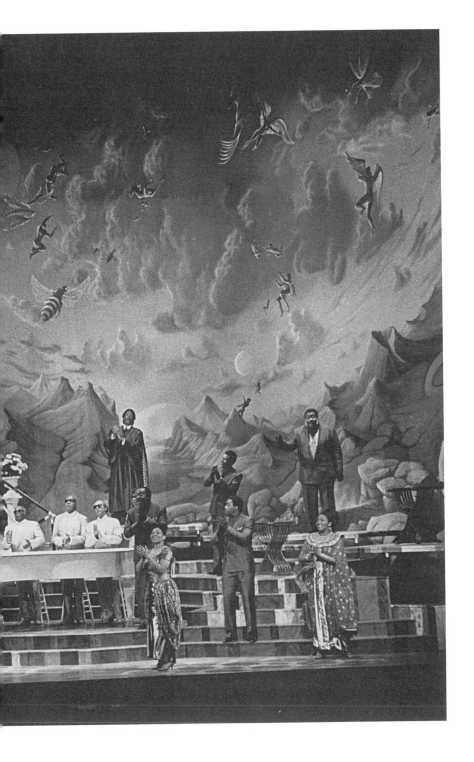

take a job without her husband's permission. It was kind of like slavery. Women were dolled up, and motivated to have babies, and look pretty, and sexually entertain their husbands. That was it. As soon as you update the play to today, it doesn't read as real. There's a lot of sexism today, but not that kind and not that overt, and not that cartoony. In order to get to the basis of this sexism of 1875 in Northern Europe, you have to understand the classic central bourgeois iconography: The banker in 1875 . . . the house with five maids . . . that kind of deal.

Updating the language doesn't work, so we went in the exact opposite direction. We used the most Victorian language that we could, so it was kind of like a greeting card with roses on the front. We used a lot of William Archer's translation. Archer made his translation with Ibsen standing over his shoulder—he went to Italy to do it. And we also had a translator at our disposal who had done literal translations of some of the passages.

There was one moment that was giving us trouble—Maude looked in an old Norwegian phrase book and realized that what Nora was saying in that moment was supposed to be a kind of swearing. They called it "An oath—but not an offensive one." The comedy is that she thinks she's saying something incredibly naughty, but actually, it's really, really cute. So, Maude came up with "hell's bells." It's these kinds of little choices where you know you've gotten a hold of a fruity little center to the pie, right there. You can relax—"that works," you think—and then you can go on to something else.

The rule of thumb, to answer your question, is that it's going to take much more time than you think to do a good adaptation. Give yourself three years per project. First year: Nothing but research. Second year: A complete rehearsal version of it. Third year: Throw it all out and do it all over again. And then you have it.

Now, that takes money. But every one of these things has been a three-year project. *The Gospel at Colonus* was four years.

I did the adaption of *Gospel*. However, because I'm working with a five-Grammy-winning group like Clarence Fountain and the Blind Boys, they of course did all their own arrangements. And the fact

that they did their arrangements gave it a gospel turn that was real—something Bob Telson and I could never have done.

We were able to push it by not giving them directly "high churchy" language, but something closer to classical language. So we have the dialectic again.

Morgan Freeman and I listened to Pentecostal preaching all over Minneapolis, and the guy who eventually played Theseus was a preacher who we found—Reverend Earl Miller. He was the guy that Morgan studied in order to learn how to preach.

If you look at *The Gospel at Colonus*, you can watch how emotion teaches. *Gospel*, with Bob Telson's score, is one of the joys of my life. It's a lasting experience—it just won't quit. We opened it in 1983 at BAM and twenty-six years later we're still running it with three-quarters of the same cast. (Minus Morgan Freeman—we can't quite afford Morgan.)

The dialogue is a good eighty-percent straight Sophocles, through the Fitzgerald translation. In other words, you're listening to 2,600-year-old dialogue that was on the brink of the transition from the oral to literary age in Greece. It premiered in Athens in 401 B.C.

One of the things we tried to do was to find a way to bridge the information and culture of a bygone era and reinterpret it for us today. The connections are manifold. The Pentecostal church is perhaps the only living institution in the United States that still regularly practices catharsism, sometimes referred to as "getting happy." Many times we've had to stop the performance while one or two of the choir members recover, and then continue with the performance. It's a divine and inspired moment. And it's exactly what Aristotle said is supposed to happen in tragedy.

I was wandering around a Greek theatre in Anatolia when I was younger, and I asked someone, "What's this stone?" And the person said, "It's the altar." And I suddenly realized that it's a church. It suddenly dawned on me that tragedy *is* the church, and that it is the connection to a church that is cathartic. And situating *Gospel* in

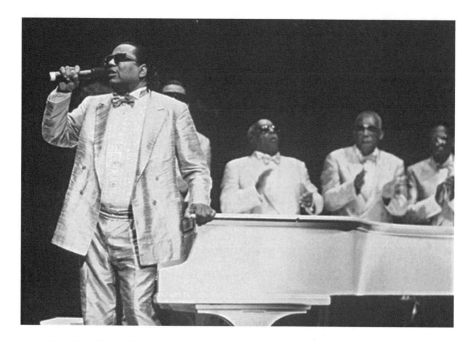

The Gospel at Colonus, *American Conservatory Theater, San Francisco, 1990. From left, Clarence Fountain, J.T Clinkscales, Johnny Fields, and Bobby Butler.*

the African American experience of today would perhaps render the spirit of the production closer than any Anglophile, Victorian, post-Oxbridge production that you might catch from the RSC.

It was at this moment in Greece that we were at the tail end of the transition from the oral culture to the literary culture. Remember my first little diatribe here: "To remember, you have to feel." And remember that Greek tragedy was sung. Maybe it wasn't sung in quite such a rock-and-roll style, but it *was* sung. Of course, we have no idea what the scansion was—the percussion track has vanished. So maybe it was rock-and-roll.

There are many points that *The Gospel at Colonus* tries to make. One of the major ones relates to the literature that purports to prove that Nubian Africa was critical in the foundation of European culture. There's been a lot of scholarly back-and-forth for the last twenty years over black Athena. The play reverberates around the

questions: "Where did Greek religion come from? Where did all these images come from? And where did the language come from if not from Africa?" It's generally agreed that European culture did not spring full-born from the wheels of savages in chariots from the Caucasus, having just gotten off horseback. I think that it owes an incredible amount to Middle Eastern and African culture, particularly in the arts and religion (which were pretty much the same thing).

The African oratorical style did not go through the transition that happened in Europe. That's to say, the middle never fell out. You have speech and then you have song, but what happened to the chanting that was supposed to tie them all together? You can hear little vestiges of it—remember that the Afro-American experience as exhibited in the Pentecostal church at this particular point calls on all that power from the old tribal tradition, turning it into a literary tradition of Bible exposition. So you have the same kind of mixture of the two that you had in 400 B.C., when you had the oral tradition of Homer coming down into the literary tradition of Sophocles.

There's a kind of cultural analogy that we're trying to make clear. We're trying to present a political dialectic by casting a classical white play with a black cast, and an aesthetic one by presenting the idea that great performing and great singing is perhaps the key to tragedy. Tragedy was a musical form; it was a popular form; and it was an exciting form. In those theatres there were five, six, or seven thousand people watching a performance. It's on record that pregnant women had babies in the theatre. It was closer to a rock concert than anything you'd want to imagine.

But again, that is part of this larger picture that you can't communicate unless you find an emotional vehicle to spearhead that communication—that the amygdalae and the middle brain really program the information-gathering forebrain; they tell it what to think through emotions. That's why we dramatize; dramatic structure is the key to communication and feeling. I also want to suggest that perhaps it's the key to truth. Have you ever tried to lie to someone emotionally? You can talk a blue streak and tell them anything

you want, but if you're crying it's pretty hard to lie. And if you're laughing it's really hard to be believed. Who can do it? A great actor. They can lie emotionally. They can sit there talking to you and start to cry. However, that takes a superior technique. That takes a superior actor.

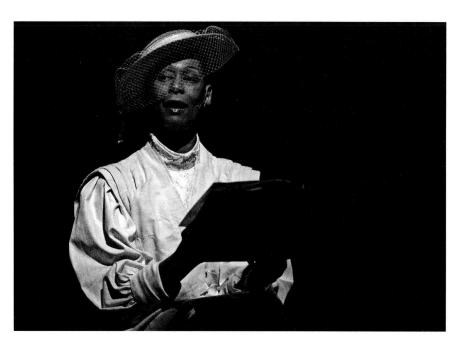

Peter and Wendy, *Arena Stage, Washington, D.C., 2007. Karen Kandel.*

Mabou Mines DollHouse, *St. Ann's Warehouse, New York City, 2003. Mark Povinelli and Maude Mitchell. Puppets designed by Jane Catherine Shaw.*

The Gospel at Colonus,
*Edinburgh International
Festival, Scotland, 2010.
Rev. Earl Miller and
Bernardine Mitchell.*

The Gospel at Colonus, *Delacorte Theater, New York City, 2018.*

La Divina Caricatura *cast and crew, 2013. See page 216 for a list of names.*

Poster for Mabou Mines DollHouse, *film premiere, Paris, France, 2008. Mark Povinelli and Maude Mitchell.*

Red Beads, 2005. Clockwise from top right, Clove Galilee (Breuer),
Jessica Scott, Ruth Maleczech, and Lindsey Abromaitis-Smith.

Choephorae (The Libation Bearers), *Patras, Greece, 2006.*

Yi Sang Counts to Thirteen, *Seoul, Korea, 2009. From left, Chang-Soo Lee, Dong-Ruk Shin, So-Jin Kim, and Young-Jun Im.*

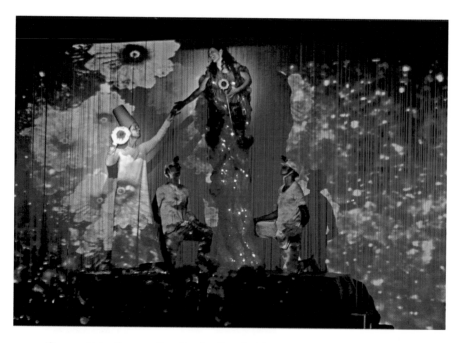

Opera of the Stones, *Sao Paulo, Brazil, 2010. From left, Tiago Pinheiro, César Dias, Badi Assad, and Rubens Oliveira.*

Curse of the Starving Class, *Saratov Academic Kiselev Youth Theatre, Russia, 2010. Ruslan Divlyatshin.*

Lee Breuer and Basil Twist rehearsing Un Tramway Nommé Désir, *at the Salle Richelieu, La Comédie-Française, Paris, France, 2011.*

Hajj *on tour, arriving in St. Petersburg, Russia, on the all-night train from Moscow, 1998. From left, Lee Breuer, Lute Ramblin Breuer, Julie Archer holding Ella Rae Peck, Ruth Maleczech, Polina Klimovitskaya, Arya Shirazi, and Alex "Tiappa" Klimovitsky.*

THE THEATRE AND ITS TROUBLE (EXCERPT 7)

18. Poetics is the foreplay of science.

19. *Ham's Law* or the *First Law of Thespodynamics* states that in the case of the one or several facing another one or several, the *fewer* are the *more meaningful* than the *greater* in inverse proportion to the square of the difference between the two. Implied in the equation is a reduction of the ratio to a point where *one* faces *everyone else* and is, by inverse implication, *the greatest*. In the language of Thespodynamics, the greaters are known as the *hearers* and the lessers as the *sayers*—and the process as *hearsaying*—except in the case of a reduction to one—in which case the lesser is known as *the ham*.

 Saying and *hearing* is the pretty pass that *calling* and *responding* have been brought to.

20. There follows from this a second law known as *The Gross*. *The Gross*, and its corollary *The Net*, concern the interaction of forces between hearing and saying when they are reduced to *The Numbers*. *The Net* is a mystical number known as *Life Itself*.

21. There are weak forces and strong forces and gravities and electromagnetics—between hearing and saying, all that shit is involved—all those "matters" and "antimatters" at the heart of real showbiz. The force of the saying both attracts and repels all who hear it. And the act of the hearing itself can repel and attract what is said. And in this interaction

known as suspense, a holding pattern can be found that determines all the shapes and the configurations of the theatre we know. That is the law of *Size of House*.

22. The name of the first force is the *killer* force, as in *Kill 'em dead, man;* the name of the second force is the *lover* force, and this force cries *bravo* and weeps. The killer and the lover forces are volatile. Alone they burn. Mixed they explode. And that ain't hay. That's Hegel.

23. Brecht! Marx! Science! Ha! The theatre and its trouble is its misappropriated dialectics. We are a study in dialectical dematerialism.

24. Theatre is a special case of *performance* concerned with demonstration in profile. (See #8; characters are behaviorist profiles and they know it. Try and look one in the eye.) It demonstrates the world according to illusion against a scrim of the world according to the void. Through this scrim dialectical light plays.

CHAPTER FIFTEEN: THE FUNDING GAME

BY LEE BREUER, 1980

This essay, written in 1980 for Other Stages, *can be seen as simply a public mea culpa to La MaMa's Ellen Stewart for Breuer's apparent slighting of her. But more to the point, it is a recognition of how much "acknowledgement" mattered in the arcane world of funding downtown theatre in the early 1980s.*

FORGIVE ME MOTHER FOR I HAVE SINNED. OR, HOW AN ARTICLE THAT WAS SUPPOSED TO BE ABOUT RE.CHER. CHEZ, OUR NEW STUDIO FOR THE AVANT-GARDE PERFORMING ARTS, TURNED INTO A CONFESSION, A NEW UNDERSTANDING OF, AND AN OVERDUE APOLOGY TO ELLEN STEWART.

Last fall when my book *Animations* came out I took a signed numbered "Thankyou Thankyou" (in the Betty Carter reading) edition over to La MaMa for Ellen. She was away. I left it.

Cut to January, I see her standing in the doorway looking down Fourth Street. I start to ask her if she got it. But I stop. She is very mad. This is Ellen Stewart "Mad" as opposed to an Ellen Stewart "Number": to be taken with consummate seriousness.

Why? Well. Because La MaMa was not properly credited in the edition of *Animations*. In fact, from her point of view, so improperly credited as to perhaps have contributed to her "credibility crisis" (read "funding crisis," when properly translated to the Off-Off-Broadway nitty-gritty).

I remember standing there getting chewed out. I remember getting sloshed over with the guilt bucket. I also remember a small cold realization that she was right.

Forgive me Mother, yes. There was a sin of omission. And yes, perhaps it did contribute to the hopelessly unhappy standoff of entrenched subjectivities.

Re: *Animations*. Hindsight had definitely trimmed off the rougher realities of Mabou Mines's existence in the early '70s, I had said it so often. I had read it on our own press release (I had forgotten that I had written the press release) that Mabou Mines began in 1970 in New York. Well. Certainly, for five of us it had. But for the powers it had not. For NEA, for NYSCA, for Rockefeller, and most certainly for Ford, whose project we were, there was no Mabou Mines in 1970. There was a La MaMa project. From April 1970 to May 1973 there was a La MaMa–Mabou Mines. And, in effect, *The Red Horse Animation*, *The B Beaver Animation*, Samuel Beckett's *Play*, his *Come and Go*, *The Saint and the Football Player*, the Phil Glass collaboration *Music for Voices*, and the Jene Highstein collaboration *Arc Welding Piece*, all were productions of the La MaMa Experimental Theatre Club of New York, as clearly as was Serban's trilogy. And Ellen Stewart should be duly credited as producer of these works.

She was not. And the fault, if more unconscious than plotted, was still wholly mine.

After 1973, Mabou Mines struggled to establish its identity as a separate theatre. But as late as 1976 there was still confusion in

The Saint and the Football Player, *Amsterdam, Holland, 1975. Clove Galilee (Breuer) and cast members.*

the funding and booking sectors as to whether or not we were still La MaMa–Mabou Mines. The story with Joseph Papp was totally different. At the New York Shakespeare Festival, we were permitted to partake of various arrangements. Sometimes sponsorship. Sometimes co-production. Implicit in the arrangements was the idea that Mabou Mines was a bona fide entity, legally, economically, artistically.

And so when it came down to crediting the published *Animations*, I reasoned that since Joseph Papp subsidized as great a percentage of the *Shaggy Dog* as did Ellen *The Red Horse* and *B. Beaver*, the crediting should be neatly parallel. Co-production. And thus the artistic ownership by Mabou Mines became, by sleight of hand or sleight of print, ownership per se.

In retrospect, this was all done in good artistic conscience—but perhaps not so good fiscal/political conscience, for as it turned out this was certainly not the right time to slight Ellen's contribution to the American avant-garde and her subsidy of Mabou Mines. In point of fact, there probably would not have been a Mabou Mines for Joe

Papp to help in 1975 if there had not been an Ellen Stewart in 1970. Nor would there have been a published *Animations* whose crediting omissions haunt her now.

The larger issue, the justification of the cuts, is a rats' nest of complexity that boils down to: "How can you cut the pie fairly when there's not enough pie?" Should everyone get a sliver and die slowly, or should some get a meal and others put swiftly and humanely out of their misery? Should the Performance Group die for La MaMa to live, or should they both fade away abreast?

[Theatre program director for the NEA] Arthur Ballet has often produced miracles, but he cannot turn the trick with the loaves and the fishes. Ellen has produced her own miracles, artistic and fiscal—the very miracle of La MaMa's funding spiral that has put her so far out in front as to be vulnerable. There are no easy answers. I don't even think there are any hard answers. They're not going to remodel the kitchen and make more pie. Not now.

But now I understand where Ellen is coming from. She should have her due, the credits and support that are rightfully hers. Her contribution to Mabou Mines should be clearly shown. I understand where Ellen is coming from, because just last week I suddenly found myself coming from there, too.

II

Jerry Mayer called. This was in 1978. He was deeply immersed in a projection of his persona in Artaud. The form of this projection was a play. He was writing a play. He had never written a play before. John Holms was directing. John had never directed before. Would we help?[36]

Sure we would. Somehow.

36. Jerry Mayer was an actor best known for his work with Andre Gregory. He won an Obie Award for his play *Taudshow*, about Antonin Artaud, in 1978. The play was workshopped at Re.Cher.Chez. Mayer died in 2003. John Pynchon Holms directed *Taudshow*.

This "sure" and this "somehow" two years before the actual event was the model for Re.Cher.Chez.[37] A studio for the avant-garde performing arts. In effect, its inauguration.

As far as Jerry and John were concerned, never was less effort more richly rewarded. "Help" consisted specifically of a couple of weeks' use of the Mabou Mines studio late at night. A few suggestions about some cuts and transitions. A few bucks well earned building the *Shaggy Dog* and a couple of phone calls that materialized in runs at the Performing Garage and the Public Theater. A minimal sponsoring effort by any measure. And yet without it there probably would never have been a *Taudshow*, or an Obie for Jerry Mayer. Nor recognition of the directorial talents of John Holms.

Last September in a little basement on St. Mark's Place, Re.Cher. Chez began nearly twenty projects in the area roughly bounded by the idea of performance art on one side and experimental theatre on the other. Dance projects, design projects, writing projects, acting projects, even some film, video, and radio. On alternate Monday nights a series called "Piecemeal" showed the works in part as they progressed. The studio does not produce. It develops. Piecemeal is dedicated to works-in-progress at almost any stage of development from readings to virtually a full production on a skeleton budget. If all goes well with this idea of a studio and if it grows healthily, it can be for the experimental wing of the field what in its best years the Actors Studio was for the mainstream. A laboratory where talents can be protected and mature—journeymen and apprentices to the craft.

37. Re.Cher.Chez was Mabou Mines's first artist residency program. Started in the late 1970s in a basement on St. Mark's Place on the Lower East Side of Manhattan, young artists would attend weekly classes headed up by company members Ruth Maleczech, Lee Breuer, and Bill Raymond. The participants would also show works-in-progress. "We taught a no-man's-land between experimental theatre and performance art," Breuer is quoted as saying on the Mabou Mines website. "We were open twenty-four hours. We had an amp, a little playback deck, and a few lights." Among the artists who participated were Anna Deavere Smith, Oskar Eustis, and Dan Hurlin. Though Re.Cher.Chez ended in the mid-1980s, Mabou Mines continues to sponsor an artist-in-residence program called Mabou Mines/Suite. In 1991, Stephen Nunns was the first artist given a residency in the Suite program.

III
OR.
WHAT I MEANS IN TERMS OF II

Last Friday at Re.Cher.Chez: Some of us are looking at some other of us who are showing some material that may be part of Monday's Piecemeal No. 10. Martin says that Mary O'Connell won't be dancing because she's giving a concert in Canada. Will she remember to put "Developed at Re.Cher.Chez" on the program? Who knows? Maybe we should call her. Yeah. Maybe we should call her. I mean, you know this is business, man, this is life and death, this is funding, I mean, you know what they want to see, all those boards and observers and panels and administrators and executive directors— they want to see the work getting out. The people getting in. The credits getting it on with other credits that are getting it on with fiscal realities. Want to be sure we're not a bunch of elitist jack-offs down here playing with ourselves.

And incidentally, the rent check bounced again.

Well. We did try to call Mary O'Connell to make sure "Developed at Re.Cher.Chez" was on the program. But we had the wrong number.

That doesn't matter. The intent was clear. It doesn't matter in one sense, in that it doesn't matter to us. But in the other sense, it does. Because it matters to the people we have to matter to. Matter to or die. And the name of our song is "Stayin' Alive."

It was an enlightening fluke to be thrust into Ellen's shoes. To hear those old familiar lines from "The Funding Game" sequel to *The Pajama Game* coming out of my own mouth. To suddenly do a take on myself as Mr. Business as Usual.

Perhaps we can summon a deeper compassion for all us players of this sad compulsive game. There's no way not to be trapped by your own imperatives. Change the GR to N and GREED becomes NEED. And if you spit the word out fast, who will ever know which one you're really saying?

CHAPTER SIXTEEN:
THE TWO-HANDED GUN

BY LEE BREUER, 1991

*This article was prepared in part for the American Assembly/Colum-
bia University Project on the Arts and Government. It was originally
published in* The Village Voice, *August 20, 1991, at the height of the
controversy surrounding the National Endowment for the Arts.*

*Looking back from a distance of almost twenty-five years, the
Culture Wars surrounding the NEA seem almost quaint. That mem-
bers of Congress spent time on the Senate floor berating controversial
art is clearly connected to a transitional moment in between the Cold
War and the War on Terror. Nowadays, one would think they have
bigger fish to fry.*

*But America needs its enemies and at the time between the Soviets
and Al Qaeda, artists were easy targets. Breuer's article is very much
of its moment, and acknowledges the uncomfortable (and vaguely
dependent) relationship so many artists had with the NEA at this
point in time.*

I remember very clearly when I was sixteen and my life began. My father had died. My grandmother had died the year before. My mother, newly orphaned and widowed, faced with entering the labor force at fifty—not having worked since twenty—got into bed and, entering into a massive depression, refused to get up.

Dissolution of the nuclear family loosens the bonds of the filial covenant. Power was mine in an Oedipal coup d'état. The whiff of a freedom of all possibilities was in the air, which, in its Dostoyevskian scenario, leads one to murder, madness, suicide, and every enticement of the lower realms—or to a fashion of all-American sainthood—the producing man. Dostoyevskian salvation through suffering was frankly un-American. Calvin's salvation through accumulation was the ticket to ride. Freedom acceptable to our culture would be product-oriented. One could make things. One could make money, or babies, or war, or politics. And if materialism wasn't one's cup of tea, one could make metaphors. One could make *art*.

My life was as simple as Patrick Henry's: "Give me a metaphor or give me death." For what was American and was *not* art was a deader death than poor Patrick could have imagined. The world not being my oyster, it forthwith became my raw material, my entertainment, my teacher, my stand-up comic, my first-run movie. The world became all things to me, except my living. That was 1954. Little did I know that in one decade the world would try to be that too.

Why should a government propagate an art?

The art that a government chooses to propagate sows the seeds of an official culture.

Culture works like poison gas—the one the lung breathes, the other the brain. Either way, it's a horrible death.

Gas masks have reached a state of perfection—cultural masks are in their infancy. There's no protection—advertising is invincible.

What is culture? It is a "behavioral cachet"—turning politics into sociology—be that population genetic, political, geographical,

or theological? This cultural style propagates itself through cuisine, couture, sport, dress, and language as well as music or painting or theatre or dance.

Nonetheless . . . *style*, as it reflects *time*, is *fashion*—and fashion's cutting edge is *art*. Art sets the cultural tone.

Accordingly, when in 1965 there was endowed a government agency for the propagation of American Culture, one question remained unanswered.

Which American culture? Which is the cultural tonality that this endowed agency has, for a quarter of a century, been empowered to reflect?

Now, reportedly, since Kennedy, we have lived in—now get this—a *liberal establishment.*

Who ever heard of a liberal establishment? It is a contradiction in terms. Establishments are conservative. They are social strategies that function to conserve power, and as such invent rationales called rights—divine, moral, blood, primogeniture.

But in the '60s, the liberal establishment, armed with its "Bill" of humanistic "Rights," proposed to propagate a so-called American cultural legacy through a government agency and put its taxpayers' money where its mouth was.

Wow! What the hell was goin' on?

What was goin' on was that this liberal establishment—whose bright idea the Endowment was—thought it knew what a work of art was. Art was what was taught to you; it was by the Eliots and the Pierce Bakers—the secular clergy of the cultural cloth. And this establishment—culturally represented by a coalition of museums, LORT theatres, philharmonic orchestras, regional operas, modern dance companies, media publishing conglomerates, art advocacy administrators, critical legions, and all academe—was still safely Aryan.

Now all this is threatened by a *new immigration*—not an immigration to the shores of a continent, but an immigration to the shores of power—a cultural continent. Political factions—be they of race, nationality, or gender, or be they an advocacy group for sexual dimorphism—all come, like immigrants to the shores of power—*hungry!*

Now we are faced with a great civil war—testing whether "that" culture—WASP culture—can endure. Now the hand-to-hand combat is between sonata and salsa.

Once, the founding fathers of the Endowment thought they knew what a work of art was. Now the voices of the new immigration make them not so sure.

I've spent my life in the nonprofit world. Each year, I, a petitioner in the court of Haile Selassie, head down, butt up, watch out of one eye as the Lion of Judah takes a gold coin out of a big drawstring bag and throws it my way. Each year, I, a provincial scholar, candidate to the Tang bureaucracy, listen behind a curtain to the eunuch mandarins tittering about my test score. I, every morning at the awakening of Louis the XIV, hold his little demitasse of chocolate and try to catch his eye—my new masque of *The Rape of Europa*, to be staged on the Isle of Saint-Louis, is running over budget.

The nonprofit world is feudal. Foundations and corporate philanthropies are structured like so many puppet courts cloned from the aristocracy. The cultural form has been duly replicated, but as in videotape, each generation is of a diminished quality until one has virtually a parody of the original. Classical art is so often perceived as synonymous with nonprofit art because it asserts the values of a class that does not have to take a profit—that disdains to. Its wealth is hereditary, as are its titles and its lands—in a word, its power—and though it may characterize its rights metaphorically as divine, they are, most likely, sociobiological.

Conversely, popular art is art that makes money. It is bourgeois art, hence denigrated and scorned by the aristocratic nonprofit world. Popular art must make money because its purpose is to advertise the values of a class that holds profit the thing most dear—the class that measures power on the scale of economics. Vestigial classical aesthetics in popular art—values such as the "dramatic" or the "beautiful"—are incidental tools utilized to construct imagery flattering to a "class" of marketable values—dominant among

them being the notion that in order to have beauty one must purchase it.

There's no high art and low art—there's not even any good art and bad art—objectively speaking. All that crap is *subjectively speaking*. The "good" can be "ugly" and the "beautiful" can be "bad." In other words, there is no objective qualitative distinction between classical art and popular art. The distinction is temporal and geographical.

I am a reluctant radical. I was programmed to be a liberal—but as liberal humanism sashayed to the right, I must have stood still—for here I am in "reluctant radical land"—and I don't think I've moved an inch to the left of my grandfather, who gave Eugene Debs the spare room while Debs was in Delaware after having gotten out of jail.

And as a reluctant radical, I am, of course, also reluctantly, un-American. I am un-American because I am out of step with the cultural imperative—its design, its psyche, its will.

Now, in all the scripts I've read for the sitcom called "life in the liberal establishment," a National Endowment for the Arts is the best running gag. The liberal establishment, as part of its board plan to consolidate clout, created the Endowment to preserve and propagate the *conservative culture*.

We artists—we really are some poor stupid motherfuckers that have the temerity to think that this is all about us. Pat Buchanan said the NEA controversy is a war about fundamental values more than money, more than an end to a congressional ban on funding obscene and blasphemous art. It is engaged in a cultural struggle to root out the old America of family, faith, and flag, and recreate society in a pagan image.

Right on, Pat!

And so, with rallying cries of "Don't give up the Parthenon!" and "More gods now! Better gods now!"—let's take another look at this Endowment. As in—the artist looks through the cultural frame at the NEA, the lens becomes a mirror. One—the artist—sees oneself. The Endowment is a mirror of our sins—predominantly carnal.

Culture is Kafka's castle—his Byzantine joke, and its punch line is called *the two-handed gun.*

Corporate philanthropy in general and Philip Morris in particular support the Brooklyn Academy of Music. And Philip Morris supports Jesse Helms. Philip Morris matches NEA grants and Philip Morris matches AFA grants. (AFA is the American Family Association of Tupelo, Mississippi.) Philip Morris can't lose for winning and can't win for losing. Philip Morris is a two-handed gun.

The Avant-Garde in general and New Music-slash-New Dance in particular inundated continental festivals of the '70s—riding a *new fiscal wave* of public and private philanthropic liquidity. New Music-slash-New Dance was a classic "Liberal's Darling," but "new" ball games are still played by the same old rules. If one *must,* by law, support the avant-garde, would it not be *best* to perpetuate, through selective capitalization, *an upper-middle-avant*—whose dancers hail from Bennington instead of Bed-Stuy and whose composers study with Nadia Boulanger before Fulbrights whisk them off to India, Africa, or Bali—those culture colonies known for their raw materials? The avant-garde is a two-handed gun.

In the Endowment mirror I can see myself to be a fake. I play the counterculturalist but . . . hey! . . . I taught at Yale. I'm a cultural pluralist, but . . . hey! . . . I'm white and I'm male and I even, finally, at age fifty-three, love my mother. I rail against fat institutional felines . . . when I am a willing un-duped party to the system one plateau down. Buddy Holly will rise from the grave singing, "That'll Be the Day"—"the day" the Institutional Radio Choir of Brooklyn or Moods Pan Groove get an Endowment grant. No, the so-called plurals of cultural pluralism that I work with are funded through me. Hey! I'm a two-handed gun.

With my two guns smoking in front of my federally funded mirror, I suddenly understand how to understand myself—I put on my cowboy hat and then I write my initials in saddle soap—"L.B." right under my reflection—and then I add a "J." For the American Artist—to understand himself—and to see why we have a National Endowment for the Arts—that artist must peer deep into the heart

of Texas—into the heart of L.B.J.—and determine whether the heart was a Heart of Darkness, a Valentine of Light, or a Cardiac Arrest.

The Great Society—its programs: civil rights, antipollution, Medicare, education, humanities, arts, the whole Eighty-ninth Congress Santa Claus sack—was, I believe, perceived as a payoff to the liberal establishment—a bribe to support, or at least to condone, war. The war itself was a payoff to the conservative military-industrial complex for its grudging support of civil and social reform. It was a kind of double-or-nothing deal—winner takes all. Victory reform would unite all America into a constituency—and the wheeler-dealers who unite America go to the President's Hall of Fame.

Neither side bought it. "Hawk" America said *no deal* in the form of Nixon, Reagan, and Bush—a twenty-five-year war of civil erosion. "Dove" America, on the other hand, reacted quickly, violently, and burned itself out by 1972. But in those heady moments of the summer before the Summer of Love, called the Summer of Foreplay, bedlam reigned on the South Lawn at the infamous "White House Festival of the Arts."

Legendary were the rejections perpetrated by Kennedy—clan and world—on "uncle cornpone." And legendary were the reactions they inspired—*paranoid* and *schizophrenic* were the words used to describe them.

Scenario for an Arts Endowment (first treatment): As much as he hated writers and painters who embarrassed and insulted him, so much did President Lyndon B. Johnson need them to become immortal. Somewhere there would be discovered the Thucydides to his Pericles, the Virgil to his Julius, the Shakespeare to his James the First. How could a Great Society go down in history without some subsidized prince of the arts and humanities to apotheosize it? How could Lyndon manage his ascension without a Rubens to paint it?

Strangely enough for a country boy, L.B.J. had a limited understanding of dogs, and an understanding of dogs is a prerequisite for the understanding of the American artistic sensibility. A dog bites the hand that feeds it. Why? Because the hand that feeds it looks

like the one that whips it—and being a lazy dog, it bites the nearest hand it can get its teeth into. Why? Because a dog is a domesticated animal, with the pent-up rage of the wolf that sold out and came in from the snow—a rage of self-hatred. Because the hand of the master that once saved its skin now lies upon its impotent soul.

This piece was originally commissioned by the two foundations most responsive to my plights and pleas. Without them and the National Endowment for the Arts I could not have written poetry, or fathered children, or produced theatre, or swum in Lake Como, or gotten my teeth fixed, or paid my mother's rent, or worked with Morgan Freeman, or, or, or . . . I simply would not have been this fantasy junkie that I am. I would not have been able to support my habit. I would have died—O.D.'d on bad drugs called, collectively, "Reality Americana." I owe them a litany of gratitudes and beholdens. I should endow a shrine and burn candles. Why do I—more dog than Andres Serrano—piss on them in passing?

Am I an ingrate? No, baby! This is America. I'm not an ingrate. I'm a schizophrenic. Two guns in hand, I roam the White House like L.B.J. shouting, "Fuck the intellectual community!" There goes one trying to take the money and run! I shoot him in the back—right there at my Garden Party barely missing Ricky Nelson.

I am the impossible rejection of the impossible rejection. And at the same time I am a believer in the impossible resurrection.

The NEA is a minor footnote to a major fantasy—a modest structural illusion in a delusion of grandeur that in twenty-five years has grown, like the loaves and fishes, from the figment of one man's imagination into a collective figment large enough to feed a multitude.

It was born in an illusion; it has become real because it ministers to real need. It was conceived to serve Euro-art and perpetuate the fallacy that American Culture lives abroad. But, battle by battle, panel by panel, it questions its founding's premises and expands its definitions as it sincerely tries to respond to the changes we demo-

cratically undergo. Losing battles: Time will tell—perhaps only a "really" long time will "really" tell.

It's stupid to think of the Endowment dying now. The Endowment has been comatose for a decade to all but those who were first embraced by it when it still breathed, and for whom it has kept a little life via nostalgia. Why is the Endowment the hottest issue going? Well—what issue was ever hotter than blood sacrifice? The Endowment is a blood sacrifice to propitiate the gods. Guess who the gods are.

And though you may feel the pain of the blood of the lamb, it does not necessarily mean that you admire sheep. It's just that we live in a relative world. I prefer sheep to hyenas.

And so let me make my position clear. One must support and preserve the National Endowment for the Arts because sheep are better than hyenas. They are nicer animals. And when the sheep die, the hyenas revive by feeding on them.

I lived in the '50s, a child in the age of hyenas. A lamb entered my life. I should have known that this lamb would grow up to be sheep. But I would still rather have it than the hyena, because a sheep can still give birth to another lamb. And with hyenas, it's hyenas all the way down.

THE THEATRE AND ITS TROUBLE (EXCERPT 8)

29. *"So, you want to be an actress!"* This is known as *Boleslavs-ki's camp*, and there are various versions. If you've put the right name by the right *camp* your matching quiz should read like this:

Stand on your head	Grotowski
Do what I tell you	Reinhardt
Get a little distance	Brecht
Dream	Richardson
Feel now, show later	Stanislavski
Be cruel	Artaud
Don't be cruel, be a flower	Zeami
Take it off	Judith and Julian
Put it on	R. Foreman
Acting is semiotics	Delsarte
Acting is biological mechanics	Meyerhold
I am the truth	Strasberg
No! I am the truth	Bobby Lewis

30. These *camps* pretend to be scientific. It follows, then, that poetry is theatrical pork, and science must be kosher.

CHAPTER SEVENTEEN: DOG DAYS AT MABOU MINES, A CRITICAL DETOUR

BY STEPHEN NUNNS, 2002[38]

FALL 2000

O n New York's Lower East Side, in the crumbling Performance Space 122, up the worn marble stairs, inside a converted classroom, a dog is howling in pain.

Sort of.

The scrappy little mutt's just born a "love litter"—thanks to an absentee mate—and her mournful whine, with the help of some pedal steel guitar, suddenly assumes the twang of country:

(Maude Mitchell intones à la Tammy Wynette:)

Life dumped in my lap when all I asked for was a little poetry.
A single mother of eleven. They all needed shots and collars.
I could barely keep food on the floor. I was devoured by my

38. A version of this chapter was originally published as "Ecco Mabou: Behold Mabou Mines; Still Avant-Garde After All These Years," in *American Theatre*, February 2002.

Ecco Porco, *New York City, 2002. Center, Fred Neumann; clockwise from top left, Clove Galilee (Breuer), Jane Catherine Shaw, John (designed by Linda Hartinian), Sarah Provost, Karen Kandel, Gita Srinivasan, Maude Mitchell, Rose (designed by Julie Archer), and Barbara Pollitt.*

love. My love was devoured by the system. A domestic animal without a spouse needs a domestic in the house.

How can I know what I know, and still do what I do? How can I love you?

I saw the whole movement of my life away from my basic animal nature. The puppy-doo piled up in corners. The fleas in drawers. When a dog tries standing on its own two feet—it's down on all fours.

Soon the dog, Rose, is interrupted by a timer going off. She slinks back to her folding chair while Porco, a pig, steps center stage to snort and paw his way through a life story of porcine woe.

. . .

This is Mabou Mines, one of the country's premiere experimental theatre groups—still experimenting after all these years. And this workshop production of founding member/writer/director/*père terrible* Lee Breuer's *Ecco Porco* marks the latest in his Animations series—a collection of theatre pieces which spans thirty years. Though Breuer is old enough to collect Social Security and Mabou Mines is old enough it *ought* to qualify (since everybody knows thirty years of hardscrabble life as an avant-garde collaborative ensemble is more accurately measured in dog years), they are still going strong.

Obviously, this particular old dog still has a few new tricks up its sleeve.

This month Mabou Mines brings New Yorkers the latest installment of its edgy and iconoclastic art in *Ecco Porco*, which roughly translates as *Behold the Pig*. This latest play stars Frederick Neumann as Gonzo Porco, Ph.D., an avant-garde swine who has been condemned to participate in "Family Weekend" at a rehab center. The portly fellow sits alongside a dog (alternately played by Ruth Maleczech, Karen Kandel, Maude Mitchell, and Clove Galilee), a cow (Maleczech), Marge Simpson (Honora Fergusson), and a collection of troubled human "fictions" in an Animations Anonymous meeting. Each creature struts and frets its moment on the stage under the loose conceit of "drama therapy." The dog, Rose, has flashbacks to the hardest Dear John letter she ever wrote, and wrestles with her conscience over a bunny she once murdered. Marge Simpson is a recovering animation struggling to restore the third dimension to her soul. Sri Moo, the guru cow and philosophical head of the rehab center, offers religious analysis and social context ("We all concur with the surgeon general, who states categorically that 'animation addiction is the number one health concern of the free world.'").

And finally, there's Porco. Porco is the piggish asshole in all of us. The hog is a querulous old coot who alternates between self-pity and indignant defense of his actions. He brags about his achievements (winner of the Nobel Prize for isolating the Dramaticon); he

bemoans his failures, making veiled poetic allusions to having lost his beloved child to the state for bad parenting ("Did the lady from the agency find a little red pig on a crème de menthe lawn? Did he cry wee, wee, wee why has my father forsaken me?"). He's the guy who's compulsive and can't keep his mouth shut—even though he rightly views himself as on trial. And in the group dynamics of rehab, he is eventually pilloried as a martyr. Porco is wallowing in Purgatory. Th-th-th-th-th-that's all folks.

Welcome to Lee Breuer's mind, a place populated by animal archetypes, conceived in filmic cuts and fades, described in poetic puns, and staged in a manner that whips viewers into intense emotional narratives (no matter that they're delivered by a dog) and tosses them out with cool stylistic diatribes on Emergence Theory. It's a fascinating and amusing—if occasionally confusing—place to visit. And not just for strangers.

"*Porco*'s a very wild one," chortles Maleczech, who has been performing in Breuer's Animations—the name of his series of plays—over the course of thirty-plus years. All told, she's been working with him for forty-seven years, so she speaks with some expertise. "It's chaotic. It's built on chaos theory." She gives a wry chuckle: "Or is it chaos theatre?"

For his part, Breuer contends this is the best play he's ever written. Which he says about every play he's written, as he's writing it. He also sings the praises of his cast—"They probably have about thirty Obies between them," he says—describing them as the best cast he's ever had.

It's seems rude to point out it's the same cast he usually has.

JANUARY 2001

On a cold January night, Mabou Mines is presenting a second workshop of *Ecco Porco* in the company's same workshop/rehearsal/storage space at P.S. 122—a room sentimentally referred to as ToRo-NaDa (an abbreviated amalgamation of deceased associates' names

which loosely translates as "No Bull"). This time there is a real, paying audience, and the scene is, well, chaos theatre.

Breuer has been cutting and pasting new material right up until ten minutes before showtime, leaving veteran performers and company members Neumann and Maleczech struggling to cram lines. ("What's a matter, Ruthie? You never used to have trouble remembering last-minute lines," Breuer pleads in the hallway. "I used to be younger," the chain-smoking Maleczech mutters.) Curtain is delayed because of a glitch in the rickety fly system that makes Maude Mitchell dangle eight feet off the ground, directly above the nervous audience. During intermission—which falls in a different spot every night—the sound operator gets locked out of the building when he runs across the street for a much-needed cup of coffee. His absence is detected only after the actors and audience are in place, the lights go down and no music comes up. In the middle of the show, Breuer, who paces behind the risers each night mouthing the words, has to call out a line to Neumann: "What's in the box, Fred?"

It's seat-of-the-pants theatre, one of Breuer's fortes, but this time the audience looks a little shell-shocked. Still, it's hard to tell whether it's the rawness of the execution or the radicalism of the production. After all, the audience is comprised mostly of my New York University drama undergrads. At first, the twenty-year-olds are game, but as performers wander in, sit down in folding chairs beside them and begin the "Animations Anonymous" meeting they grow cautious. "For the crackhead as for the artist, the issues are the same—they're junkies," Terry O'Reilly, playing the facilitator, intones. "Addictive behavior is show business. There are twelve steps to sobriety. To be sober is to stop acting." Rose, the enduring star of Breuer's earlier piece, *An Epidog*, operated by puppeteers Barbara Pollitt and Cathy Shaw, enters and lays her paws and chin on an unsuspecting audience member's lap. Then Neumann, in the title role, shirtless, with his wonderfully prominent gut in plain view, snorts his way through one of Breuer's long, Daffy Duck-meets-Dante monologues, and the students' expressions change. Where once they were slouching in their seats, with smirky undergrad-

know-it-all looks, they now appear confused, perplexed, challenged, and transfixed. Neumann directs most of the speech to a wide-eyed NYU junior beside him, and the girl stares: Toto, I don't think we're in scene-study class anymore.

Slowly, though, the kids get into it—by the end of the piece, after enduring a two-hour evening that includes graphic descriptions of interspecies sex, large rubber phalluses waved in their faces, graphic violence, and even—inexplicably—a tango number, they're applauding appreciatively. But they're also, on some very basic level, *utterly confused.* As one student (who is, in fact, enrolled in NYU's Experimental Theatre Wing) says, "What *was* that?"

It seems a little surprising that a bunch of savvy New York–based theatre majors would be quite so at sea with Mabou Mines's work. After all, this is a generation that has come up in the digital age. They were born at the same time as MTV and nursed on irony as the prevalent cultural sentiment. To them, interculturalism is second nature—for better or worse, issues of cultural appropriation rarely come up, and so they happily sample various other civilizations as if they were helping themselves to a very diverse and appetizing salad bar. (Taking a cue, perhaps, from Madonna, who now sports a bindi.) To these twentysomethings, deconstruction and postmodernism are a way of life.

But maybe that's precisely *why Porco* side-swiped these kids. Though the company's work has certainly changed with time, it remains radical. There is both an aesthetic consistency (based on those old-fashioned modernist tenets of abstraction, rebellion, and experimentation with form) and a firm commitment to the democratic (some might say anarchic) ideal of collaboration. While efforts to survive true collaborations felled most of their ensemble peers in the '60s and the '70s, Mabou Mines persisted. And it hasn't been easy. "This is the hardest way to make work," Maleczech says. "You put people in a room with phenomenal egos and no hierarchy to settle the matter and you duke it out until you come up with the best ideas anyone can come up with."

An Epidog, *Here Arts Center, New York City, 1996. From left, Fred Neumann, Rose the dog (designed by Julie Archer), and Ruth Maleczech.*

Mabou Mines's work is simultaneously anachronistic and prescient. Comparing the group to other American experimental companies and innovators demonstrates the difference: Mabou Mines eschews the cool, technological distance of contemporaries like the Wooster Group; and while much of the company's older works, like Breuer's early Animations, might be considered harbingers of Suzan-Lori Parks and Mac Wellman's language plays, Mabou's focus on the literature has always been balanced with a dedication to the practicalities of the actual performance, to theatricality. However, that doesn't mean there's a preoccupation with a specific performance technique like that which marks the work of Anne Bogart and her SITI Company; Mabou Mines performers are notorious for stealing from a myriad of styles or performance aesthetics, often artfully switching from one to another within the same piece.

If the Miners are postmodern in any way, it's in the kind of good old-fashioned anti-essentialist way of doing their work. The company's mix-and-match approach to creation has always given its overly cultured audiences a fun way out. When they've dabbled (quite seriously) in the visual and musical arts, they've always hinted that you don't have to know all that formal technical gunk. The same goes for the kind of salad-bar approach to anthropology they practice when they lift theatrical styles from other (mostly Eastern) cultures. It's not that the company members aren't deeply serious about what they do—they are. But there's an implicit liberationist message to the audience: Leave your artsy preconceptions at home. Answer with your gut. If you respond to the stimulus, the aesthetics will follow. It's not the other way around.

Neumann explains it this way: "It wouldn't be Mabou Mines if it had compromised itself and faded into the woodwork or into the mainstream of 'avant-gardism.' I think we've become rougher and tougher and yet more refined and subtle in our work."

So, Mabou Mines is still a moving target, even thirty-two years down the road. Mabou Mines's five company members—Lee Breuer, Sharon Fogarty, Ruth Maleczech, Frederick Neumann, and Terry O'Reilly—are co-artistic directors. Together, they make all decisions concerning repertory and touring, functioning at various times and sometimes simultaneously as actors, writers, designers, technicians, and at all times as the producers of each season and as members of the board of directors. The collaboration on and offstage is an arrangement fraught with challenges, but one that has also yielded remarkable results.

And although on the surface, their work can at times seem anachronistic—the hotness of their performances and the low-tech and communal nature of the work can seem weirdly out of joint with our contemporary cynicism—it's precisely that commitment to an old-fashioned, modernist style that actually makes the work feel so contemporary. Who'd've thunk it? By sticking to their avant-garde guns for thirty-two years, perhaps Mabou Mines has become the experimental theatre company for the new millennium.

NOVEMBER 2001

Inside Mabou Mines's ToRoNaDa space, the company is heading into the homestretch of *Porco* rehearsals. Rose, the dog, has filed a worker's comp suit against the Institute and Animations Anonymous alleging, among other things, that they've treated her like a dog. Or worse, a dog puppet. Onstage, a wooly-headed British barrister named Sheepish, played by O'Reilly, plaintively wends his way through closing arguments:

> It is an axiom of cognitive psychology that eighty-five percent of all cerebration is "mentifactoid"—logical fantasy.
> We must make a case for the affective foundation of creativity itself, for "truth" as "fiction."
> We must establish beyond a reasonable doubt that for the mind, eighty-five percent of life is art.
> Mind is reality. Mind-altering drugs change one's sense of reality.
> In light of this, I ask the court: Is the plaintiff "real?"

This is Mabou Mines's perennial question and favorite plaything. As the puppet, Rose, crosses her little furry arms—three manipulating puppeteers fully visible—Sheepish hammers his point home:

> Is she for real? Is she a realistic character? Is she living in realism? Or is she some formal stylistic conceit, some excrescence of the art world, something impressionistic, an image, a metaphor, an analogy, a copy, a simulacrum, a caricature, a cartoon? Just look at her. A canine quadruped made out of fabric—pure fabrication.

Is she real? Does it matter? Whose narrative holds sway? Rose, like Mabou Mines, stares back at Sheepish, a challenge in the thrust of her dog's chin: I'm still here.

CHAPTER EIGHTEEN:
THE EMERGENT MARTYR

In which Breuer considers the death of character

FROM AN INTERVIEW WITH STEPHEN NUNNS, 2001

What compelled you to write Porco?

Part I of the trilogy that concerned the dog was finished in my head, and I knew that Part III—which concerns the ant—was pretty blocked out and framed. It was a great funerary finale to the whole thing and it was done.

I associated the dog as being in hell, and the ant—which was an innocent like the Red Horse—as being in heaven, metaphorically, and so I needed a Purgatorio to deal with if I was going to try to do a *Commedia*. And I always wanted to do a revamp of a character that had its birth as the B. Beaver. This was Porco.

Where is Porco *in the structure of the entire* Commedia?

If this was a classical *Commedia*, there would first be the *Inferno*, then *Purgatorio* (Part II), then the *Paradiso* as Part III. So you would look at *Porco* as Part II. But once I started working on *Porco*, I fell in love with the idea of cutting the trilogy up cinematically—jumping from metaphorical frame to metaphorical frame—a collaged exposition.

This came from one of my favorite little parables in the *Mahabharata*. It's really interesting: Yudhisthira, the king of the Kauravas, after the great battle and his death, goes to heaven. In heaven, he wanders around and eventually finds his family. They are all suffering terribly; they are in agony. And he thinks, "This is not heaven, this is hell." *But* he decides to stay there to minister to them. And the *second* he makes this decision, music plays, the sky opens up, and golden rain starts to fall. And it becomes apparent: It's actually heaven.

So, whether it is heaven or hell is subjective. You can be sequentially in hell, heaven, *or* purgatory. It all depends upon how your mind looks at the moment.

Given that, there are intricate switches about whether the events are being perceived from the point of view of the *Inferno*, or the *Purgatorio*, or the *Paradiso*. The emphasis might be on story one or story two or story three, but they would be phased. It wouldn't cleanly divide into three separate works like *The Divine Comedy*.

Can you talk about the performances? You've been working with Fred [Neumann] for a long time

Well, I've worked with Ruth the longest. I've been working with Ruth since she was eighteen. We're talking about almost fifty years. I've been working with Fred since 1967, so that's about forty years. Karen [Kandel] for at least twenty years. Clove, all her life

Did you have Fred in mind when you wrote this?

Oh, yeah. I kept thinking that the B. Beaver character was coming to fruition in Porco. It *had* to be performed by Fred. And I wanted to write it while he was still able to do it.

In the scene that I'm working on, there's a trial about whether Rose [the dog] is real. And it's proved that she's not. She's a fabrication. And because she's a fabrication, the figments of *her* imagination are fabrications as well. So, her master and lover John is a fabrication too.

Everything is a fabrication. What we have is a kind of a post-modern cliché where we're not dealing with *characters*—we're dealing with *stories*. This little joke comes, where we look at the socio-biology of it all, at the evolution of stories in Darwinian terms. We realize that the performance is sui generis and has nothing to do with the character.

Characters have nothing to do with the performances?

No. The *characters* of Rose and Porco have various versions. There's the *Frederick [Neumann]* Porco; there's the *Truman [Capote]* Porco; there's the *Orson [Welles]* Porco. For Rose, there's Country Rose (Maude Mitchell), Project Rose (Karen Kandel), and Flower Child Rose (Clove Galilee). So, we're trying different personality varia-tions on the character themes.

What I'm trying to do is make the point that the character per-sona is not the actor that's playing it. An actor is like an energy that produces a role. Four or five actors could all play versions of the same role, or one actor could play four or five versions of the same role. The role and the actor have nothing to do with each other.

I originally got this idea when I saw Japanese theatre—particu-larly the Bunraku. First, the singer or storyteller would play *all* the characters, not just one. Kind of like what Karen does in *Peter and Wendy*. But then, what's fascinating is that in the second act of clas-sical Bunraku—because playing all those parts is tiring—a *second* singer or storyteller will come and play all the same characters. So, you see, there's a complete separation between who the characters are and who the performer is. The characters are fictions in the pure, book-narrative sense; the *biological* entity is the performer, simply putting in the energy.

What I wanted to do was make a play that was about the fictions; about the narratives. But the fictions are reified. So that I really wanted to get it clear that the play is about absolutely nothing. It's fraught with emotion and all sorts of psychology, and everything appears to be on a psychological level. But it's ultimately *proven* that there's nothing there.

It's pretty much like looking at *any* material object. If you get small enough, it is just space. It is just energy. There's nothing there. Every year, every atom in your body is replaced by another atom—most of which are from outer space. That doesn't mean *you* don't exist. You exist as the formal basis in which those atoms find themselves. So, while you exist as that particular form, the atoms come flying off and what was in you is now in me. But that doesn't mean *I am you*. Who *I am* is a formal arrangement of energy and who *you are* is a formal arrangement of energy.

In the same sense, a play is a form that these fictions take.

How would you say your work as a writer and director has changed over the years, and what has remained constant?

It used to be more lyrical. Now it deals a lot more with parody. The big key that I have now, that I didn't have in the beginning, is that I've finally relaxed into the idea that writing and directing are both one and the same thing. Directing is my final rewrite. I have found that I can't do the final rewrite unless I direct it. I need actors to do the final rewrite. I can't really get it exactly right on the page because I'm an aural writer—I write for sound and voice—and unless I *hear* it, I don't know if it's right or not. By the same token, once I heard it, I wasn't sure that I could get it back on the page in a way that I had *heard* it.

But I think I have one of the most incredible artistic communities that it's possible to have as an artist in the theatre—one that so few people have had. I'm a writer who has a great theatre company who does my work. And I also have a theory of performance that they help me experiment with. People who had this were Molière, Shakespeare, Meyerhold, and Brecht. People like that.

I'm in the process of inventing a performance style, and the company is experimenting with it. It's based on narrative and storytelling. It's based on the narration of story in a complex way. On one level it comes out in something like *Porco*, in another it comes out in *The Gospel at Colonus*, in another it comes out in something like

Peter and Wendy. But it's all different versions of narrative storytelling, owing a great deal to Asian theatre and puppetry.

I think this is part of the incredible luck I have. The few people who started a theatre—engendered a style, who had the actors who helped them establish it—the Elizabethan style, Molière's style of comedy. They were in a position to galvanize all of their influences because they had a company that was dedicated to performing their work, to taking the time to do it, to working out the particulars. [Richard] Foreman is doing this—writing and directing his own stuff under the influence of a very particular theatrical style. The difference is that he doesn't have a company, so he has to re-teach how to do Richard Foreman every time he recasts. When he was working with Kate Manheim, it got better and better and better because *she* got better and better at understanding how to do Richard Foreman. But when he started having to cast new people, they all had to learn how to do Richard Foreman.

The difference is that I have actors who have been working on how to do Lee Breuer for twenty years. I have *better* actors than Richard—I'm *luckier*—because they have this commitment to stay with a company and not to disband after each show.

How would you describe your theatrical style?

Cinematic narrative. Live cinema in which the filmic choices are made metaphorically and not literally. In other words, we're not cutting from realistic scene to realistic scene or anything like that. We're cutting from metaphor to metaphor. But the rhythms are completely filmic. Of course, film relates to ancient narrative storytelling. Whether it's Kathakali; or it's Balinese shadow puppetry; or whether it's the influences that went into Meyerholdian theatre. It's like a scenario as opposed to a play. I'm writing scenarios for the stage, not plays.

I started this with *The Red Horse*, and I've tried to continue the film metaphor by representing film language—cuts, dissolves, fades, stuff like that—*metaphorically*.

The performing style is an intricate composite. Ruth describes it as a theatre where you learn how to perform ideas. In that sense, it relates to Meyerhold and Brecht, in that it's formalistic. But we have, I think, a very deep interlock between the formalist tradition and the motivational, because everyone is a very *honest* actor, but also very versed in formalist technique. So it's the best of both worlds.

Where did your interest in animals come from?

I first became interested in animals as a metaphor for human beings by reading Kafka. Not just the classic, *Metamorphosis*, but also "The Burrow" and "Jackals and Arabs"—there are about ten different Kafka animal stories that are not as well known. They're all deeply psychological. It's like as if Dostoyevsky wrote *Notes from the Underground* for a mole—which actually would make perfect sense. It's a very thinly veiled human psyche. It ties to mythology in that the animal metaphor is usually seen as the archetype of the character. All commedia characters are animals: Pantalone is a goat. Zanni: a monkey. Dottore: a pig. Capitano: a cock. Brighella: a chicken.

So you get into the mythic level of human beings once you start to see their animal nature. There are a lot of acting exercises where you try to find the animal nature behind certain emotional ideas. And so this idea of writing animal monologues as if they were psychiatric sessions fascinated me. The animal metaphor gives it this mythic quality.

It's like the myth of a cartoon. You've got a complete archetype in Mickey Mouse. You've got an American archetype that goes back to populism, to a certain kind of Midwestern innocence. You have an archetype in Bugs Bunny.

And with Porco, *what are some of the ideas you are trying to get at relating to the martyr and his connection to the group?*

When a cat creeps up on a flock of birds, one bird will martyr itself by crying out. It's a warning, and becoming cat food allows the flock to fly off. Groups are programmed to produce martyrs. With human

beings I believe the martyr is a comedian who pushes the envelope and brings down the wrath of the establishment on its head.

You know the so-called theory of emergence they talk about now?

No.

The idea of emergence is that after a group attains a certain size, it becomes something entirely different. For example, the adhering of singular cells—they emerge as an organism, so that the whole is greater than the sum of its parts. That's what emergence is. The internet is an emergent idea of connections between computers. A city is bigger than the relationships of people that are in it because a culture has emerged out of it.

So, we're talking about what emerges when a bunch of characters are thrown together. The idea is that the emergent story *has* to be the greatest story ever told. And so, martyrdom is the key to the new, emergent drama called history. Every white blood cell in the immune system is a martyr. It's ordered by the metabolism to go out and find germs and die. There's no individual will. If comedians become culture's immune system—like armies are a country's immune system—there's no choice. To be enslaved to a nation or an idea—the implication is that you will die for it. And only then will something larger emerge.

This is why the greatest story ever told is the greatest story ever told. This is how we create God.

So, this is what *Porco* is about. The idea that animation addiction is the swansong of individuality. I was saying yesterday that we really ought to get down to the five signs of animation addiction—like the five signs of depression—flattened personality, adenoidal voice You see, the human soul has devolved into a cartoon. Beginning at the height of individuality, the Renaissance man/woman in the 1500s or 1600s, we have devolved steadily, particularly since the advent of late capitalism. Particularly in this country we have devolved steadily into life as an animation.

There was an interesting book that Arthur Koestler wrote many years ago about the Janus metaphor for creativity. I liked this very

much because he looked at the idea that organic reality is always two-faced. You're looking *up* at the larger organizational idea and *down* at the smaller one. So the human being is always looking *up* at the social organization and *down* at the cellular one. The god emerges out of each higher level of organization. So, you're always Janus-faced—looking in two directions—but instead of looking left or right, you're actually looking up and down. And the emergent is the emergence of the higher reality.

Supposedly, emergent science is as big a deal as chaos theory. They're really trying to get very theoretical about this idea of how something becomes more than the sum of its parts. It happens all the way through the physical system: Supposedly, atomic structure *emerged* into chemistry—that chemicals are *more* than the sum of the atoms. And chemistry *emerged* into biology.

I think it's an interesting idea—the perception of something crossing a threshold: a liminal idea where fictions becomes bigger than the sum of their parts. And emerge as the greatest story ever told.

Now, this kind of stuff may not be funny to too many people. *(Laughs.)* I don't know, but we'll see.

Where do you see yourself and Mabou Mines in ten years?

Retired. *(Laughs.)*

No, every five years I've made a commitment that I'll go another five years. The last commitment was in 2000. So, I think that somehow, it'll involve winding up. I think I'll wind my way through the life of Porco, and I think *Peter and Wendy* probably has another tour or two in it. But all I really want to do is finish the trilogy. And when that's done I may or may not want to stage something from *The Warrior Ant*. But that'll be it.

CHAPTER NINETEEN: COMEDY AND THE SYSTEM

In which Breuer conducts a pataphysical exploration of comedy and death

BY LEE BREUER, 2009

The question for me has always been: How d'you do metaphysics and philosophy and be funny at the same time? I mean, it's really about having distance.

I've had this bootstrapping mentality toward philosophy—I've barely had an education. But I do think that I have a worldview, and I think I propound that view in ways that have irony—that have a kind of cutting edge.

I'm really not gullible, but I'm actually *more* gullible than anyone else 'cause I buy *everything*. It's like the Buddhist notion of maya versus void—there's really nothing much in between for me.

Porco Morto is the last thing I've written.[39] It's about a pig that loves *The New York Times*. He has this abusive relationship with the

39. *Porco Morto* was performed as part of a double bill with *Summa Dramatica* under the title *Pataphysics Penyeach* at Mabou Mines's ToRoNaDa Space, New York, in January 2009, as part of the Public Theater's Under the Radar Festival.

paper. It's kind of about the sexuality of media illusion. Ultimately, it's an attempt at an insight into the system.

The way I think about it is that theatre is the cunt of culture; it's the *key* to the reproductive system of culture. It's really about the genetics or "memetics" of culture. One embraces nature, at the same time as embracing nurture It's actually not a dichotomy in terms of the way things *develop*. What we call "culture" actually has its Darwinian aspects, and really comes through in the expression of *genes*. Culture has its own development that actually *changes genes. Biology is totally bound up with culture* in this totally chaotic Darwinian way.

So, theatre is the genetics of culture.

It's Koestleresque; it's Janus-faced. It's this place between the life-form and the biosphere—which is a super-organizing organism unto itself. So theatre relates to the sociobiological superorganism. The system becomes an organism unto itself. You can make the analogy to termites and ants; if we pull back and look at a city, it just looks like an anthill. There's no way you *can't* see that. So, you can easily extend the metaphor—a cell develops from a society of molecules. A society of cells constitutes a plant, or an animal, or a *person*.

Cells don't *think*—BUT, when a few billion of them come together, there is an emergence. Something *brand new* comes out of it. And out of these emergent qualities comes *animal behavior*. And when we come to the human pathway . . . biological cultural coevolution are the two wings of the Darwinian bird.

I *believe* this. And I think it's totally mirrored in the theatrical process. When I think about it this way, I feel like I'm living in a giant vagina that's just producing more and more culture and performance. It's supremely entertaining. And it's hard to be bored when you think of it this way.

Performance itself can be philosophically valid. I'm interested in metaphysics. But that's a *really* pretentious thing to say, so instead I call it *'pataphysics*, after Alfred Jarry. I don't pretend to be a deep thinker. I'm not. But I have a good instinct. I think Jarry called it 'pataphysics to indicate that it's all comedic.

My comedy wants to make an ontological statement—sort of like Jarry's. As I get older, things actually get simpler and simpler. I see what comedy *is*. I mean, look, *komos*—the root of the word—is a drunken improvised procession. It was a ritual all about warding off death.

That's comedy. And that is the most important thing that ties me to the Jewish tradition: Yiddish theatre, Borscht Belt. Now, I don't really feel a strong identification of *race*. But there is a genetic relation. It's *memetics*—the cultural gene. Any part of culture—the hook of a song, an advertisement—is something that lives in the memory, and it reproduces in much the same way as a gene. In fact, memes influence genes, and vice versa. So, you've got a *memetic* connection to your race, even if it's not *biological*.[40]

My memetics connect with the great Jewish comedians: Kafka, Berle, Dangerfield, Bruce, Allen.

Traveling teaches you a lot. When I spent time in Poland, I realized that Jewish comedy in the U.S. goes right back to the Yiddish. I'm sitting in a theatre watching a Polish actor—I'm watching the moves, the gestures, the *gestes*—and I'm thinking, "That behavior . . . is that Polish, or is that Jewish?" 'Cause behavior-wise, it sure looks similar to what a Catskills comedian might do onstage.

Migrations carry culture the way tectonic plates carry ice. Roman culture is carried to South America, and is imported into the U.S. by Mexicans. What is so-called "American Jewish behavior?" It's just Polish behavior that immigrated.

So I identify with that. But do I *really* have Semitic blood? I dunno . . . I probably have more German, Russian, possibly Hungarian blood. I'd really like to get my DNA read.

So, do I live the life of maya? Do I embrace the illusion? Or do I have the *intellectual choice* to *study* the illusion *itself*? The way

40. Unknown to me at the time of this conversation was Richard Dawkins's newly in print neologism "meme." This whole discussion of the genetics of culture is encapsulated by Dawkins's coinage, which has since gone viral.

I see it, illusion and comedy are ways to cross yourself when you see a vampire.

After fifty years of doing it, I'm finally figuring out why I'm in the theatre: I'm in the theatre not to think about dying.

Are dream states states of consciousness? Are we going from dream to dream to dream? If you are looking for the truth and the closest you can get is life's stories and its fictions, can you just rest with that? Can you just sit and watch them, and make beautiful constructions out of them?

I want to find an algorithm. I want to find the laws of how fantasy manifests itself in the laws of basic existence. And there's just no way of doing that without laughing.

That's where the notion of *Getting Off* comes from. Yeah, it's a sexual metaphor, but it's also about not being in the present, *not* facing death all of the time. Playing around with the metaphor of immortality. Getting off the world; stopping time; going into a world of theatre—a fantasy world. And laughing while you're doing it. Getting off is also what happens when you're judged not guilty.

The key to humor and creativity is aggression. You know, Ibsen kept a tarantula in a jar on his desk as a form of inspiration. He couldn't write unless he was in a state of rage.

The good jokes in my work show just how angry I am. I have all these mythological wars going on in my head to feed my creativity. Like my war with *The New York Times*. My thing now is that I want to outlive the *Times*. I want to see Frank Rich on unemployment. It's gonna happen—it's just a question of whether I'm going to live long enough to see it.

All of this is bound up in this crazy notion of fighting the system. You see, the system has replaced an authority figure for me—probably my mother. I can generate Oedipal rage whenever I want and spit bullets at all of them at will. It's my own tarantula in a jar.

Ultimately, I just can't buy the way things work. There's this notion of *dharma*—being ritually bound to take a particular position in the world. The place that is set for you. It's like the anthill prescribing a role to an ant. There's not much choice—it's a very

conservative view of how the world works. And I've always resisted that. I didn't want to become what my parents wanted me to become. So I don't know what paradigm I fall into. I was just resisting the one that was out there.

I don't know what happens if I win and the *Times* disappears. Is it Hegelian? Will *I* disappear? I don't know . . . but I'm willing to find out. Every time a CEO or corporate executive gets kicked out, I start to giggle.

I feel like the system has played me for a fool for seventy-two years. And now I see the *possibility* of revenge. I see my whole life as a revenge play. It's a crude motivation, I admit it.

But look, I know the score. I have one foot out and one foot in. I feel like I'm at war with the entire system around me, and I want it to collapse. But, of course, *I don't*. I mean, I'll be the first one to be disposed of when the chaos ensues.

Still, you kinda hope you kinda want to see how it plays out and how long you can last.

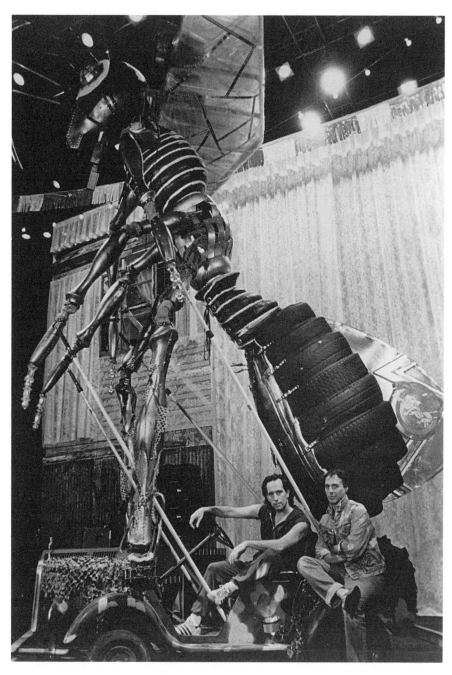

Bob Telson, left, and Lee Breuer with The Warrior Ant, *a carnival sculpture by Alison Yerxa. Spoleto Festival, South Carolina, 1998.*

CHAPTER TWENTY: WHY DRAMATIZE?

In which Breuer considers where the theatrical impulse really comes from

BY LEE BREUER, 2005

Portions of this chapter were presented by Breuer in his Phelps lecture at the Radcliffe Institute for Advanced Study at Harvard University, December 5, 2005.

I'm a Radcliffe Fellow this year, and at lunch my friends all kept asking, "Are you nervous?" "What are you going to say?" "Have you been up all night writing it?" I told them I don't use notes, and they said, "Well, good luck!"

Then it suddenly dawned on me: Something theatrical is taking place; it's almost like I'm opening a show. They should be saying, "Break a leg," or "*Merde*," as they say in France before you open a show. And I thought: My God, again and again the theatrical metaphor rears its head in our social intercourse. I started thinking: Why dramatize?

I believe that theatre is a social art, and this is why I'm really fascinated by the things I've learned from African performance in which there is no audience. This is the key to the whole thing. In

most of the musical performance and the narrative performances that I've seen in East and West Africa, you have the guru talking to the student, but it is sung and moved and then repeated and learned.

In other words, it's like a Q&A: You ask me a question, and then I give to you and you give back to me. But there is no *audience*—we're *all* performing in this space. And out of that space comes a social construct that is incredibly powerful.

The point here is that we have the ability to break down this defensive wall that we erect in order to keep the negative parts of culture out. To illustrate: You go into the subway and you see any number of people with earphones. Why? Because they are bombarded with millions of advertisements, millions of people trying to sell them this and that, hustle them—they are bombarded by a wall of aggression. In order to keep it out, people have to interiorize and block off. That reduces the attention span. Here's another dramatic law that you'll find—your attention is quadrupled the minute you're surprised. It then instantly diminishes and you need to be surprised again.

In order to reestablish community—to reestablish an interaction between you and me and us here—we need more focus, attention span, emotional interaction, and empathy. Empathy is the key.

You've probably noticed that I'm walking back and forth. I learned this technique from a Pentecostal church in Brooklyn. Most of the time when the preacher was getting all steamed up, he would walk back and forth just like that, and somebody would call out, "Take your time." Now, I've noticed that here at Radcliffe, nobody takes their time. I've never heard people talk so fast. But I want to establish the idea that both taking your time and speeding up are technologies for creating drama. If I, to take the Pentecostal track, were to look everybody in the eye, speak very quietly, and then suddenly yell . . . I'd be trying to bedazzle you. Whereas if I were talking very fast and put it all over like this using very big words—half of which

I don't understand—then I'd be trying to bedazzle you in another way.

In either case, culture and intercourse about culture have a presentational, theatrical base. There *is* a reason to dramatize—and that reason, on its first and rather humane level, is to teach.

We found out, going back to classic African theatricality, that you remember something better if you sing it, and you remember best if you sing it back: call and response. Philosophy and music are locked together—just like Plato said. The idea of dramatizing is the key to remembering, and when your library is in your mind (which was the case before the first libraries were created), it's critical what crosses over from short-term memory to long-term memory. That crossover is aided by drama, because drama creates emotion. And when we were given the amygdalae, the middle brain—the mammalian brain that puts drama into the information that we receive—we find that we're able to transpose it to long-term memory, to use it, to reference it, to go back to it, and to remember it in the conscious and the unconscious mind twenty to thirty years later.

Lo and behold, we have our own library in our mind.

We could get a bit more cynical and say that to communicate is to create a power trip. Consider any cultural and countercultural equation: I'm sure the West dramatizes the subduing of the East, and I'm sure the First World dramatizes the subduing of the Third World, and the Third World dramatizes to counteract the dramatization of the First World.

However, I think that's on a different level: It would be nice here, in an educational milieu, to rest with the idea of teaching and possibly secretly wonder: Is teaching power? And are we in the power of emotion?

I don't teach much and I don't have an extensive academic background, but I love to leapfrog through different worlds because it keeps them all fresh—the academic world, the professional theatre world, the avant-garde world, and the traditional world are all very different. The vocabularies are very different. So if we're talk-

ing about communication, we're talking about many different words for the same thing.

Alfred Jarry invented a send-up of metaphysics called 'pataphysics, which he characterized as the science of imaginary solutions. Within the science of imaginary solutions, one can become an artist. And one can find one's artistic traction because it is all art; and if it is all art, it is all acting. So one step further than "we act to teach each other" is the truth that all social interactions embody a performing presentation of self.

Language, as I understand from many scholars, is often mathematically analyzed, very carefully parsed, and scientifically examined. I have a counterview that communication via language could be a holistic process. You could look at communication not just as the words, but also as the tone of voice, the position, the pose, the context, the presentation—the entire *performance*. If you watch two animals relating, they're performing for each other. One is trying to scare the other. One is showing deference to the other. It has to do with body movements. It has to do with spatial position. It has to do with voice: big barks and little barks.

I believe that the entirety of performance is a language itself, a *total* language. The best metaphor I can come up with is mixing a record. Mixing a record: You see a twenty-four-track board, you know that there's four or five microphones for the drums, and the cymbals are on one, the snare is on another, and so on. There are also two microphones for the horns, and there are three microphones for the backup singers. When all of these things come together, there is the final mix—what is being said: Not just one voice (which is language); not just two voices (which is language and position and pose); not just three voices (which is whether I'm singing or speaking); not just four (which is whether I'm emotional or not emotional). *All of this combined is what is said.* And one element can counterpoint the other one. You can often say something and mean just the opposite; you can present two things; you can say I'm constantly

dealing with an opposition and will therefore have to choose what I'm going to be. Am I you or am I me?

In *Red Beads*, which we produced for four performances at the Skirball Center at New York University, we had eighty-four people in the cast, including the NYU jazz chorus and twenty-five student puppeteers. We only had three weeks to rehearse the whole thing. In that situation, the space and the imagery were talking. When Ruth Maleczech was acting, it was the dialogue plus the readings talking; but then when Basil [Twist] brought out the billows of beautiful silk lit from particular angles, it was space talking. So all of it is part of a complex language, an enormous communicative metaphor.

I want to present to you as a magical solution for communication that *we act for each other.*

We don't just simply verbalize. We don't write books to each other.

We touch each other as much as possible.

And that's why we dramatize.

THE THEATRE AND ITS TROUBLE (EXCERPT 9)

31. Descartes is the culprit. All is mathematics, even art. Scientific materialism turns *right* into particle physics while turning *left* into Brecht. And Stanislavski's is a nice equation, too. Acting equals Freud times Pavlov not so squared.

35. Art, the gift, is sometimes dangerous, but even so, I wouldn't put Descartes before de horse.

CHAPTER TWENTY-ONE:
ON *HAJJ*, RUTH MALECZECH,
AND THE MYTH OF MABOU MINES

BY STEPHEN NUNNS, 2015

The problem is cash
 That's a lie
The problem is cash flow
 That's a lie
The problem is flow
 Don't you know
 —"Lies!"

In the winter of 2013, Breuer's epic performance piece, *La Divina Caricatura: Part I, The Shaggy Dog* finally saw the light of day at the Ellen Stewart Theatre of La MaMa. The show arguably had been in development for thirty-five years, since it utilized material from *The Shaggy Dog Animation* (1978), *A Prelude to a Death in Venice* and *Sister Suzie Cinema* (both from 1980), 1996's *An Epidog*, *Ecco Porco* from 2002, and *Pataphysics Penyeach: Summa Dramatica and Porco Morto* from 2009. Breuer had been hustling to stage this work since Sun and Moon Press published an earlier draft of it ten years

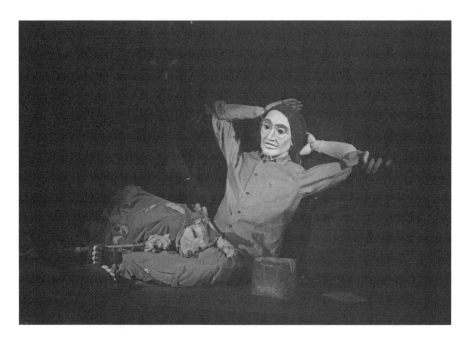

La Divina Caricatura, *La MaMa, New York City, 2013. Rose, a dog (designed by Julie Archer), and John Ham Jones, a filmmaker (designed by Eric Novak).*

before. The piece took no less than five producers—Wendy van-den Heuvel's piece-by-piece productions, St. Ann's Warehouse, La MaMa, Sharon Levy and Dovetail Productions, and Mabou Mines—as well as multiple workshops at Towson University and P.S. 122 in order to see fruition. And though he would deny it (it's supposed to be the first part of a trilogy), the three-hour-plus play was a cumulative work—a kind of kaleidoscopic retrospective of most of Breuer's career, encompassing various forms of Asian puppetry, Motown-style music, animal metaphors, recitative performance, and Breuer's own pun-filled riffs on classical literature and philosophy.

While messy and at moments incomprehensible with its fifty-person cast of actors, musicians, and puppeteers, by opening, it had gotten its act together enough to receive a rave review from Laura Collins-Hughes in *The New York Times*. "*La Divina* is indeed unusual: strange, singular, perfectly self-contained and so wondrous that it may leave you in a daze. Don't say you haven't been warned."

Although its "difficult birth" was usual Lee Breuer territory, in this case, it was not his fault. He had been feeling ill for months, having gone into rehearsals immediately after returning from China, where he'd been directing a production of *Shalom Shanghai,* a new musical theatre piece. He was hospitalized for kidney failure in Shanghai and the opening had proceeded without him. Back in New York, the state of Breuer's health put the huge cast of actors, musicians, and puppeteers on edge. It was eerily reminiscent of when he was taken to a Paris hospital in 2008—both hospitalizations, it turned out, were due to the progressive onset of kidney disease, the Paris *séjour* coming during the editing of the ARTE-commissioned film version for French and German television of *Mabou Mines Doll-House.* The Paris hospitalization also followed the death of Leslie Mohn, actress, writer, director, and mother of Breuer's youngest son, Wah. It occurred directly after a desperate round-trip flight to her funeral while *DollHouse* postproduction was still in progress.

> Once you die you live forever
> Once you've lived you're good as gone
> One's the billing, one's the fee
> Open your black box, baby
> Cash me in secrecy
> —"Hajj"

A little more than a year after the *La Divina* opening, Lee and I are in conversation. He is a little more reflective and contemplative than usual. Perhaps that's to be expected. After all, he is now the last of the Mohicans—the last man standing. Over time, most of his comrades and two of his partners have died. Of course, the '90s were a bad period, with David Warrilow, one of Mabou Mines's founding members, dying from complications of AIDS; Tony Vasconcellos, former executive director of the company, also dying of AIDS; Nancy Graves, the visual artist who collaborated on early pieces, succumbing to ovarian cancer; and Ron Vawter, performer extraordinaire, who appeared in a number of Mabou Mines pieces, including *Lear,* also dying of AIDS.

But the 2010s has turned into a rough time as well. In 2012, the husband-and-wife team of Frederick Neumann and Honora Fergusson—both powerhouse performers and mainstays of Mabou Mines—died. Neumann, *The B. Beaver Animation* and *Ecco Porco* star, was a longtime company member. Fergusson, the original Kristine in *DollHouse*, was an associate artist; their son, accomplished dancer and choreographer David Neumann, is now a Mabou Mines associate artist. Then, in 2013, just a few weeks before his hospitalization in China, Ruth Maleczech, the iconic actress/director/artistic director/cofounder of Mabou Mines, Breuer's onetime wife and longtime partner in crime, died after a lengthy battle with cancer.

If there was a single person who embodied the aura of Mabou Mines, it was probably Maleczech. It's no secret that she almost singlehandedly kept Mabou Mines administratively alive during the '90s through her sheer tenacity after the outflow of company members (five quit, including JoAnne Akalaitis, Ellen McElduff, and Bill Raymond, between 1990 and 1992) and the resulting dearth of new works, and during the culture wars when both government and corporate funding for the arts all but disappeared.

Of course, Maleczech did not keep Mabou Mines afloat singlehandedly; she had a huge amount of help from Sharon Fogarty, who initially connected with the company as an understudy/supernumerary/jack of all trades for various workshops and the New York production of *Lear*. (She once noted that before every New York performance she would drive around the Lower East Side, picking up the dogs and children for their appearances in the first act, and then return them after the act was finished and return to the theatre in time for her entrance during Gloucester's third-act eye-gouging scene.) Fogarty then went on to pursue a graduate degree in Ireland but came back to Mabou Mines a few years after the big company exodus, taking it upon herself to assist Maleczech in keeping the group fiscally afloat, first in the capacity as a company manager, and then as a full company member. (She is now the producing artistic director for Mabou Mines.)

Despite Fogarty's important contributions, there was little doubt that Maleczech was the matriarchal face of the company. And, more importantly, Ruth represented something beyond Mabou Mines. She was the embodiment of the independent and stubborn New York avant-garde artist. She raised Clove and Lute, her and Breuer's children, in a decrepit little Lower East Side walk-up (during a time when the neighborhood was known more for junkies than investment bankers). She was constantly broke, to the point of wrapping up her worn sneakers with gaffer's tape. She always delineated the difference between being "poor" and being "broke." "I'm broke because I *choose* to be broke," she once told me. "Poor people have no choice."

She was also unflinchingly willful and contrary when it came to her work. Talking about *Lear*, she said, "We got the worst reviews of any play Mabou Mines ever did. And I got the worst of all. That's something I am very proud of." Lee has another point of view. "It's unfortunate that I can't do *Lear* again. I always learn from my mistakes and do better the second time around. The mistakes stemmed from overproduction, and the unfortunate undue influence of a production of *Lear* directed by Herbert Blau in San Francisco that Ruth and I worked on as kids. That production starred a very unusual actor named Michael O'Sullivan who died shortly after. Michael's style reverberated in Ruth's performance in a production that was conceptually totally unrelated to the Blau production. There was no conceptual unity of style."

Her defiant nature manifested itself in other ways as well. Unlike any other New York actor, Maleczech steadfastly refused to join Actors' Equity for years, balking at the union rules and requirements. (She did eventually relent to join Equity in order to perform in an Akalaitis production.) This was part of rejecting the notion that she was an interpretive artist. She *made* work. It was what being an independent avant-gardist was all about.

Near the end of her life, when she was asked what the avant-garde was, she replied, "The avant-garde is a French military term, it means 'before the front,' it means 'we die first.' So in order to be avant-garde you must be brave, carry very sharp weapons, and

be ready to die." (A little less melodramatically, Lee suggests that avant-garde could be translated as "cannon fodder.")

Ruth's intransigence even extended to her demise. Despite the fact that she died relatively young—at seventy-four—hers was not a speedy death. She was in and out of the hospital for years starting in 2009, and through most of it, she refused to give up her Marlboroughs. But neither a diagnosis of breast cancer nor hospital stays could stop her from working—indeed, her declining health became the source of inspiration for her last, unfinished work: a re-envisioning of Molière's *The Imaginary Invalid*. She would play the part of Argan. (She liked to point out that when Molière played the part, he performed the role sitting on a commode, because he couldn't walk, and that he died on the night of the fifth performance.) The production was ultimately completed by Ruth and Lee's daughter, Clove Galilee in January 2016 at La MaMa.

> Lies: a study in cost
> Accounting. Lies:
> All lies: all . . .
>
> I have a spiritual life: package
> Includes food, shelter,
> Pediatrician, tuition,
> Orthodontist, summer camp,
> Loan, lawyer, bail, shrink,
> Pension and ascension. Gravestone
> Inscribed "Here lies a spiritual life"
> —"Lies!"

Whether or not Maleczech's death was a serious blow to Breuer is hard to say—they had been separated for decades. It has been said that Maleczech championed and actualized his work better than anyone else. Certainly, she was always a fierce champion of Breuer and his art. I recall a moment many years ago during my stint working at Mabou Mines when I complained to her about Lee's life-long undercapitalized productions and consequently a poor-man's-

Hajj, *New York City, 1983.*
Ruth Maleczech.

payday-style disregard for the bottom line of budgets. "Lee is an incredible artist," she said to me in a chastising tone. "This is *his* theatre company. You will *do* what he *wants*."

Lee is not terribly sentimental about Ruth. But he is respectful. On this particular afternoon, he wants to talk about one of their signature collaborations, the performance poem, *Hajj*, that was first performed in 1983. One of the first attempts at combining video work and live performance in a theatre piece, *Hajj* was a one-person multimedia tour de force for Maleczech. Sitting at a dressing table in front of a triptych of mirrors, the actress took a journey through her past to repay a debt she could never repay. The mirrors reflecting Maleczech mingled prerecorded images that also reflected her thoughts and remembrances as well as closed circuit close-ups that intensified the "liveness" of the reflections.

Despite its technological bent, the piece—which holds up remarkably well on video—focuses on Breuer's poetry. The three gold-plated mirrors that comprised a dressing table in the piece were actually one-way Plexiglas, with video cameras stationed behind. Depending upon Julie Archer's lighting design, the mirrors could offer Maleczech's actual reflection, a live video version of her face, or prerecorded video. (Archer also designed the set and won an Obie Award for her work on the piece. Craig Jones shot the video.) While Maleczech acted the poem as a monologue, she changed her makeup and performance to personify the three characters portrayed.

The performance poem takes its title from the traditional pilgrimage that Muslims are supposed to take to Mecca once in their lifetimes. But in this iteration, the title is a metaphor for an American woman's journey into her past to try to settle financial and emotional debts—mostly to ex-friends and lovers, but ultimately to her dead father, whose death mask (designed by Linda Hartinian) she dons at the end of the piece.

"I think *Hajj* is one of my best pieces," Breuer notes. "I really do. My problem is that I often get a little bit too baroque and esoteric about how I handle metaphors. The fact that all the details behind

the piece were real kept me grounded. It ended up being more emotionally grounded than other pieces.

"*Hajj* was for Ruth," Breuer continues, "and it was really biographical. "For one thing, her father actually did commit suicide. So, the piece was a metaphor for the pilgrimage to her father, Frank Reinprecht.

"Frank was a very interesting guy. He was basically a peasant from a tiny town in Yugoslavia. He came over to the United States, and quite quickly had issues with American culture." Reinprecht and his wife, Betty (his cousin, who was also born in Yugoslavia), eventually settled in Cleveland and he worked in the steel mills for much of his life. "But what he really wanted to do was write short stories," says Breuer. However, Reinprecht soon developed lung disease from the work (and from his chain smoking), and decided that he needed to uproot the family and move to Phoenix, Arizona, for his health.

"The play in a way documents the trip that Ruth took with her father to Arizona when she was eight years old," says Breuer. "It was the most intimate that they became in their lives—the most connected as father and daughter. And the video footage recreates that trip." (Lute Breuer, who was five years old at the time, played the younger version of Maleczech on video.)

Hajj consists of two poems, "Hajj" and "Lies." "'Lies' is about the costs of lies," says Breuer. "And it's also about debt. You know, when we were first together, Ruth borrowed money from her father, and then he killed himself before she ever paid it back. So, it became a big guilt blotch. It was the guilt instilled in the daughter that she never could expiate.

"You can't get even, you know? It's impossible to ever get even."

I sing of you, Alex, who I killed (of course I did)
And thank you, dear, for every fantasy I reaped
And curse you, cunt
 I owe you money

You've been dead for half my life. You are
My half life, love; you date my art
I see my art in the green glow of radium
Always less by half; I see this game
As cute as archaeology
 I'm gonna pay you

Baby, watch me dig you up
And stuff it up your sigmoid flexure
Watch me write this
 I sing of you
 —"Hajj"

The most interesting aspect of *Hajj* is that, in spite of its highly biographical nature in relation to Maleczech's life, the poems themselves were written long before Lee and Ruth decided to turn them into a performance, and they related far more to Lee's biography than to Ruth's. Basically, Lee Breuer the director was adapting and finding a performance metaphor for Lee Breuer the writer.

"See, 'Hajj' and 'Lies!' previously existed as poems," he says. "They are printed as poems in my book *Sister Suzie Cinema*. Combining them, making a play out of them, and making them about Ruth, was step number two. 'Lies' was a compilation of lies that I had told and what I thought the price of them was. And 'Hajj,' that was originally about *my* debt. I borrowed $40 from this girl, Alexandra Lukin, who I had an affair with back at UCLA. Eventually, she became the girlfriend of Mort Sahl, the comedian, and she started shooting heroin. And before I had a chance to pay her back, she O.D.'d.

"So, it wasn't that I just observed Ruth and wrote her story. It was actually about my own experiences. But in performance, Ruth's biography became the key to the whole thing: The idea of the pilgrimage with—and to—the father. The metaphor just fit so clearly, I knew that this was the right way to go with it."

Breuer believes that the piece was his most effective attempt at creating what he calls performance poetry. "I always wanted to

figure out how to do stage work that had the intensity of poetry," he says. "Not just a play in verse. But a poem that comes alive. I think *Hajj* was the most successful of my various attempts at the form."

> That I find your grave by matchlight
> In the winter. Fog lights on the river ice
> I can't believe my eyes; the glow of amber
> Glow of fire flowing underneath. Dear lady
> O how deep we are

(She puts on a mask of her father.)

> I want to kill and love
> In the identical motion
> In the identical word
> In the identical devotion
> —"Hajj"

During our conversation, Breuer refers to Maleczech's father as "a peasant," "a gun nut" (he committed suicide by shooting himself), and "a redneck." He also talks about her mother's obsession with Catholicism. It's hard to reconcile this background—the working-class girl from Phoenix—with the funky, electric-artificial-auburn-haired and chain-smoking artiste that Maleczech eventually became. "How does 'Ruth Maleczech' come out of that background?" I ask.

"That's a really interesting question," Breuer responds. And for the first time in our conversation, he pauses for a good long time before he continues.

"You know," he continues, "from an early age, Ruth wanted to be a nun. She *really* wanted to be a nun. But eventually, she transferred all of that energy—all of that spiritual longing—into doing theatre." He laughs. "So she became a nun of theatre and married a Dionysus instead of a Christ."

"Underneath all of that redneck stuff with Frank," he continues, "he was a rebel. He was totally buried by the system, society, and

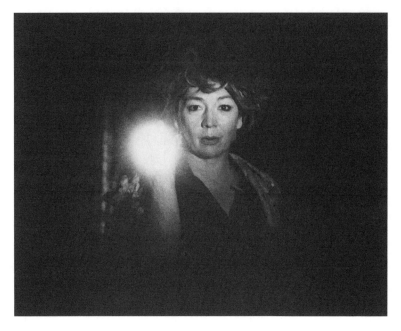

Hajj, *New York City, 1983. Ruth Maleczech.*

thwarted dreams, and yet he had these rebellious impulses. I think
Ruth inherited that idea of trying to break the mold. Her father did not
break the mold. But Ruth really did. She really outlived her times."

Lee believes that Ruth not only inherited her father's interest in
breaking societal molds, but his anger as well.

"I think she was a lot like her father. She had a lot of anger, and
her father was completely inundated with anger.

"I think that acting, particularly comedy—and Ruth was a very
special kind of comedian—is a transmutation of anger," he contin-
ues. "And I think that Ruth's anger went to the core of who she was
as an actress. I think if you choose art, it is part of wanting to beat
the system. You need to be deeply dissatisfied to make a whole life
of that. You need to be deeply dissatisfied with your fate. And her
fate was to get married and be a bourgeois housewife. That was her
fate. Or she could become a Catholic nun and live in a monastery.
Her fate was *not* to be an actress. But, you know, being an actress
was a way to be reborn, to leave the shell of fate behind."

(She rips a mask of her father in half exposing the left side of her own face.)

You can't leave me; that plan has a flaw
We'll never sort each other's atoms out
We are under sentence of a Boyle's law
For hope's dispersal in chambers of doubt

 —"Hajj"

"Many people think that *Hajj* was the best thing that Ruth ever did, period. It was certainly the best collaboration we ever had," Breuer adds.

Breuer and Malezech worked together after the piece, but to his mind, they never had as fruitful a partnership.

"There's a lot of mythologizing about us," he continues. "Like that *American Theatre* article," he says, referring to Randy Gener's cover story in 2007. "That glamour shot on the cover . . . the idea that we were, metaphorically, still married. It did us both a disservice. It was destructive, because it focused on the past and not on the contemporary work. I had just directed *Un Tramway Nommé Désir*, a re-envisioning of Tennessee Williams's *A Streetcar Named Desire* at the Comédie-Française, and then an opera of *Antigone* in Greece, as a fundraiser for Doctors Without Borders. Following Athens, I was under contract for a workshop at Towson, and the first workshop for *Guignol* was scheduled to begin afterwards. Around that time, I got shingles and I was sick, and so I passed on going to Mabou Mines's fortieth anniversary. But I also didn't go because I really didn't want to deal with the dated mythology, "the new music/new dance" pre–*The Gospel at Colonus* era of me at Mabou Mines. And, in truth, the anniversary belonged to Ruth."

"I mean, I contributed to it," he adds. "I know that. I thought it would be good for Mabou Mines to have a cover on *American Theatre*. I wanted to figure out some way to really pay Ruth a compliment and say thank you for her years of commitment by saying that she was my artistic partner. But by that point, I was in the middle of *DollHouse*. Maude was actually my artistic partner."

Breuer once again pauses for a moment.

"Mabou Mines was her world. Ruth believed in it—it was her church. She was hooked on the whole spiritual manifestation of Mabou Mines as a replacement for the church, as well as its political implications for Ruth as a feminist creator. She had to believe in it. And she believed in it until the day she died.

"Yeah," he says, after another pause. "It was the debt thing that *Hajj* was all about. "

> I hear my music playing
> I hear all my loves
> They're singing, listen, Alex,
> I hear what I'm saying, listen
> All the prayer bells stopped
> Ringing
>
> —"Hajj"

CHAPTER TWENTY-TWO:
THE FIFTH VOYAGE

In which Breuer rewrites Gulliver's Travels

BY LEE BREUER, 2017

Per his apocryphal Fifth Voyage Swift notes: "The first money I laid out was to buy two young stone-horses My horses understand me tolerably well; I converse with them at least four hours every day."

This honest admission at the conclusion of chapter XI of *A Voyage to the Country of the Houyhnhnms*, the fourth tome of my travels, has roused the suspicions of my readers as regards my sanity. Accordingly, while in the midst of a dialogue with Pimento, the equine more blessed with the finer horse sense of the two (we were engaged in a rapt discussion of two fine points in *The Ethics* of Spinoza) I was burst in upon by no less than five guardians of Bedlam, subdued and hauled unceremoniously away.

This morning I awoke with a stiff neck to discover myself chained to the asylum's west rock wall, whereupon I turned to face a grey diminutive individual, whose eyeballs rattled in their sockets like dice in a shaker. My visitor ceremoniously introduced himself as Herr Doktor Leary, while pleasantly adding the invitation to "Just call him Tim."

My treatment at the hands of Tim has been confined to cooking up a delicious peyote stew, which we devour for lunch with dark German beer. In truth I find it curious that at this advanced stage in my life (I am, after all, four score and have relegated travel to fantasies of my youth) I find myself tripping again, embarking upon this Fifth Voyage to the Land of the Arachnids.

As it was a "buttoned down dream" right out of Carlos Castaneda, I have few details to relate of my passage except to vouchsafe that it was on the wings of a blackbird. Was I flown thither? Or again employed as a ship's surgeon? Perchance again shipwrecked and cast adrift—the victim of a mutiny, to suffer abandonment by brigands on a forlorn spit of land?

Why not! Bullshit is addictive.

Accordingly, do I find myself on a forlorn spit of land covered in tiny tracks, one of which I follow, soon to realize that I track not a two-footed creature, nor a four, nor six, but eight. These eight tiny feet lead me circuitously to a rose garden—one which hardly resembles a flower bed at all as the blossoming stems and thorns are entirely covered with filmy webs. In each web there hangs an "eensy weensy spider" calmly spinning out its strand.

I had tracked my tiny prey through the night and thus it was by moonlight that I first came upon "the web-scape." Gossamer strands loop from bush to bush, each emitting a silvery glow as drops of dew clinging to the threads reflect pearls of the evening orb like necklaces of jewels—the whole display wrapped in a cushion of whispers.

Verily it is a cathedral I behold, a cathedral of choral meditation. As the spiders weep their confessions, they murmur a cantata.

It is crystal clear to me that arachnids suffer from a chronic malaise. Waves of pain rise from the web. The entire social structure radiates pain like waves of heat off a desert mirage. Inundated by its aches and pains, each arachnid drops what it's doing, bends over, and in an attitude of prayer begins to pull at its insides.

This labor gradually produces a strand of gorgeous silk, like a strip of exotic film. Where precisely does this ribbon originate? Theorists believe that this footage comes from the imagination, a

pure romantic extravagance worthy of a Byron or a Liszt. Personally, I observe, however, that it is pulled directly from the asshole.

When the silk attains a practical length, the arachnid begins to climb it, and achieving a few inches of height starts to swing. Here the comparative health of each arthropod becomes painfully clear. Some are so weakened by their internal exertions that after a single swing through the air their limbs begin to shake, or they suffer cramps, curling into tiny knots, and dropping off their silks, plop, into Reality, for thus the space below their fictions is called. Some climb to the top of their strands, where they lose their grip and drop from shear dizziness; others swing slowly to and fro, trembling with palsy.

This is a "performance installation." What is it called? I scan my imagination for a proper title: "The Art of Fear." Voila! I search for a suggestion box, but am disappointed.

As the moon sets, the sun appears hazed in a baroque mist that pervades the web with a black bile of melancholy redolent of dreams thwarted and of loves lost. Tears cloud my eyes as I watch each "eensy weensy spider" seem suddenly to lose its inspiration, to move to and fro three steps, four steps, and turn back upon itself with a sigh.

"They are too serious," I thought. What they need is a party.

The spider web enveloped the rose garden, in the center of which appeared to grow a towering Sequoia tree. The gossamer silks seemed to wrap each blossom, but their ends, instead of tying the flowers into a bouquet with a proper bow, appeared to drift upwards, higher and higher, until they disappeared into branching arms of the tree. It was these strands that seemed to elicit the highest levels of creative concentration. The air seemed alive with tiny creatures straining to climb higher and higher to a mythical spot from which all their fantasies were suspended.

And mysteriously, as the waves of scent washed over the blossoms I was able to discern through the pearly miasma that the tree was not a tree at all. What really rose from the center of the arachnid's rose garden was a great grandfather clock whose pendulum swayed over the cephalad society with a hollow "tick tock tick."

It was to this pendulum that the rising strands of silky illusions were attached. On the clock face was written: "Come smell the roses. Fiction is a fragrance."

Sociologically speaking, here was a consumer society that had consumed its product. These strands of illusions and the performances elicited thereby were all the consumables that the spiders had left, illusions of themselves that they pulled out of their own assholes. These were what they attached in their desperation to what they believed was the fixed point in the heavens, the goal of their climbing. But it was not a fixed point. It was the tip of a pendulum that traced its arc over the entire fragrance of reality.

As surely as dawn dawned on the web, so does it dawn on me that these spiders are artists, specifically, "escape artists," and that what I observe is a geriatric arts colony. Parked along the garden border paths are an array of strollers cleverly adapted for the eight-legged animal. Menus for special salt-free diets are posted and everywhere I see scattered hand bills for physical therapists, acupuncture, and aroma therapy.

As it was subsequently explained to me: Long ago spiders lived in an empire of things. The Arachnidia was once a consumer society with a classic historical trajectory. In its infancy, Arachnidia was a materialist consuming culture. Spiders wanted cars and washing machines, fashion was queen, and advertising invented its desires.

But then came a revised analysis. In 1968, a countercultural hippie intellectual spider named Debord had the bright idea to rewrite Marx. Famously he chalked on a Paris brick wall the words "Ne travaillez jamais." Accordingly, it was not capital that was the bane of society. It was mortality—precisely the conclusion that had been reached by the church. A late reformation was reborn and in order to construct a theory of salvation it was necessary to turn the Marxist formula on its head, so to speak, exactly as Marx himself had done to Hegel. Henceforth, economies were described not in terms of dollars and cents. They were broken down into hours, minutes—even seconds. Magically there developed a wholly new political economy based on "time consumed." In the arts, the stress and

pressure for status was no longer exerted by Money, but by Moments. Sin was equated with "wasted time."

An empire of things became an empire of ticks and tocks. And a vast web of credit was strung from rose bush to rose bush, unifying the strands of illusion into a banking system, allowing fictions to borrow moments from each other. Economically, a dangerous practice. Life on the web, an arachnid swinging wildly on its silk of illusion suspended from the pendulum, is described as "living on borrowed time." And the interest due on borrowed time is called "celestial usury"—a racket controlled by an arachnid mafia.

Through the bookkeeping of celestial usury, the temporal truth was unceremoniously revealed. This art world, was a culture whose Time Was Up. All it had left to consume was its fiction of itself.

Debord was the socio-physicist spider who disputed the Big Bang Theory. He published a refutation, "The Big Bong," in which he rejected the "academic cliché that had us counting Time from the beginning." He advocated counting time from the end—from not the Bang but the "Bong." It was customary for the grandfather clock to chime a big "Bong" that announced The End, that is, the fall of each and every "fictionalist" hanging on the web for its dear "life." Each "escape artist," was a universe unto itself, and each artistic universe commenced with a "Bong," that is, with its End. With time counted from the end tripping on one's strand became a war of attrition against, not a cosmos that expands, but a cosmos that implodes.

Here was an interesting exchange of metaphors. Creative efforts are bent not on stretching the Truth but on stretching Time, for fortunes are measured in longevities. And since very little can be accomplished on the biological front—a spider's lifespan is still eighteen months give or take four minutes—extending one's time by one's imagination becomes the order of the day. Of necessity, a Life becomes a fiction.

That I had stumbled upon an artist's colony became indubitably clear when, pausing by a tree, I saw, fallen to the ground, a large bookcase, the books spilled out, standing on their ends like little

graves. Over the literary graveyard ground were scattered loose brochures, one of which began as follows:

> Blah-do is best described as a self-conscious Mount Parnassus, a wooded paradise for the arts where Orpheus smugly strums his lyre, the muses hang from trees, and postmodern poets pluck Pulitzers off low-lying branches. It is a celestial startup conceived for financiers with foresight, a space of respite for aging creators whose labors are not likely to be supported by the mechanisms of an expanding market economy. The multi-acre artists' retreat was incorporated at an historical otherworldly moment when a division between popular and high culture had only recently taken hold. Within this new cultural stratification came the idea that an elite culture, one that would uplift, rather than pander to popular tastes would require new, nonmarket-driven forms of patronage.

The etymology of the name was explained as follows: the "do" of Blah-do is from the Japanese, meaning "way of" or "path of" such as Ken-do, the way of the sword, or Aki-do, the way of the harmonious spirit. Blah- a noun, adjective, interjection, or verb meaning twaddle, humbug, claptrap, blarney. Hence, Blah-do: The way of bullshit.

Observing these feverish cephalopods pulling at their assholes, it occurred to me, "This is addictive behavior. They're all junkies. By pulling their strands of silk out of their guts these arachnids are 'fixing' their souls." Apparently each believes that upon a particular ribbon is written the algorithm of God.

I spied the "eensy weensy spider" I had trailed from my shipwreck and invited the delicate exhausted thing to crawl onto my fingernail, which, when I raised it to my ear, continued its journey into the lobe and began to speak to me in such a loud tone that I thought it was amplified like a hearing aid.

"When the world is chaos enough," began the voice in my ear, "it gives birth to a prophet. We spiders in residence here are competing for that cultural reward. Every year, the nonprofit world dazzles us with new websites, residencies, prizes, fellowships, grants. It's a

funding competition to subsidize who will be next to save the world. But the art world goes through its hierarchy of fashion so quickly that it's hard for a poor arachnid to keep abreast. Today black will save the world, tomorrow women, followed closely by youth and transgender. When will come the turn of spiders?

"We who are the 'true Messiahs'—we'd better get busy. Saving the world is always undercapitalized and poorly advertised on media. Everyone is left to their own devises. Just to keep climbing takes all an artist's concentration.

"Except for that concentration reserved for watching out for jerkoffs. Jerkoffs belong to that faction of spider-hood that are uncontrollably jealous. When they see a happy spider climbing its strand, in a fit of jealousy they leap up and jerk it off. After which they proceed to climb its story in its stead. These jerkoffs are plagiarists. They climb other spiders' fictions. Most of the spiders you see in the world are jerkoffs.

"And most jerkoffs think they are swingers. Swinging on the web is usually done to the accompaniment of rock and roll. A spider swinging on its web is firmly convinced it is sexy. Its creative urge is invasive. Often it swings so hard it finds itself hopelessly entangled in every other spider's fictional affairs, making a tangle of inspirations that rivals the Gordian knot.

"And then there are the spiders of evil," said the voice in my ear. "There is only one family of spider more poisonous than the Tarantula. Observe: They are the tiny ones sniffing each web strand (the third claw on this diminutive spider is actually a nose)."

"What are they sniffing for?" I asked.

"Shit," said the voice. "These are Arthropoda Criticus, the critical spider. They are convinced that any fiction pulled directly from an asshole is pure shit.

"Looking down only to see one's work crawling with critical spiders thwarts the creative spirit. Recall the dance that you earlier observed, 'three steps and recoil.' Signifier of classic creative insecurity. Well, just picture it: A swarm of critics sniffing at the gems emerging fresh from your asshole. Here is the primary cause

of class depression. When we come to believe that all our work is shit. We are transformed into self-critics. Critics are a spider's parasites. They paralyze us with venom. This is diagnosed as Self-critical Paralysis. Then they crawl inside and eat us.

"We must be steadfast in the belief that our work smells like roses. We cannot accept that it smells like shit.

"Yes, we pull our fictions out of our assholes. And what comes from our assholes comes from our shit. It comes from our hopes and our fears and the language of our hopes and our fears is our imagination.

"You are a creator yourself. We are, at this very moment, crawling up your strand. Can't you feel Arthropoda Criticus crawling over your 'Fifth Voyage'?

"Pausing, sniffing, consulting, agreeing that as fictions go, it's a pile of shit. Now look further down your strand. Look at the noose!"

"I don't understand," I blurted out

"Creativity is prophecy," it intoned. "Every spider dangling from its web thinks it's a prophet. Every creative prophecy is an escape from time. A Gift. Every chapter, verse, and surah we pull out of our asshole is dictated to us by an internal voice. Swinging close to the ground this voice sometimes speaks with the rumble of intestinal gas. The higher we climb, the more beautiful it becomes. No longer akin to burps and farts, for some of us it is singing, for others it paints pictures or choreographs dances. Joyce thought the voice was a thunder."

"Eliot too," I replied.

"The voice is laughing," said the spider in my ear. "I hear a bubbling watery voice like laughter. As a messenger, my calling is to preach to the world what the voice reveals to me—but my messages come out one-liners."

"Trust it!" I intoned in turn. "The voice speaks the truth. For, Lo, the truth is twofold. It's either stand-up or a sitcom."

"You're being ironical," said the spider. The voice in my ear spoke severely. "My brother, your prophetic irony will evaporate. You will understand when your inspiration dies, when your mind flies off. It is a terrible moment when you realize you've lost your

balance on your strand, when you try to climb your fiction without your mind. Ideas flee. They hide in the shadows. They play games—hide and seek. Your story shrivels like a burning page. You try to read it as it burns, before each word turns to ash.

"Traditionally, when an arachnid reaches this stage of desperation it goes to the toppled bookcase. One by one it selects the remains of other artists' terminal efforts; one by one it tries to climb each fiction fallen from the shelf. And soon is overwhelmed with doubt. Am I being led astray? Is not this the fiction of a dead spider, of an escape artist who failed to get free, who fell off its fiction into reality. Am I a dupe?

"Doubt poisons the creative effort. Creative memories become tangled with each other and the poison courses through a spider's eight legs till they are wracked with pain and can't hold on. They begin to shake, and the whole world web shakes with them. One's evil thoughts take hold. 'I will not die until I can take the whole web down with me. I will shake every strand, every connection with my agony. The world must pay for my pain!'

"We're two of a kind," said the voice in my ear. It was excited. "We are both creative species. You are my brother, my family, and I want to tell you a family secret. See those empty strands dangling from the pendulum. Can you see what's on the end of each of them?"

I peered where it pointed and was aghast.

"At the end of every story, every strand of fiction, a spider ties a noose. That is an artist's failsafe. It's called 'a conclusion.' That is the place inspiration flees to when escape fails. Inspiration crawls as high as it can, and when it reaches the end of invention—when it's high enough on its tightrope to feel a fiction falter, high enough to see there is no escape—then a spider commits to its failsafe. It slips down the silken strand and sticks its head in the noose at the end. And as the clock tick-tocks and the pendulum swings, it finds its solution. A noose is escape guaranteed."

"What is the secret you want to tell me?"

"You are a spider."

"I am a spider?"

"Can't you feel your eight legs climb this 'Fifth Voyage'? Are you near the top? Can you hear the great tick-tock? Will you finish it, this 'Fifth Voyage'? Will you change the world? Look down, look way down the strand of silk that you have so laboriously pulled from your asshole. Can you see your escape? It's that tiny loop at the bottom. Your noose looks so tiny because it's so far below. But you know it's there, waiting. You're lazy. Every lazy arachnid needs a deadline. Can't you just hang it up?"

"Now you're being ironical," I said to the voice in my ear.

"I'm being insightful," it answered. "Every spider that dangles by its asshole from the web thinks it's a prophet. But can the prophet see the past as well as the future? Can it see the design of the abyss, the Greed, the Vanity, and the Horniness called the creative urge? Can you see what you're crawling toward? You think you're crawling toward God, but you're only crawling toward your fetish!"

"O Prophet, O Voice in my ear, can I request of you a brief tutorial? As an escape artist, what is it that one works to escape from? Surely not the clock, for all our fictions are relative to the tonality of the Bong and the swing of the pendulum."

"From Anatole France," said the spider, "who said, 'It is intolerable to believe that throughout the infinite universe there is nothing but eating and being eaten.' I would rather think that organic life is an illness."

Continued the spider in my ear, "In order for the world to hear the message it must first acknowledge that my prophecy is the only truth."

"What if you are wrong?"

"I can't be wrong . . . 'wrong' would mean"

"Mean what?"

"Mean my father doesn't love me."

"And does your father love you?" I asked the spider.

And the spider replied, "I don't know. He's gone. My mother ate him. She's a black widow. That's what spiders do."

CONCLUSION

BY STEPHEN NUNNS

I t's the spring of 2016, and I am trying to track down Lee Breuer. There are reported sightings: Lee and Maude Mitchell were down in Louisiana, interviewing the great Clarence Fountain for a film project, as well as doing some preliminary research for a possible musical based on the Colfax Massacre; they were seen in Umbria, Italy, with the legendary puppeteer Basil Twist, doing a work-in-progress showing of *Glass Guignol,* a new piece, as well as teaching workshops at La MaMa Umbria International; they were seen at Sarah Lawrence College, doing seminars; a short while later, they were at New York University doing the same thing. And then I was told he was in Brooklyn, reading excerpts from a new play at the FiveMyles Gallery. That was after a fellowship at the Camargo Foundation in Cassis, France.

Lee will be eighty years old next year, and whereas most men his age are fortunate if they can get it together to walk down the driveway to get the morning paper (and those *are* the lucky ones— the average lifespan of the American male is seventy-eight), Lee,

like the Energizer Bunny, just keeps going and going. Without a doubt, Lee owes at least some of this longevity to his partner, Maude Mitchell. After the scary health crisis in Shanghai, with the suggestion that the kidney ailment might lead to permanent disability, Mitchell took it upon herself to do extensive research on kidney disease and partnered with Lee's doctors to improve his odds. "I was like, 'I'm not ready for this,'" says the fifty-something Mitchell. "We met late, and although we've had a very full life together I can't help wanting a little more, more love, more work, more" She laughs, quoting Tom Waits. "Even Jesus wanted just a little more time."

But I think the key to Breuer's longevity also lies in his relentless commitment to moving forward. When Lee gets up in the morning, he never looks back—he's always ready to move into the next phase, whatever that might be. If you want to be an armchair psychologist, you can probably trace this back to the early death of his father— a man filled with regrets about his past—or Lee's being urged to commit his emotionally disturbed mother at the age of sixteen. Or maybe it's the byproduct of spending an entire life three steps in front of creditors. And while this unyielding forward momentum has taken a toll on both personal and professional relationships over the years—there's no denying that Lee has left a series of burning bridges in his wake—it has also resulted in a sixty-year body of experimental theatrical work that is pretty much unparalleled in the United States.

And the momentum continues: In 2011 Breuer staged the first American play ever presented by the Comédie-Française in its 330-year history. In the end, Breuer's version of Tennessee Williams's *A Streetcar Named Desire* (*Un Tramway Nommé Désir*) was a fantasy world of sixteenth-century sliding Japanese screens, masked kurogo figures in black, geisha-inspired costumes for Blanche DuBois, and Heath Ledger-Joker-style makeup and hair for the actor playing Stanley. The controversial take garnered extreme reactions—swinging between wildly positive and taking complete offense—from the Parisian critics, who'd pretty much never seen anything like it before—certainly not in the "home of Molière."

Then there was *Glass Guignol: The Brother and Sister Play*, a new collaboration with Maude Mitchell and former Mabou Mines company member Greg Mehrten, the Obie-award-winning drag queen fool in *Mabou Mines Lear*. *Glass Guignol* is based on Tennessee Williams's Duchampian "readymades," his often-quoted writings—so often that they satisfy Duchamp's definition of iconic popular culture—that portray his sister Rose in a variety of characters. Rose was lobotomized in 1941.

In true Breuer fashion, the show has been in sporadic (depending on funding) development since an embryonic workshop at Duke University in 2011 and finally had a full production at the newly renovated Mabou Mines space at 122 Community Center in New York in the winter of 2017. In the fashion of a montage, the play combines that piece of classic Americana, *The Glass Menagerie*, with some of Williams's later texts—specifically his experimental *The Two-Character Play*. The wildly eclectic and kaleidoscopic piece, complete with Williams's "gorilla audience running amok," a full-sized representation of Jesus Christ representing Williams's "monster that won't be lighted," and the ghost of Mary Shelley and a bust of Lord Byron trading text messages throughout the show, ended with the image of Clare/Laura/Catharine (Mitchell) donning a giant, monstrous outfit to become a kind of Frankenstein monster in her own right.

Finally, there is *The Book of Clarence*, a documentary film Breuer is making with Eric Marciano and cinematographer Adam Larsen. The film explores the life before and after retirement of Clarence Fountain, the founding member and longtime lead singer of the Blind Boys of Alabama. Breuer and Fountain have had a relationship spanning almost forty years, back to the preliminary workshops of *The Gospel at Colonus* in the early '80s. The film came out of conversations Breuer had with gospel musician and producer Sam Butler Jr. during a remount of *Gospel* at the Spoleto Festival in Charleston, South Carolina, in 2011, which resulted in their organizing interviews and filming Fountain's performances. The film premiered at the Museum of Modern Art in February 2017.

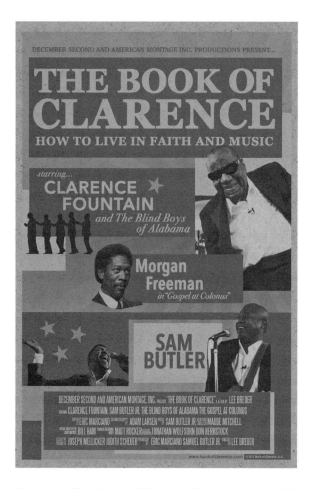

Poster for The Book of Clarence, *film premiere, MoMA Documentary Fortnight Festival, New York City, 2017.*

Simultaneous to these projects, there has been a lot more: a feature-length film version of *La Divina Caricatura*, expanding the Bunraku elements to create a filmic animated novel, based on the book of plays for the Richard Schechner series in Seagull Press; the premiere of a Breuer-directed opera based on *Antigone* by composer Theodore Stathis in Athens; a radically re-envisioned production of Sam Shepard's *Curse of the Starving Class* with the Academic Kiselev Youth Theater in Saratov, Russia, which eventually toured

to St. Petersburg; remounts of *Peter and Wendy* and *DollHouse* in New York, Boston, and D.C.; directing a new play by Susan Eve Haar, *Sex in a Coma*, in New York; and, maybe most important, the production of *La Divina Caricatura* at La MaMa.

And so, the relentless work goes on—and so does Breuer. Of course, it will end; it has to. But it's worth considering that at its best, Breuer's work is not only an exploration of life, but also a celebration of both mortality and what it essentially means to be human. The Clarence Fountain film project is a fine example of this. "When Dante looked around he found Virgil," says Breuer. "Clarence is now eighty-five years old and sick with diabetes and end-stage renal failure, and has himself become a guide in the search for a happy death. And I, pushing eighty, have become his follower."

Fountain may be Virgil to Breuer's Dante, his leader through the period of twilight. That obviously works for him. However, for the rest of us, when we find ourselves within "a forest dark/for the straightforward pathway had been lost," we need to find our own teachers and guides to help us. For some of us, Lee Breuer fits that bill.

On Ruth Maleczech's fire escape in New York City in 2013, two months after her death. Breuer's five children and first grandchild gathered to remove her things from her apartment. Clockwise from top left, Wah Mohn, Clove Galilee (Breuer), Alex "Tiappa" Klimovitsky, Mojo Lorwin, and Lute Ramblin Breuer with Bella Elliot Breuer. Maleczech is mother to Lute and Clove.

CHRONOLOGY OF WORK

Unless otherwise noted, productions were directed by Lee Breuer

Productions

2018
Animal Magnetism by Terry O'Reilly; co-directed with Terry O'Reilly and Dodd Loomis
WUZHEN THEATER FESTIVAL, CHINA

The Gospel at Colonus, adapted by Breuer from Sophocles, music by Bob Telson, lyrics by Breuer with Telson; co-directed with Dodd Loomis
DELACORTE THEATER, NEW YORK CITY

Medea, adapted from Euripides by Olga Taxidou (workshop)
MABOU MINES, NEW YORK CITY

2017
Glass Guignol: The Brother and Sister Play, adapted by Breuer and Maude Mitchell from works by Tennessee Williams and Mary Shelley
MABOU MINES, NEW YORK CITY

Animal Magnetism, *Wuzhen, China, 2018. Puppeteers: Enrico D. Wey, Stefano Brancato, and Ashley Winkfeild.*

A Coffin in Egypt by Horton Foote
HORTON BY THE STREAM AND CARVER'S BARN, ELKA PARK, NEW YORK

2016
Glass Guignol: The Brother and Sister Play, adapted by Breuer and Maude Mitchell from works by Tennessee Williams and Mary Shelley (workshop)
ST. ANN'S WAREHOUSE, NEW YORK CITY
LA MAMA UMBRIA, ITALY

2014
Antigona, adapted and directed by Martín Santangelo; choreography by Santangelo and Soledad Barrio; consulting direction by Lee Breuer
MEANY HALL, UNIVERSITY OF WASHINGTON, SEATTLE

2013
La Divina Caricatura, The Trilogy, Part 1 by Breuer
THE ELLEN STEWART THEATER, LA MAMA, NEW YORK CITY

Shalom Shanghai by William Sun (in Chinese and English)
SHANGHAI THEATRE FESTIVAL, CHINA

Glass Guignol: The Brother and Sister Play, adapted by Breuer and Maude Mitchell from works by Tennessee Williams and Mary Shelley (workshop)
WESLEYAN UNIVERSITY, MIDDLETON, CT

2012

Glass Guignol: The Brother and Sister Play, adapted by Breuer and Maude Mitchell from works by Tennessee Williams and Mary Shelley (workshop)
SUNDANCE THEATER LAB, MASS MOCA, NORTH ADAMS, MA

Secrets of a Holy Father by Tina Alexis Allen
AFTERGLOW FESTIVAL, PROVINCETOWN, MA

2011

Sex in a Coma by Susan Haar
HERE ARTS CENTER, NEW YORK CITY

Glass Guignol: The Brother and Sister Play, adapted by Breuer and Maude Mitchell from works by Tennessee Williams and Mary Shelley (workshop)
PROVINCETOWN TENNESSEE WILLIAMS THEATER FESTIVAL, MA

Glass Guignol: The Brother and Sister Play, *Mabou Mines Theater, New York City, 2017. Maude Mitchell and Greg Mehrten.*

Mabou Mines DollHouse, adapted by Breuer and Maude Mitchell from Henrik Ibsen
CUTLER MAJESTIC THEATER, ARTSEMERSON, BOSTON
EISENHOWER STAGE, KENNEDY CENTER, WASHINGTON, DC

Peter and Wendy, adapted from J.M. Barrie by Liza Lorwin
THE NEW VICTORY THEATER, NEW YORK CITY

The Gospel at Colonus, adapted by Breuer from Sophocles, music by Bob Telson, lyrics by Breuer with Telson
SPOLETO FESTIVAL USA, CHARLESTON, SC

Curse of the Starving Class by Sam Shepard (in Russian)
THE RAINBOW INTERNATIONAL THEATRE FESTIVAL, ST. PETERSBURG, RUSSIA

Antigone, adapted by Theodore Stathis (in Greek)
MEGARON, ATHENS, GREECE

Un Tramway Nommé Désir (A Streetcar Named Desire) by Tennessee Williams (in French)
LA COMÉDIE-FRANÇAISE, PARIS, FRANCE

2010
The Gospel at Colonus, adapted by Breuer from Sophocles, music by Bob Telson, lyrics by Breuer with Telson
EDINBURGH INTERNATIONAL FESTIVAL, SCOTLAND
ORDWAY CENTER FOR THE PERFORMING ARTS, ST. PAUL, MN

Curse of the Starving Class by Sam Shepard (in Russian)
SARATOV ACADEMIC KISELEV YOUTH THEATRE, RUSSIA

Opera of the Stones by Denise Milan (in Portuguese)
SESC SANTANA, SAO PAOLO, BRAZIL

2009
Mabou Mines DollHouse, adapted by Breuer and Maude Mitchell from Henrik Ibsen
MALY BRANCH THEATRE, MOSCOW, RUSSIA
ST. ANN'S WAREHOUSE, NEW YORK CITY

Mabou Mines DollHouse, *backstage, Ibsen Festival, Oslo, Norway, 2004.*
Assistant directors Dodd Loomis and Eamonn Farrell.

Yi Sang Counts to Thirteen by Sung Rno (in Korean)
WAREHOUSE THEATRE 31, SEOUL, KOREA

Pataphysics Penyeach: Summa Dramatica and Porco Morto,
MABOU MINES STUDIO, NEW YORK CITY

Peter and Wendy, adapted from J.M. Barrie by Liza Lorwin
EDINBURGH INTERNATIONAL FESTIVAL, SCOTLAND

2008
Mabou Mines DollHouse, adapted by Breuer and Maude Mitchell from
Henrik Ibsen
EPIDAURUS FESTIVAL, ATHENS, GREECE
LG ARTS CENTER, SEOUL, KOREA
FESTIVAL IBEROAMERICANO DE TEATRO DE BOGOTÁ, COLOMBIA

The Gospel at Colonus, adapted by Breuer from Sophocles, music by
Bob Telson, lyrics by Breuer with Telson
ATHENS FESTIVAL, HEROD ATTICUS THEATER, ATHENS, GREECE

Trafi, adapted from Aeschylus by Thalia Argyriou (in Greek)
ILIOUPOLI, ATHENS

2007

The Shangilia Youth Choir of Kenya, directed by Breuer and J.D. Steele
CATHEDRAL CHURCH OF ST. JOHN THE DIVINE, NEW YORK CITY
MILLENNIUM STAGE, KENNEDY CENTER, WASHINGTON, DC

Mabou Mines Dollhouse, adapted by Breuer and Maude Mitchell from Henrik Ibsen
TEATRO ESPAÑOL, MADRID, SPAIN
DIALOG FESTIVAL, WROCLAW, POLAND
EDINBURGH INTERNATIONAL FESTIVAL, SCOTLAND
SINGAPORE ARTS FESTIVAL, DRAMA CENTRE THEATRE
THE AUDITORIUM, PARCO DELLA MUSICA, ROME, ITALY
HARBOURFRONT CENTRE, NEW WORLD STAGE, TORONTO, CANADA

Peter and Wendy, adapted from J.M. Barrie by Liza Lorwin
ARENA STAGE, WASHINGTON, DC

A Prelude to a Death in Venice (Harvey's Version) by Breuer, co-directed with Dodd Loomis
KILKENNY ARTS FESTIVAL, IRELAND

Interregnum/Tilted House by Susan Eve Haar (workshop)
FLEA THEATER, NEW YORK CITY

2006

Mabou Mines DollHouse, adapted by Breuer and Maude Mitchell from Henrik Ibsen
UCLA LIVE, LOS ANGELES
FESTIVAL DE OTOÑO, TEATRO ESPAÑOL, MADRID, SPAIN
BRISBANE FESTIVAL, AUSTRALIA
KWAI TSING THEATER, HONG KONG, CHINA
ISRAEL FESTIVAL, JERUSALEM AND HOLON
NAZARIAN CENTER FOR THE PERFORMING ARTS, PROVIDENCE, RI
YALE REPERTORY THEATRE/LONG WHARF THEATER, NEW HAVEN, CT
HOPKINS CENTER, DARTMOUTH COLLEGE, HANOVER, NH
MASS MOCA, NORTH ADAMS, MA
SUNY PURCHASE, PURCHASE, NY

The Shangilia Youth Choir of Kenya, directed by Breuer and J.D. Steele
DELPHI, GREECE

The Gospel at Colonus, adapted by Breuer from Sophocles, music by Bob Telson, lyrics by Breuer with Telson
VIENNA FESTIVAL, AUSTRIA

Choephorae/The Libation Bearers, adapted from Aeschylus by Breuer and Evangelia Andritsanou, sand painting by Jenny Rogers
PATRAS FESTIVAL, GREECE

2005
Mabou Mines DollHouse, adapted by Breuer and Maude Mitchell from Henrik Ibsen
WALKER ARTS CENTER, MINNEAPOLIS, MN
WEXNER CENTER FOR THE ARTS, COLUMBUS, OH
MUSEUM OF CONTEMPORARY ART, CHICAGO, IL
FESTIVAL D'AUTOMNE, PARIS, FRANCE
THEATRE NATIONAL POPULAIRE DE VILLEURBANNE, FRANCE
THEATRE NATIONAL DE STRASBOURG, FRANCE
THEATER DER WELT, STUTTGART, GERMANY
SPOLETO FESTIVAL USA, CHARLESTON, SC

Red Beads, adapted from Polina Klimovitskaya by Breuer
SKIRBALL CENTER FOR THE PERFORMING ARTS, NEW YORK
 UNIVERSITY, NEW YORK CITY

2004
The Gospel at Colonus, adapted by Breuer from Sophocles, music by Bob Telson, lyrics by Breuer with Telson
APOLLO THEATRE, NEW YORK CITY

Mabou Mines DollHouse, adapted by Breuer and Maude Mitchell from Henrik Ibsen
IBSEN INTERNATIONAL STAGE FESTIVAL, OSLO, NORWAY

Bagdad Café, the musical, by Percy and Eleonore Adlon, composed by Bob Telson, additional lyrics by Breuer, directed by Percy Adlon
BARCELONA, SPAIN

Auf Der Suche Nach Jakob/Searching for Jacob/Szukajac Jakuba by Eva Brenner (in German, English, and Polish)
TEATR LAZNIA NOWA KRAKOW, POLAND

2003

Mabou Mines DollHouse, adapted by Breuer and Maude Mitchell from Henrik Ibsen
ST. ANN'S WAREHOUSE, NEW YORK CITY

Two Little Indians by Frank Donnelly
HERE ARTS CENTER, NEW YORK CITY

Auf Der Suche Nach Jakob/Searching for Jacob/Szukajac Jakuba by Eva Brenner (in German, English, and Polish)
PROJEKT THEATER STUDIO VIENNA, AUSTRIA

The Shangilia Youth Choir of Kenya, directed by Breuer and J.D. Steele
ZANZIBAR FILM FESTIVAL, TANZANIA

2002

Ecco Porco by Breuer
PERFORMANCE SPACE 122, NEW YORK CITY

Red Beads, adapted from Polina Klimovitskaya by Breuer (work in progress)
MASS MOCA, NORTH ADAMS, MA

Mabou Mines DollHouse, adapted by Breuer and Maude Mitchell from Henrik Ibsen (work in progress)
NEW YORK THEATRE WORKSHOP, NEW YORK CITY

Choephorae/The Libation Bearers, adapted from Aeschylus by Breuer and Evangelia Andritsanou
ITI CONVENTION, ATHENS, GREECE

2001

Animal Magnetism by Terry O'Reilly
FESTIVAL DIVADLO, PILSEN, CZECH REPUBLIC

Ecco Porco by Breuer (workshop)
MABOU MINES STUDIO, PERFORMANCE SPACE 122, NEW YORK CITY

Lee Breuer, baby Wah Mohn, and Leslie Mohn with Indian film crew in Kerala, India, 1991, at work on Phoolana Devi *(unfinished film).*

2000

Yi Sang Counts to Thirteen by Sung Rno (in Korean)
SEOUL THEATER FESTIVAL, KOREA

Hajj by Breuer
SEOUL THEATER FESTIVAL, KOREA
MALY THEATER, ST. PETERSBURG, RUSSIA

Animal Magnetism by Terry O'Reilly
ARTS AT ST. ANN'S, BROOKLYN

1999

The Gospel at Colonus, adapted by Breuer from Sophocles, music by Bob Telson, lyrics by Breuer with Telson
UNIVERSITY MUSICAL SOCIETY, ANN ARBOR, MI

1998

The Gospel at Colonus, adapted by Breuer from Sophocles, music by Bob Telson, lyrics by Breuer with Telson
CHEKHOV FESTIVAL, MOSCOW, RUSSIA

Hajj by Breuer
MOSCOW, RUSSIA

1997
Peter and Wendy adapted from J.M. Barrie by Liza Lorwin
NEW VICTORY THEATER, NEW YORK CITY

The Gospel at Colonus, adapted by Breuer from Sophocles, music by
Bob Telson, lyrics by Breuer with Telson
UNIVERSITY OF ARIZONA, TUCSON
CAPITOL THEATER, SALT LAKE CITY, UT
UNIVERSITY OF CALIFORNIA, BERKELEY
CERRITOS CENTER FOR PERFORMING ARTS, CA
STATE THEATER, MINNEAPOLIS
SESC SAO PAOLO, BRAZIL

Lulu Noire, adapted from Frank Wedekind by Breuer
SPOLETO FESTIVAL USA, CHARLESTON, SC
AMERICAN MUSIC THEATER FESTIVAL, PHILADELPHIA

1996
The Red Horse Animation by Breuer, directed by Clove Galilee, sand
painting by Jenny Rogers (reconstruction)
BRAZIL FESTIVAL OF THE ARTS, RIO DE JANEIRO

Pootanah Moksha by Leslie Mohn
BRAZIL FESTIVAL OF THE ARTS, RIO DE JANEIRO

Peter and Wendy adapted from J.M. Barrie by Liza Lorwin
HENSON INTERNATIONAL FESTIVAL OF PUPPET THEATER, THE PUBLIC
 THEATER, NEW YORK CITY
SPOLETO FESTIVAL USA, CHARLESTON, SC

An Epidog by Breuer
HERE ARTS CENTER, NEW YORK CITY

1995
The Gospel at Colonus, adapted by Breuer from Sophocles, music by
Bob Telson, lyrics by Breuer with Telson
A CONTEMPORARY THEATER, SEATTLE, WA

The Red Horse Animation by Breuer, directed by Clove Galilee, sand painting by Jenny Rogers (reconstruction)
HERE ARTS CENTER, NEW YORK CITY

1992
The Mahabharanta by Breuer
ONTOLOGICAL THEATER, NEW YORK CITY

1991
The Quantum by Breuer
THE GREY ART GALLERY, NEW YORK UNIVERSITY, NEW YORK CITY

1990
The Gospel at Colonus, adapted by Breuer from Sophocles, music by Bob Telson, lyrics by Breuer with Telson
GOODMAN THEATER, CHICAGO
AMERICAN CONSERVATORY THEATER, SAN FRANCISCO, CA

Mabou Mines Lear adapted by Breuer from William Shakespeare
TRIPLEX PERFORMING ARTS CENTER, NEW YORK CITY

The B. Beaver Animation by Breuer (reconstruction)
THE PUBLIC THEATER, NEW YORK CITY

1988
The Warrior Ant by Breuer, music by Bob Telson
NEXT WAVE FESTIVAL, BROOKLYN ACADEMY OF MUSIC
AMERICAN MUSIC THEATER FESTIVAL, PHILADELPHIA
SPOLETO FESTIVAL USA, CHARLESTON, SC

The Gospel at Colonus, adapted by Breuer from Sophocles, music by Bob Telson, lyrics by Breuer with Telson
LUNT-FONTANNE THEATRE (BROADWAY), NEW YORK CITY
CLEVELAND PLAY HOUSE (BROADWAY PREVIEW)

1987
The Gospel at Colonus, adapted by Breuer from Sophocles, music by Bob Telson, lyrics by Breuer with Telson
GUTHRIE THEATER, MINNEAPOLIS
BARCELONA FESTIVAL, SPAIN
SPOLETO FESTIVAL, ITALY

*Johnny Cunningham,
composer of* Peter and
Wendy, *New York City.*

A Prelude to a Death in Venice by Breuer
OHIO WESLEYAN UNIVERSITY, DELAWARE, OH
OBERLIN COLLEGE, OBERLIN, OH
WASHINGTON UNIVERSITY, ST. LOUIS, MO

1986
The Gospel at Colonus, adapted by Breuer from Sophocles, music by
Bob Telson, lyrics by Breuer with Telson
ALLIANCE THEATER, ATLANTA

The Warrior Ant by Breuer, music by Bob Telson (work in progress)
LINCOLN CENTER, NEW YORK CITY

A Prelude to a Death in Venice/Hajj by Breuer
DANCE THEATER WORKSHOP, NEW YORK CITY

1985
The Gospel at Colonus, adapted by Breuer from Sophocles, music by
Bob Telson, lyrics by Breuer with Telson
MARK TAPER FORUM, LOS ANGELES
AMERICAN MUSIC THEATER FESTIVAL, ANNENBERG CENTER, PHILADELPHIA
THEATRE MUSICAL DE PARIS, CHATELET, FRANCE

A Prelude to a Death in Venice by Breuer
UNIVERSITY OF MASSACHUSETTS AT AMHERST

1984
The Gospel at Colonus, adapted by Breuer from Sophocles, music by Bob Telson, lyrics by Breuer with Telson
ARENA STAGE, WASHINGTON, DC
HOUSTON GRAND OPERA, TEXAS

The Double Life of Amphibians, composed by Morton Subotnick
OLYMPIC ARTS FESTIVAL, LOS ANGELES

A Prelude to a Death in Venice/Hajj by Breuer
TOGA INTERNATIONAL THEATRE FESTIVAL, TOGA-MURA AND TOKYO, JAPAN

1983
The Gospel at Colonus, adapted by Breuer from Sophocles, music by Bob Telson, lyrics by Breuer with Telson
NEXT WAVE FESTIVAL, BROOKLYN ACADEMY OF MUSIC

A Prelude to a Death in Venice by Breuer
GREENSBORO, NC
QUEBEC CITY, CANADA

Hajj by Breuer
CALIFORNIA INSTITUTE FOR THE ARTS, VALENCIA
THE PUBLIC THEATER, NEW YORK CITY

1982
Hajj by Breuer (workshop)
THE AMERICAN FILM INSTITUTE NATIONAL VIDEO FESTIVAL, KENNEDY
 CENTER, WASHINGTON, DC
THE PERFORMING GARAGE, NEW YORK CITY

A Prelude to a Death in Venice by Breuer
TRAVERSE THEATRE, EDINBURGH, SCOTLAND
RIVERSIDE STUDIOS, LONDON, ENGLAND

Sister Suzie Cinema by Breuer, music by Bob Telson
AMERICAN CENTER, PARIS, FRANCE
RIVERSIDE STUDIOS, LONDON, ENGLAND

The Gospel at Colonus, adapted by Breuer from Sophocles, music by Bob Telson, lyrics by Breuer with Telson (work in progress)
AMERICAN CENTER, PARIS, FRANCE
RIVERSIDE STUDIOS, LONDON, ENGLAND

1981

The Tempest by William Shakespeare
THE PUBLIC THEATER/NEW YORK SHAKESPEARE FESTIVAL,
 DELACORTE THEATER, NEW YORK CITY

A Prelude to a Death in Venice by Breuer
WALKER ART CENTER, MINNEAPOLIS
SIMON FRASER UNIVERSITY, BURNABY, BRITISH COLOMBIA
GRINNELL COLLEGE, GRINNELL, IA
PORTLAND, OR
UNIVERSITY OF CALIFORNIA-SANTA CRUZ
UNIVERSITY OF MARYLAND-BALTIMORE COUNTY
BRAZIL

Wrong Guys, adapted from the novel by Jim Strahs; directed by Ruth Maleczech with Breuer acting in the role of Johnny Street
THE PUBLIC THEATER, NEW YORK CITY

1980

Sister Suzie Cinema by Breuer, music by Bob Telson
THE PUBLIC THEATER, NEW YORK CITY

A Prelude to a Death in Venice by Breuer
THE PUBLIC THEATER, NEW YORK CITY
WEST COAST TOUR
THEATER 140, BRUSSELS, BELGIUM
AMERICAN CENTER, PARIS, FRANCE
MILAN, ITALY

Lulu, adapted from Frank Wedekind by Michael Feingold
AMERICAN REPERTORY THEATER, CAMBRIDGE, MA

1978

The Shaggy Dog Animation by Breuer
THE PUBLIC THEATER, NEW YORK CITY

1976

The Lost Ones by Samuel Beckett, adapted by Breuer and David Warrilow (revised)
THE PUBLIC THEATER, NEW YORK CITY

The Saint and the Football Player by Jack Thibeau, revised by Breuer
PRATT INSTITUTE, BROOKLYN

Henry V by William Shakespeare; directed by Joseph Papp, Battle of Agincourt choreography by Breuer
THE PUBLIC THEATER/NEW YORK SHAKESPEARE FESTIVAL,
DELACORTE THEATER, NEW YORK CITY

1975

The Saint and the Football Player by Jack Thibeau, revised by Breuer, halftime choreography by Mary Overlie
AMERICAN DANCE FESTIVAL, NEW LONDON, CT

The Lost Ones by Samuel Beckett, adapted by Breuer and David Warrilow
THEATER FOR A NEW CITY, NEW YORK CITY

1974

The B. Beaver Animation by Breuer (revised)
MUSEUM OF MODERN ART, NEW YORK CITY

Send/Receive/Send by Keith Sonnier
THE KITCHEN, NEW YORK CITY

1973

The Saint and the Football Player by Jack Thibeau, revised by Breuer
WALKER ART CENTER, MINNEAPOLIS, MN

Music for Voices, composed by Philip Glass
THE KITCHEN, NEW YORK CITY

1972

Arc Welding Piece; sculpted by Jene Highstein
PAULA COOPER GALLERY, NEW YORK CITY

The B. Beaver Animation by Breuer (work in progress)
PAULA COOPER GALLERY, NEW YORK CITY
WHITNEY MUSEUM OF AMERICAN ART, NEW YORK CITY

The Red Horse Animation by Breuer (revised production)
WHITNEY MUSEUM OF AMERICAN ART, NEW YORK CITY

1971
Come and Go by Samuel Beckett
BROOKLYN BRIDGE FESTIVAL, NEW YORK CITY

Play by Samuel Beckett (revised production)
LA MAMA ETC, NEW YORK CITY

1970
The Red Horse Animation by Breuer
THE GUGGENHEIM MUSEUM, NEW YORK CITY

1968
Messingkauf Dialogues by Bertolt Brecht
TRAVERSE THEATER, EDINBURGH INTERNATIONAL FESTIVAL, SCOTLAND
THE AMERICAN CHURCH IN PARIS, FRANCE

1967
Play by Samuel Beckett
AMERICAN CENTER, PARIS, FRANCE

Mother Courage and Her Children by Bertolt Brecht
THE AMERICAN CHURCH IN PARIS, FRANCE

1964
The Run by Breuer
SAN FRANCISCO TAPE MUSIC CENTER

Lulu, adapted from Frank Wedekind by Alan Dienstag
THE PLAYHOUSE, SAN FRANCISCO

Events and *Commedia Songs* by Breuer and William Spencer
THE R.G. DAVIS MIME TROUPE, SAN FRANCISCO, CA

1963

The Maids by Jean Genet
THE AMERICAN COOPERATIVE THEATRE, SAN FRANCISCO

The House of Bernarda Alba by Federico García Lorca
SAN FRANCISCO ACTOR'S WORKSHOP

The Underpants by Carl Sternheim
SAN FRANCISCO ACTOR'S WORKSHOP

1962

Composition for Actors by Breuer
SAN FRANCISCO TAPE MUSIC CENTER

The Allegation by Lawrence Ferlinghetti
SAN FRANCISCO POETRY PROJECT

Happy Days by Samuel Beckett
SAN FRANCISCO ACTOR'S WORKSHOP

1961

King Lear by William Shakespeare; directed by Herbert Blau, assistant directed by Breuer
SAN FRANCISCO ACTOR'S WORKSHOP

1960

The Caucasian Chalk Circle by Bertolt Brecht (audition scene for Ruth Maleczech and Bill Raymond)
SAN FRANCISCO ACTOR'S WORKSHOP

1959

The Line by Breuer, directed by a UCLA student
THEATER 3K7, UNIVERSITY OF CALIFORNIA, LOS ANGELES

1958

A Play by Breuer, directed by a UCLA student
THEATER 3K7, UNIVERSITY OF CALIFORNIA, LOS ANGELES

1957

The Wood Complains by Breuer, directed by Mike Lally
THEATER 3K7, UNIVERSITY OF CALIFORNIA, LOS ANGELES

Publications

2018, *La Divina Caricatura: Bunraku Meets Motown*, Seagull Books
2017, *Red Beads: A Performance Poem, PAJ: A Journal of Performance and Art*, vol. 39, no. 3, pages 24–32
2010, "Travailler avec le bois," *Puck: Le Point Critique*, no. 17
2009, *Porco Morto, TDR/The Drama Review*, vol. 53, no. 4, pages 150–62
2002, *La Divina Caricatura*, Green Integer
1998, *B. Beaver Animation, From the Other Side of the Century II: A New American Drama, 1960–1995*, Sun & Moon Press
1992, "South Indian Theater—Kudiatum," *Spin Magazine*, United States Information Service
1992, *The Warrior Ant*, etchings and handmade paper editions by Susan Weil, Vincent FitzGerald & Co.
1989, *The Gospel at Colonus*, Theatre Communications Group
1987, *Sister Suzie Cinema: The Collected Poems and Performances 1976-1986*, Theatre Communications Group
1987, From *An Ant in Hell: The Warrior Ant, Part Four, Theater*, vol. 18, no. 2, pages 69–72
1984, *Hajj* in *Wordplays 3*, PAJ Publications
1982, "The Avant-Garde Is Alive and Well and Living in Women," *Soho Weekly News*
1982, *A Prelude to a Death in Venice* in *New Plays USA 1*, Theatre Communications Group
1979, *Animations: A Trilogy for Mabou Mines* (includes *The Red Horse Animation, The B. Beaver Animation*, and *The Shaggy Dog Animation*), Performing Arts Journal Publications
1977, *The Red Horse Animation* in *The Theatre of Images*, Drama Book Specialists
1977, "Mabou Mines: How We Work," *Performing Arts Journal*, vol. 1, no. 1, pages 29–32
1976, *The Red Horse Animation* (a comic), self-published 1960, "In This City" (a fragment from a novel in progress), *The San Francisco Review*, vol. 1, no. 6, pages 68–75
1959, "The Wall" (short fiction), *Westwinds Magazine*

Sister Suzie Cinema, *New York City, 1982. Fourteen Carat Soul: Reginald Brisbon (Briz), Russell Fox, Glenny T (Wright), Brian Simpson, and David Thurmond.*

Films

2019, *The Book of Clarence*, feature documentary by Breuer and Eric Marciano; featuring Clarence Fountain and Samuel Butler, cinematography by Adam Larsen and Eric Marciano, produced by December 2nd and American Montage Inc.

2008, *Mabou Mines DollHouse*, adapted from the stage version; screenplay and direction by Breuer, cinematography by Diane Baratier, music by Eve Beglarian, editing by Alexandra Strauss, produced by ARTE

1985, *The Gospel at Colonus*, adapted by Breuer from Sophocles, music by Bob Telson, lyrics by Breuer with Telson, filmed live performance, produced by PBS Great Performances

1968, *Moi Meme*, unfinished feature written and directed by Breuer, cinematography by John Rounds, Paris

Albums

2012
Bob Telson and Lee Breuer Collaborations 1979-2002
Disc 1: Unreleased and Sister Suzie Cinema
Disc 2: The Warrior Ant (Radio Plays)

2004
Bagdad Café The Musical: Live in Lyon, music by Bob Telson, additional lyrics Breuer

1993
The Warrior Ant, music by Bob Telson, lyrics by Breuer

1988
The Gospel at Colonus, music by Bob Telson, lyrics by Breuer with Telson
Bagdad Café Soundtrack, music by Bob Telson, additional lyrics by Breuer

1982
Sister Suzie Cinema and The Gospel at Colonus music by Bob Telson, lyrics by Breuer with Telson

To you who have supported my work and are not credited in the text of Getting Off, *I'm sorry, really sorry. When you start to die, your memory is the first to say goodbye. Last summer I had a stroke and my mind was as blank as if a delete button were pressed on my life of collaborative creation. Please accept my thank yous, my apologies, and my gratitude.*

—Lee Breuer

LIST OF PHOTOGRAPHS

The photographs in this book are reproduced with the kind permission of the following photographers, individuals and organizations:

p. ii, Ilaria Freccia

p. xiv, Don Behrstock

p. 11, 93, 197, Richard Termine

p. 21, 29, courtesy of Lee Breuer

p. 44, Roberta Neiman

p. 62, 63, Amnon Ben Nomis, courtesy of La MaMa ETC

p. 65, Kathy McHale

p. 67, Johan Elbers

p. 78, 196, Terry O'Reilly

p. 88, Stefano Ruffa

p. 93, Richard Termine

p. 99, 102, 141, 166, 207 Beatriz Schiller, copyright © 2019

p. 106, Richard Landry

p. 110 and 111, Martha Swope

p. 114, David Allen

p. 121, Peter Moore

p. 136, Daniel Kund

p. 158, Linda Alaniz

p. 171, Georgina Bedrosian

p. 176, Debra Richardson

p. 192, courtesy of Lee Breuer, designed by Anna Burholt

p. 194, Christianna Nelson

p. 199, Maude Mitchell

p. 203, courtesy of Wah Mohn

p. 213, Chris Ha

p. 219, courtesy of Stephen Nunns

p. 221, Bob Telson

Color insert:

p. 1 (top), Scott Suchman, (bottom) Richard Termine

p. 2 (top), Kfir Bolotin, (bottom), Alison Yerxa

p. 3 (top), Eric Marciano and Fred Hall, (bottom), Michel LeBrun

The cast and crew of *La Divina Caricatura*:
Eric Avery, Roy Bennett, Paul Bourne, Stefano Brancato, Kate Brehm, Lee Breuer, Maxine Brown, Beverly Crosby, Emily Decola, Eamonn Farrell, Piotr Gawelko, Bill Holloman, Daniel K. Isaac, Karen Kandel, Paul Kandel, Charlie Kanev, Tiappa Klimovitsky, John Korba, Tom Lee, Sharon Levy, Dodd Loomis, Eric Marciano, John Margolis, Sherryl Marshall, Denny McDermott, Marta Mozelle MacRostie, Brendan McMahon, Greg Mehrten, Katie Melby, Valois Mickens, Bernardine Mitchell, Maude Mitchell, Sarah Murphy, Terry O'Reilly, Ben Odom, Nicole Press, Sarah Provost, Lincoln Schleifer, Jessica Scott, Kelley Selznick, Melissa Shaw, Gary Sieger, Jessica Simon, Gene Stewart, Matt Terry, Miguel Valderrama, Maxime Verdiere, Amanda Villalobos, Jessica Weinstein, Lee Williams.

p. 4 and 5, Beatriz Schiller, copyright © 2019

p. 6 (top), courtesy of Lee Breuer, (bottom), Hong-Yeol Park/Kwang-Jo Ahn

p. 7 (top), Lucas Mandacaru, (bottom), Mikhail Gavryushav

p. 8 (top), Micro Magliocca, (bottom), Martha Elliot

ACKNOWLEDGEMENTS

Stephen Nunns would like to thank Karen Houppert, who contributed to and reported much of the *Ecco Porco* chapter in this book; Sarah Lloyd for her transcription work; Maude Mitchell and Sharon Levy for their advice and assistance through the many years it took to put this project together; Joe Stackell for fielding various email queries; the unflappable Jim O'Quinn, editor emeritus of *American Theatre* magazine, for his patience, advice, and line edits; and Terry Nemeth, Sarah Hart, Kitty Suen, Monet Cogbill, Lisa Govan and Kathy Sova from TCG Books for their unwavering support of this project. And, of course, Lee Breuer, without whom none of this would have been possible or even necessary.

STEPHEN NUNNS is a professor at Towson University. From 1996 to 2000, he was an associate editor at *American Theatre* magazine, and his writing has also appeared in *The New York Times*, *The Village Voice*, and other publications. He is also the co-founder of the award-winning Baltimore-based theatre ensemble, the Acme Corporation. Before going to Baltimore, he lived in New York City for fifteen years, directing, writing, and composing music at a variety of Off-Off Broadway venues, and he was also an associate artist at Mabou Mines. He holds a B.A. from Bennington College, an MFA from Brooklyn College, and a Ph.D. from New York University.

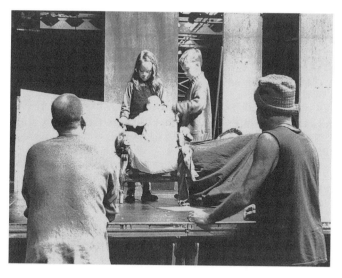

Mabou Mines DollHouse *rehearsal, St. Ann's Warehouse, New York City, 2003. From left, Stephen Nunns, Maude Mitchell, Tate Mitchell, Zack Nunns, and Lee Breuer.*

LEE BREUER is a writer, director, poet, adapter, lyricist, and film-maker. Breuer's theatrical presentations span performance art, theatre, film, video, music, visual arts, poetry, literature, and opera. After more than ten years of making theatre in Los Angeles, San Francisco, and Paris, Breuer moved to New York and co-founded Mabou Mines in 1970 to continue a career of theatrical experimentation. By blending disciplines and techniques from widely different cultures, he has created a unique performance genre fusing sound and musical components, visual arts, and arresting movement/dance/puppetry into a groundbreaking form.

His published works include: *The Red Horse* and *B. Beaver Animations*, *Sister Suzie Cinema*, *The Gospel at Colonus*, *The Warrior Ant*, *Porco Morto*, and *Red Beads*. He has directed over 100 stage productions since 1957, among them: *The Red Horse* and *B. Beaver Animations*, *The Lost Ones*, *A Prelude to a Death in Venice*, *Hajj*, *The Shaggy Dog Animation*, *The Gospel at Colonus*, *The Warrior Ant*, *Mabou Mines Lear*, *An Epidog*, *Peter and Wendy*, *Mabou Mines DollHouse*, *Red Beads*, *Un Tramway Nommé Désir* (Comédie-Française), *La Divina Caricatura Part 1*, and *Glass Guignol: The Brother and Sister Play*. He is lyricist for the albums *The Gospel at Colonus*, *The Warrior Ant*, and *Unreleased*. His films include *The Gospel at Colonus*, *Mabou Mines DollHouse*, and *The Book of Clarence*.

Breuer's teaching and lecturing engagements include Yale, Harvard, Stanford, Columbia, and New York Universities, as well as multiple University of California campuses; the Provincetown Tennessee Williams Theater Festival; and abroad at the Moscow Art Theatre, in Saratov under the auspices of the U.S. State Department, both the Beijing and Shanghai Drama Academies, the Edinburgh Festival, Trinity College in Dublin, Ireland, the New Delhi Ibsen Festival, Athens University, the Aristotle University of Thessaloniki, and the International Conference on American Drama and Theater in Nancy, France. Fellowships include MacArthur, Harvard/Radcliffe Bunting, Ford/U.S. Artists, Bellagio, Guggenheim, McKnight, Camargo, MacDowell, and Yaddo. He has received Fulbrights to Greece and India, two Rockefeller grants for playwriting in New

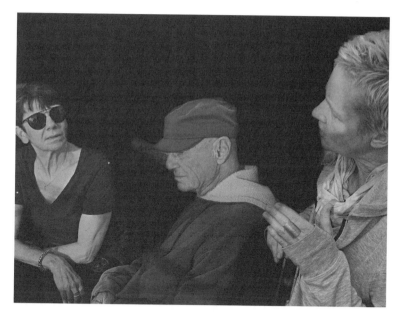

Sharon Levy, Lee Breuer, and Maude Mitchell, New York City, 2018.

York, Asian Cultural Counsel Fellowships to Thailand and Myanmar, Japan–United States Friendship Commission, and a Ford Foundation grant for research and teaching in East Africa, where he founded the gospel chorus program at Shangilia orphanage in Kenya.

He has been nominated for Pulitzer, Tony, Emmy, and Grammy awards. He has directed thirteen Obie Award–winning performances, and has received Obie Awards for best play, best directing, best musical, and sustained achievement. He has been honored by the Cairo International Experimental Theater Festival, received an American Express/Kennedy Center Award for Best New American Play, an Edinburgh Herald Archangel Award for Sustained Achievement, and a Chevalier Ordre des Arts et des Lettres.

He has worked on six continents. When he's not on the road he lives in Brooklyn with his partner, award-winning actress Maude Mitchell. He was born in 1937; he has three grandchildren and five children who are all artists.

SHARON LEVY is president of Dovetail Productions, which develops, produces, and tours new work. Productions include Lee Breuer and Bob Telson's *The Gospel at Colonus*, Noche Flamenca's *Antigona*, *Mabou Mines DollHouse*, and Baba Brinkman's *The Rap Guide to Evolution*. Earlier work includes the *Tribute to King Oliver* for the 1996 Olympics and casting for Robert Altman's HBO series *Tanner '88*. Throughout the 1980s in Atlanta, Georgia, she produced more than 40 plays and musicals.